Let's eat sweets and talk sweetly.

Turkish proverb

Spice a dish with love and
it pleases every palate.

Plautus

I love you not only for what
you are, but for what I am when
I am with you . . . I love you for the
part of me that you bring out.

Elizabeth Barrett Browning

For Sylvia Zephyr,
with love

A whisper of
CARDAMOM

80 sweetly spiced recipes
to fall in love with

ELEANOR FORD

APOLLO
PUBLISHERS

CONTENTS

AN ODE TO CARDAMOM 54

SWEET & WARMING 76

A IS FOR ANISEED 106

VANILLA IS NOT A NEUTRAL 130

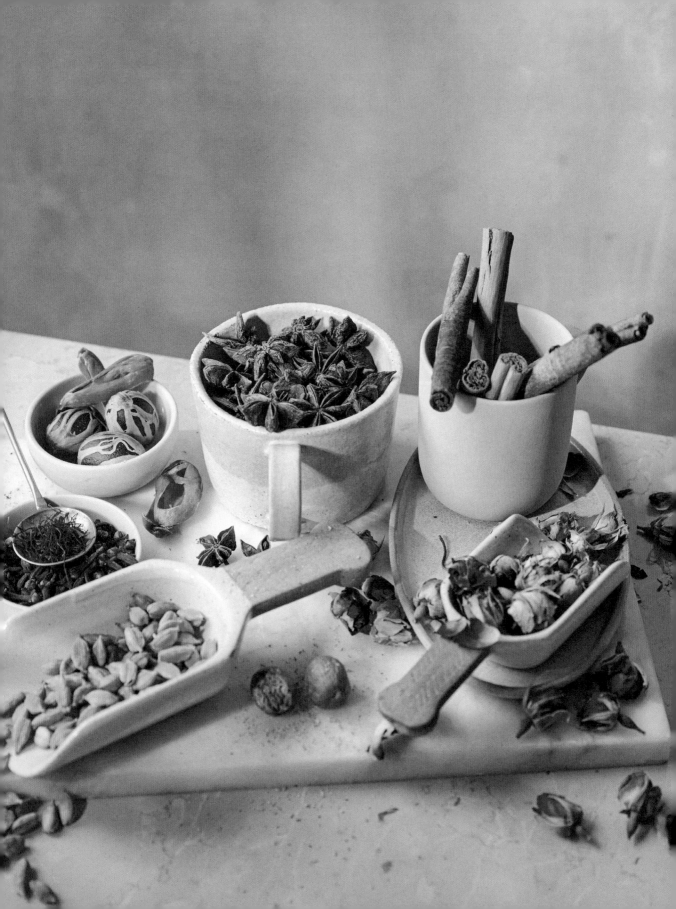

A WHISPER OF CARDAMOM

The most famous lovers of all time were cast together by the sultry aroma of burning cardamom luring Mark Antony to Cleopatra's palace. In Medieval Europe, sachets of cardamom would be tucked into mattresses to inspire ardor, and in India, a wax-sealed bundle of cardamom, cloves, and nutmeg was given as a love token. Today, Indian brides bathe in saffron and women in Zanzibar eat nutmeg porridge on their wedding morning.

Spice and sweetness have been bound together with lust and ardor since the first syllables of recorded history.

This is their love story.

Spice is often the party girl, the loud, bold, exuberant element in the mix. Indeed "spicy" has become synonymous with racy and spirited, and sometimes that is exactly what we want from our food. A generous swirl of woody-sweet cinnamon elevates a simple bun; pistachio-green baklava is made otherworldly by the headiness of rose water; and a truly fiery gingerbread is thunder and wonder in the mouth.

There is also another art, more subtle yet equally seductive.

In sweet cookery, spice can provide a delicate fragrance, hard to put your finger on but one that gives backbone to a dish. It can balance tartness and bring sweetness so you can tone down the sugar. Flavors can be enhanced by a thoughtful addition from the spice cupboard, making chocolate more chocolaty and fruit taste more of itself. Added not in shouts but in whispers, an intrigue of spice deepens allure.

You can't enjoy spices in isolation, they need foods to bounce off, so cooking with them is an art of creating relationships. Like any successful marriage, when paired with the right ingredients they will bring out the best in each other. In this book,

we'll explore how to find compatibility and how to unlock flavors.

Floral and fruity spices combine well with buttery fats. Warming spices like ginger and clove play off treacly brown sugar. Anise sweetens, lemony coriander seed brightens, and herbaceous notes pick out complexity in chocolate. A suspicion of nutmeg cuts the sweet creaminess of custard for a more rounded tart, and a whisper of cardamom makes inky poached plums jaunty and interesting.

The chapters in this book are divided by flavor to guide you toward a dessert or bake that is bright and zippy, floral and fragrant, or dark and spicy. Recipes include spice switches so, as you develop a nose for the flavors, you can be creative and playful with your spicing.

SUGAR & SPICE: AN INFATUATION

Do we need dessert? Isn't abstemiousness a virtue? But then again, is pleasure really so inessential?

An intoxicating blend of yearning and fear marks humans' relationship with sugar and spice. We crave sweets with a fire that verges on the narcotic, being both drawn to them and also having a latent sense of their power over us.

For centuries, these ingredients have held key positions in cooking, medicine, and worship, with a thread of magic and superstition woven through it all. Wedding cakes are laced with cloves and sweet cinnamon; bitter pills are sugar-coated; cardamom is burned as incense to carry prayers heavenward in wisps of scented smoke. It seems philters, potions, and enchantments the world over would be impotent without spice.

In 1562, the English physician William Bullein wrote a health journal recording foods to defend against sickness, including crushed gems, powdered hedgehog (good for baldness), mandrake, and unicorn horn. A host of spices were embraced too, their otherworldliness making them at home in his treatise.

Writers through the ages have been lured by the links to faraway lands and so "spice" has been laden with poetic symbolism. It stands as a contradictory metaphor for both love and death; for the sacred and the impure; for the erotic, exotic, and fantastical.

Our love language is sugared—*sweetheart, honeymoon*—yet sweetness too isn't straightforward. Whereas honey is almost always a positive term (honeyed words are endearing, a mellifluous voice rich and smooth), sugar is more ambivalent. A sugary smile suggests insincerity, and a saccharine romance is perhaps not one to hanker for. Perhaps sweetness needs to feel rare and special, even nectarous, for us to truly love it.

Sugar and spice and all things nice have long flavored our literature, our customs, even our history.

It isn't hyperbole to claim that spice shaped the modern world. One of humankind's earliest exports, the great value it came to hold rippled out into far-reaching political consequences. Sea trade dating back millennia laid the pathways for globalization, discovery, and the mapping of our globe. I explored these themes in my book *The Nutmeg Trail*, looking at how centuries of exchange and cultural diffusion along the ancient spice routes influenced society and the food we eat today.

While the history of spice begins with the movement and sharing of ingredients and ideas, it descends into dangerous greed and exploitation. The same is true of the sugar industry, which was part of the Atlantic Slave Trade that shipped more than 12 million human beings from Africa to the Americas between 1501 and 1867, with a mortality

rate of up to 25 percent on each voyage and a miserable life for those who survived and their enslaved descendants. In Jamaica, for instance, the indigenous population was wiped out by the Spanish, then replaced by Afro-Caribbean peoples mainly from Ghana and Nigeria. The influx of slaves escalated fiercely under later British rule, all in service of the sugar trade. This is a book about sweetness and union but there is a dark side to acknowledge. Mass sugar imports from the Caribbean and South America to Europe and Northern America were only made possible through slavery, and the spice trade was a trigger for colonialism. Deep wounds were caused through suffering and humiliation and the scars remain today.

Given the extents Europeans went to in order to satiate their desire for sweet and the fashion for spice, it meant the foodstuffs held an irresistible air of glamour from their rarity. Prices saw astonishing inflation as people used extravagant culinary displays to show off their social standing. Unlike savory food, which has a purpose to sustain,

sweet food was reserved for special occasions where cost and practicality slipped in the shadows behind indulgence.

A positive side of superpowers is they have always attracted diverse diasporas, and when cultures merge it creates intellectual movements and fires artistic—including culinary—progress. Tracing centers of world power through the epochs we find hubs of sweet creativity. Capitals of cosmopolitan life become capitals of confectionery.

Late to the game were the Europeans as they didn't know about sugar until 1100 and it was a luxury for another 600 years after that. Indeed,

sugar was so rare and sparingly used it was itself categorized as a "spice" until the 1500s when it became more plentiful.

Yet in India, sugarcane had first been refined sometime before 500 BC. Here, its juices were boiled down to syrup-swathed crystals used to make sweets; later it was washed to white and exported as a medicine. But a sweet tooth is hardwired in humans (read more on page 114), so the story of dessert predates this all. In Ancient Egypt, where agriculture stretches back at least 4500 years, honey was used to sweeten early bakes and spices gave foods zip. In early Mesopotamia, gods were indulged with sweets, the love goddess Ishtar receiving a sensual medley of dates, sesame, butter, honey, and rose water. It was the pleasure-seeking Romans who elevated cooking with spice to an art form, imbuing the imports with high value. Emperor Nero hosted heavily spiced feasts that would last all day from the mechanically rotating banquet hall in his Golden Palace. His subjects never doubted the potent magic held within spice.

South Asians felt no differently about the condiments' powers. The subcontinent is both the birthplace of sweets and many homegrown spices, including pepper, cinnamon, and cardamom, and the two fused naturally together. Confectionery was a craft long before a taste of sugar spread to the West and early Hindu sweetmeats made from cooked milk, sugar, and perfumed spices remain to this day.

India had been delighting in sugar for a millennium by the time the cane came to be used for sweets in the Middle East. This was at a pivotal moment as one great culinary empire of the Persians was declining and the sun rose on another, Islam. Long monopolizers of the spice trade, Arabs soon became masters of sugar and spread it across Central Asia, North Africa, and to the Iberian Peninsula.

The era saw the creation of many new confections, oozing sweet nectar and heavily perfumed with mastic, flower waters, and musk.

When sugar finally arrived in Medieval and Renaissance Europe, it was embraced so enthusiastically that savory foods were sweet, sweet foods were savory and all shared a table together. This era also saw another peak of spiced excess. We must dispel the pernicious myth that spices disguised the taste of rotten meats. Quite the opposite: never would ingredients so rare and expensive be used to mask the quality of those relatively cheaply available. Rather, they were sought after as a display of wealth and refinement and so always featured in the finest cooking.

Ingredients from faraway lands hold a spicy whisper of mystery and adventure to spark imaginations. It is no wonder then that sweets and spices have been universally used as offerings to fertility gods, amulets, love tokens, charms for the bridal bed, and ointments to fire desire. They are both evocative and provocative.

Sugar sculpture has served to titillate guests and demonstrate power from ancient Egypt to the Ottoman empire. The art reached elaborate heights in sixteenth-century Venice. When Henri III of France visited, one sweet banquet treated him to a bevvy of 300 bodies crafted from pistachio and almond paste, each gilded with real gold and standing guard over more than a thousand sweetmeats.

Sweetness and temptation have been associated with femininity, and bound with misogyny, since the stories of creation, of Pandora and of Eve. Across cultures, numerous pastries are molded into the female form with either playfulness or devotion. Italy has marzipan renderings of Saint Agatha's breasts, Turkey has lady's navels and Iraq enjoys rolled baklava called bride's fingers.

There are also explicit aphrodisiacs, such as the cinnamon-breathed rice puddings taken in the court of Charles I and chocolate liquors from Aztec Mexico. Humans tend to get aroused by food in three categories: expensive or difficult to acquire; warming; or resembling genitalia. Spices fall into all three, so no wonder we are entranced. Nearly every spice has been ascribed a lusty power—see the A–Z of aphrodisiacs on page 242.

Culinary seduction has been a preoccupation of humans since the dawn of time, but we can also make food to nourish the soul. It's a well-worn sentiment that love is the secret ingredient in the best cooking. It allows us to nurture and show affection by offering something intangible and unspoken. *I cooked for you. I made something special. I baked a cake for your birthday. My mother used to cook this for me. This made me think of you.* The love hums through without mawkishness, and appreciation need only be expressed in sighs of satisfaction. Certainly, not all love tokens need to be as obvious as iced gingerbread hearts or a Renaissance sugar statue.

Another curious relationship is between flavor and emotion. When we are in a positive frame of mind, food has been proven to taste sweeter and, in a delightful feedback loop, eating sweet food makes us happier. A sweet circle of pleasure!

It is only natural then that sweets are used for celebration across global cultures. Birthdays and weddings demand cake, and religious feasts call for confectionery. In a learned inheritance from our forebears, they often include spices to mark the specialness of the events. Christmas cakes are dense with fruit, nutmeg, and cloves; Diwali sweets, shimmering with edible precious metals, are heady with cardamom; date-stuffed mahmoul biscuits are scented with rose and orange blossom waters for Eid.

An endless parade of heavenly spiced cakes and sweetmeats marks life's rituals from birth to death and every significant event in between. They join decorations and music as the joyful or poignant markers of commemoration and festivity.

Sweet foods fall outside the realm of everyday staple; they should be an occasional pleasure to savor. People don't need sugar or spice for nutrition, but neither do they need poetry, love songs, art, cathedrals, or mausoleums. They all fulfill a higher purpose: of pleasure, emotion, celebration, togetherness; of being human.

HISTORY OF A SWEET LOVE AFFAIR

Sugarcane is domesticated by the peoples of New Guinea, who chew on the raw canes to release its honeyed sap. Over the following millennia, Austronesian and Polynesian seafarers spread its cultivation and use across Asia. Meanwhile, ginger is the first spice on the move, also diffusing gradually across Asia by ship.

Maritime spice trade begins and so sets up trading routes that will act as the central nervous system of the human world for millennia, enabling the flow of not just goods, but plants, peoples, disease, arts, knowledge, beliefs, and conquest. Arab merchants take Sri Lankan cinnamon and Chinese cassia westward, where they become exotic and prized commodities. In Egypt, spices are much used in cooking—aniseed, cumin, cinnamon, fennel, fenugreek, and mustard—and baking skills are honed using hot stones to produce honey-filled pies, conical tigernut candies, and fried dumplings rolled in sweet cinnamon.

C. 2000 BC

Eating becomes a pleasure rather than just fuel as humans add aromatic seeds, roots, flowers, and stems to spice their food.

The Queen of Sheba brings gifts of gold, jewels, and spices to King Solomon.

C. 1000 BC

C. 50,000 BC

C. 8000 BC

C. 10,000 BC

Honey and fruits rule as sweeteners across Europe, Africa, and Asia. There are no honeybees in the early Americas so tree syrups and agave nectar are used instead to meet the innate craving for sweetness.

C. 1400 BC

A recipe for fruitcake called mersu is etched onto a tablet in Mesopotamia: sow-enriched bread dough with large quantities of dried fruits and pistachios, then spice with cumin, coriander, nigella seeds, and, curiously, garlic.

C. 1200 BC

Sugar makes its earliest literary appearance. In the Sanskrit Veda, a man plants a circle of sugarcane around a woman, so casting her under his love spell.

C. 3000 BC

The first "ice cream" is made in China, a scented rice milk packed into mountain snow.

Sugarcane is grown throughout Southeast Asia and China. In India it is chemically refined for the first time; sugar dealing and confectionery become widespread trades. The Emperor Darius of Persia invades India, finding sugar and extending its slow, sweet march westward. In Persia, essential oils are produced from coriander, saffron, and fragrant flowers, while in China, local vanillas and peppers are burned as incense. Cocoa is seen as a symbol of life and fertility in Central America and the Mayans prepare the first chocolate drink, a spicy, bitter elixir made by grinding unsweetened cocoa seeds with water, cornmeal, and chili.

C. 500 BC

The *Kama Sutra* is published, promoting aphrodisiacs of warming spices, saffron, and sugared milk.

2ND CENTURY

"Song of Solomon," a lyrical love poem of the Old Testament, describes the sensory excitement of cinnamon, saffron, figs, and pomegranates. In Greece, a drink promising to boost libido is made from ground orchid roots.

C. 300 BC

Early Indian Ayurvedic texts espouse the health benefits of spices, including nutmeg, cardamom, and clove. Cleopatra bathes in saffron milk and douses herself with honey before meeting with suitors.

C. 100 BC

The Visigoths sack Rome, demanding 3000 pounds of peppercorns as ransom. The fall of the Roman empire triggers the Dark Ages in Europe; trade with the Middle East dries up and spices fall largely out of use in European food.

5TH CENTURY

C. 400 BC

Honey is the sweetener of Greece and used in a layered pastry cake called plakous (later named placenta in Latin and the model for derivative confections across Central and Eastern Europe). Greek and Roman envoys to India learn about sugar and bring small amounts back for medical use. It is described as "The reed which gives honey without bees."

C. 200 BC

Rice puddings and fermented ginger drinks are enjoyed in India, and a tradition of gently spiced milk-based sweets is woven into Hindu rituals. Newborn babies have a mixture of honey and ghee dripped into their mouths to ensure their first taste is a sweet one.

1ST CENTURY

Spices are used extravagantly in Ancient Rome. Indian peppercorns feature especially heavily in the world's first cookbook written by Apicius, which includes dishes such as lozenges of fried dough soaked in peppered honey. Due to their cost, imported spices are used as a display of lavishness, epitomized by Emperor Nero burning a year's supply of cinnamon at his wife's funeral (the romance tempered by the fact he is atoning for his role in her death). A tradition of birthday cakes starts as bread is enriched with butter, eggs, and honey for the celebrations.

International scholars gather at the great Persian university of Jundi Shapur to discuss a new medicine from India: sugar. It becomes a prized ingredient in Persian cooking and "jeweled rice" is sprinkled with rock sugar crystals.

6TH CENTURY

Persians enjoy drinking sweet-sour sharbats, heavily perfumed with flower waters, herbs, and fruits. These are sometimes considered love potions.

12TH CENTURY

In the palaces of Indonesia, fresh spices like turmeric and galangal are blended to jamu, bittersweet elixirs drunk by princesses to sustain eternal youth and beauty to serve their kings.

8TH CENTURY

Baghdad is the world's largest city, a cosmopolitan melting pot where academics, doctors, poets, and cooks come together from across Asia, the Middle East, and North Africa to share ideas. Sensual and edible pleasures are built into the culture—the ultimate of these luxuries being sweets and spice. In Egypt, elaborate feasts feature sugar models of trees, animals, and castles.

10TH CENTURY

9TH CENTURY

Sugar is grown in southern Europe, notably Spain and Sicily, following the Muslim conquest of the region.

11TH CENTURY

Soldiers returning to Western Europe from the Crusades bring home spices and sugar, sparking widespread demand among those rich enough to afford them.

7TH CENTURY

Seeds for the Golden Age of Islam are sown. Arabs invade Persia, discover sugar and soon become masters of its refinement and use. Joining a position long held by spice, it is seen as both a drug and a delicacy to be enjoyed by the most wealthy. Sugar syrups are scented with rose petals and orange blossoms, and they are formed into marzipans, halvah, and extravagant sugar sculptures. Taste for such luxuries spreads with the growing Arab empire.

13TH CENTURY

The Persian polymath Nasir al-Din al-Tusi writes *The Sultan's Sex Potions*, which includes a syrupy tonic made from ginger, cardamom, cinnamon, and clove. The Arab poet Rumi describes mastic and rose-scented pastries as being as delicate as the morning breeze and as thin as locusts' wings.

Venice, the entrance port of Europe, is built on the wealth of spice and sugar. Prices become increasingly exorbitant as Marco Polo's book piques interest in the rare produce, so much so that peppercorns are accepted as currency. The first large shipments of sugar come to England where it is treated much like nutmeg and pepper, as an exotic seasoning. Indeed, the term "spice" in Europe has a broad meaning, including precious items such as candied citrus, rose water, sugared almonds, and aniseed balls, as well as saffron, cinnamon bark, and paper twists of cloves. Chaucer lists cumin, licorice, and sugar as "royal spicery." In the court of England's Richard II, a gently sweetened cheese tart is served laced with saffron and ground ginger, though the sweet crystals are just as often paired with fish. Dishes sweet and savory (or often somewhere in between) all come to the table together. Chemists start selling candies and lozenges as medicines, and coating pills in sugar.

14TH CENTURY

In the Middle East, power shifts to the Ottomans and Istanbul becomes the center of influence as well as confectionery. Baklava, exquisite buttery pastry layered with nuts, sugar syrup, and spices, is conceived and refined in Topkapi Palace and spreads throughout the empire. An annual tradition begins, the Baklava Procession, where hundreds of circular copper trays of the sweet are given to soldiers on the fifteenth day of Ramadan to reward their loyalty. In London, a day's wages can buy 100g cloves and less than 20g sugar. Demand for sugar and spice across Europe escalates, the high values fueling an Age of Discovery and a Portuguese empire. Columbus sails west in search of a new route to India and its valuable peppercorns and instead finds the Americas, allspice, and chilies. In Madeira, sugar is cultivated for large-scale refinement. The Portuguese introduce sugarcane to the New World and the plants take quickly to the Caribbean climate.

15TH CENTURY

16TH CENTURY

Chocolate is an essential part of Aztec culture, made into a frothy, spiced, and annatto-stained drink used to demonstrate high status. When Cortés conquers Mexico in the name of Spain, he brings chocolate back to his home country. With the delicious additions of honey, cinnamon, nutmeg, and black pepper, it becomes a Spanish obsession and one viewed dimly by the Catholic Church. Meanwhile, sugar mills are built across South America and the Caribbean for the new industry, and slaves are exported to Brazil to keep up with production to feed rich, sugar-crazed Europeans. Tabernaemontanus writes, "Nice white sugar . . . cleans the blood, strengthens body and mind," and "Sugar wine with cinnamon gives vigor to old people." In Tudor England, a cordial of rose water and cinnamon is taken as a medicinal tonic, though Italy is setting the culinary fashions of Europe. Catherine de' Medici popularizes ice cream among the elite, and nutty cinnamon sweetmeats are encased in hard sugar. In India, sugar has become affordable enough to be a staple food for all, and even elephants and horses have their feed sweetened. With the start of Mughal rule, a parallel cuisine develops and so perfumed, flour-based halvahs from the Middle East join ancient Hindu milky sweets. Chili is burning a trail across Asia, having been introduced by the Europeans, and quickly overthrows peppercorns as the preferred source of piquancy.

Spices remain in hot demand in Europe as the ultimate way to show off wealth and sophistication. Carrying a silver nutmeg grater in one's pocket is considered a suitable display of standing. Spectacular sugar sculptures are in vogue in both Renaissance Italy and Ottoman Turkey, and the first iced, circular cakes are baked, usually in the form of spiced fruitcakes made in cake hoops. European nations compete fiercely to control the lucrative spice trade, setting off a wave of colonization. Nutmeg sees a 32,000 percent price increase and is so especially valuable that in 1667 the Dutch and the English exchange two strategic islands on opposite ends of the Earth: the Dutch gain the tiny Indonesian island of Rhun, home of the nutmeg; the English get Manhattan, New York. European lust for sugar is also ever increasing, especially driven by the new imports of coffee, tea, and chocolate. Slavery is escalated to cope with the growing demand, and Africans from West Coast regions are shipped across the Atlantic to work in the plantations, many dying on the voyages.

17TH CENTURY

18TH CENTURY

Trading advances mean both spices and sugar in Europe pass their peak in value and become that deathly thing for a luxury: attainable. Heavily spiced, sweet-savory dishes are seen as medieval and outmoded as fashionable people turn to newer exotic commodities like tobacco and chocolate. Now that sugar is affordable to the working classes, Europe's sweet tooth hits a high and sugar represents 20 percent of all imports. England has a particularly fierce sugar habit, where the working-class day starts with jam and sweet tea. Portuguese monasteries use egg whites for laundering, and monks find a way to put all the yolks to use: in pastel de nata—sweet custard tarts with a breath of cinnamon. Meanwhile, France is setting the tone for culinary sophistication across Europe with new ideas, such as using vanilla to flavor ice cream.

Most sugar comes from British and French colonies in the West Indies, but collective conscience is growing and abolitionists boycott slave-grown sugar. In Britain, a parliamentary bill to ban slavery fails, but preference grows for slave-free sugar. Industry seeks alternatives: in northern America, maple syrup is pushed and in Germany, beet is identified as another sugar source.

The slave trade is made illegal, replaced in part by indentured labor, and Caribbean sugar falters. New ways to satisfy demand must be established. The sugarcane industry in the US grows, making sugar affordable to all Americans for the first time, yet it still relies on cheap slave labor until 1865. In 1892, Coca-Cola is founded, starting an invasion of the American beverage around the world. The potent concoction of sugar, cocaine, and caffeine is flavored with a top-secret blend of spices, thought to include cinnamon, nutmeg, coriander, and neroli.

In Europe, sugar beet manufacture flourishes, replacing imported cane. The habit of serving sweet and savory foods together wanes and dessert moves to become an exclusively sweet way to finish a meal. Vienna is a center of creativity for the new course, drawing on the ethnic diversity of the Central European Hapsburg empire. Strides are made in confectionery as toffee, fondant, and nougat are developed and the French chef Antonin Carême becomes renowned for his fantastical, edible sculptures. The English firm Fry & Sons creates the first chocolate bar; Henri Nestlé of Switzerland makes the first solid milk chocolate.

19TH CENTURY

High-sugar manufactured food increases exponentially, the products losing much subtlety and complexity as well as the class connotations long associated with confectionery. The birth of the child consumer sees sweets designed with them in mind. Awareness grows of the health concerns of excess sugar consumption, so artificial sweeteners have a moment on the stage before their own health risks are exposed. Spices fall out of use in many commercial products, though vanilla reigns as the world's most coveted sweet flavoring; 99 percent of it is artificially produced rather than coming from the bean.

20TH CENTURY

21ST CENTURY

Sugar has never been cheaper nor more abundant in our diets. Sugarcane is the world's third most valuable crop and sugar accounts for 20 percent of calorie consumption. We have come full circle as sweeteners fall further out of favor and ancient sources of sugar make a comeback: honey, stevia, dates, agave nectar, maple syrup. The resurgence of artisan foods sees imaginative new flavor combinations, epitomized by the macaron craze that sweeps Europe in the first decade (one such Hermé macaron combines smoked tea with saffron, iris, carrot, and violet).

Spices, once some of the world's rarest ingredients, have become ubiquitous and production is greater than at any point in history. Though mostly affordable to all, a few reminders linger of their ancient value. Vanilla beans overtake the price of silver when 2017 Madagascan storms decimate crops, and saffron remains as expensive as gold.

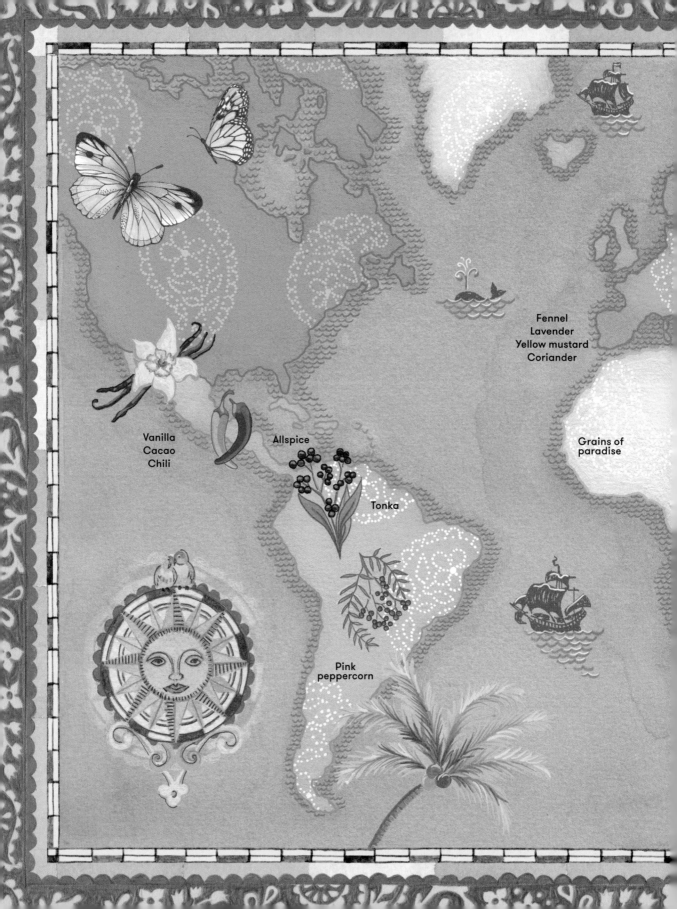

Fennel
Lavender
Yellow mustard
Coriander

Grains of
paradise

Vanilla
Cacao
Chili

Allspice

Tonka

Pink
peppercorn

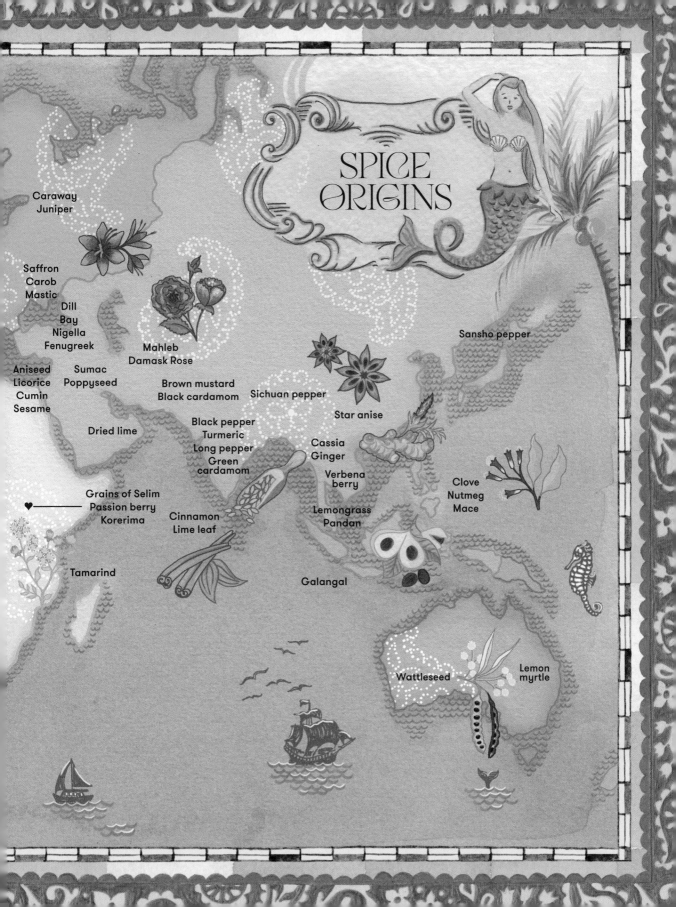

SPICE ORIGINS

Caraway
Juniper

Saffron
Carob
Mastic
Dill
Bay
Nigella
Fenugreek

Mahleb
Damask Rose

Aniseed
Licorice
Cumin
Sesame

Sumac
Poppyseed

Brown mustard
Black cardamom

Sichuan pepper

Sansho pepper

Star anise

Dried lime

Black pepper
Turmeric
Long pepper
Green
cardamom

Cassia
Ginger

Verbena
berry

Clove
Nutmeg
Mace

Grains of Selim
Passion berry
Korerima

Cinnamon
Lime leaf

Lemongrass
Pandan

Tamarind

Galangal

Wattleseed

Lemon
myrtle

UNDERSTANDING SPICE

Unassuming pips and dusts in little glass jars, it is easy to forget the journey spices have gone on both literally and figuratively. Your flavorings started life in a tangled jungle or mountain plain, perhaps on the other side of the Earth from where you are now, where they were nurtured by tropical sun and the seasonal rhythms of the monsoon. They may be the seeds of plants destined to create new life, the stamen of a flower harvested by hand at sunrise, or the dried bark of a fragrant tree. Like most of the food we eat, spices come from living things and that is what gives them their variety and depth.

So what exactly constitutes a spice?

They are the parts of plants most densely rich in flavor: the roots, rhizomes, fruits, seeds, arils, flower buds, and resins that even in tiny quantities can enhance and enliven a whole dish.

Heady with essential oils, oleoresins, terpenes, and other compounds, these chemical stores are there to help plants reproduce and survive. Often the very things we are drawn to—the pungency, bitterness, warmth, or numbing qualities—are the plants' defense mechanisms, their armor to repel predators.

A sense of their power and extraordinariness is hidden in the name, for "spice" comes from the Latin word "species," meaning "merchandise of special value." They also require some special skills in the kitchen to tease out their aromas and enjoy the full impact. In the pages that follow, we will explore how to get the most out of individual spices, as well as some more general tricks for unlocking their unique flavors.

GREEN CARDAMOM

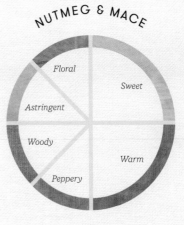

Flavor wheel: Sweet, Medicinal, Penetrating, Herbal, Floral, Citrusy

Why love it

Perhaps the most complex of spices, cardamom has brightening qualities of citrus, flora, and eucalyptus that can cut through richness. Use in whispers and it will add intrigue.

Match with

Bean: white chocolate, chocolate, coffee
Nut: pistachio, almond, coconut
Sweet fruit: apple, pear, apricot, banana, mango, plum, persimmon, fig
Tart fruit: orange, quince
Spice & herb: saffron, rose, allspice, ginger, cinnamon, coriander seed, pepper
Sweet: maple syrup, honey, caramel, date syrup

Extract the flavor

The whole pod can be ground, or for more intensity use only the seeds and grind with a little sugar. Combine with fat to bring out the fullest flavor.

BLACK CARDAMOM

Flavor wheel: Penetrating, Medicinal, Piney, Citrusy, Smoky

Why love it

The larger pods of black cardamom share a medicinal note with green cardamom, but the flavors are bolder and aggressively smoky. Wonderful with chocolate.

Match with

Bean: chocolate
Nut: pecan, hazelnut
Sweet fruit: blueberry, pear
Spice & herb: pepper, ginger, vanilla, black sesame

Extract the flavor

The husk holds the smokiness, so lightly crush and infuse the whole pod to capitalize on this quality.

NUTMEG & MACE

Flavor wheel: Floral, Sweet, Astringent, Woody, Warm, Peppery

Why love it

Nutmeg completes a custard tart as it cuts through sweetness with its musky spiciness, transforming cloying to elegance. Mace, the aril from the same plant, has a similar flavor profile but with less astringency.

Match with

Bean: milk chocolate
Nut: walnut, hazelnut
Sweet fruit: apple, pear
Spice & herb: pepper, saffron, vanilla, cinnamon, ginger, allspice, clove
Sweet: maple syrup, caramel, treacle, palm sugar, coconut sugar

Extract the flavor

A dichotomy: nutmeg is both potent yet fleeting. Grind it early and the flavor is gone. The kernels should always be stored whole and grated toward the end of cooking to harness the intensity that is there—before it isn't.

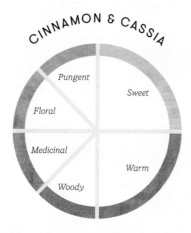

CINNAMON & CASSIA

Pungent
Sweet
Floral
Medicinal
Warm
Woody

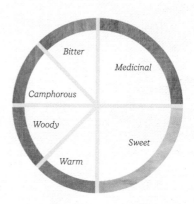

CLOVE

Bitter
Medicinal
Camphorous
Woody
Sweet
Warm

Why love it

Cinnamon's versatility meant it was the baker's spice before vanilla entered the game. It introduces complexity, a warm base note and, while not sweet in itself, it reads as such because it enhances the sweetness of its partners. Cassia bark, often used in its stead, is more intense with a note of astringency. Cassia buds (the dried, unripe flowers) have a floral, peppery bite.

Match with

Bean: chocolate, coffee
Nut: peanut, almond, coconut, walnut
Sweet fruit: cherry, fig, apple, apricot, blueberry, strawberry, banana, pineapple, pear, watermelon
Tart fruit: orange, lime
Spice & herb: nutmeg, cardamom, clove, ginger, allspice, pepper, anise, mint, thyme
Sweet: maple syrup, honey, treacle, caramel, malt syrup, date syrup, pomegranate molasses

Extract the flavor

Ground cinnamon gives an instant hit and can be dusted over desserts without cooking. Whole sticks are more demure and suffuse slowly—the addition of fat or alcohol will help the flavor release.

Why love it

Usually used in smaller quantities than other baking spices, a suggestion of clove brings a resinous intensity. It is best as an ensemble player.

Match with

Bean: coffee
Sweet fruit: apple, pear, peach
Tart fruit: orange
Spice & herb: ginger, allspice, pepper, cinnamon, vanilla, rose, basil
Sweet: treacle, malt syrup, date syrup, coconut sugar

Extract the flavor

Freshly grind cloves to keep their power. The flavors are oil-based so need fat or alcohol to distribute them.

ALLSPICE

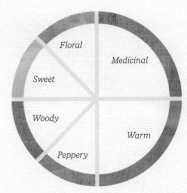

VANILLA

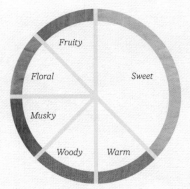

TONKA

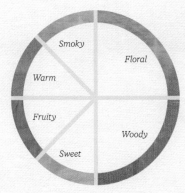

Why love it

Allspice brings a hint of many spices in one with notes of nutmeg, ginger, cinnamon, and clove. Combine with all of these to make a wintertime dessert spice. It carries some heat as well.

Match with

Bean: chocolate
Nut: walnut, pistachio, macadamia
Sweet fruit: banana, blackberry, apple, fig, pineapple, pumpkin, pear, peach, apricot, cherry
Spice & herb: cardamom, pepper, cinnamon, nutmeg, ginger, fennel, clove, vanilla, rose
Sweet: brown sugar, maple syrup, honey, pomegranate molasses, caramel, treacle, date syrup

Extract the flavor

Gently toasting allspice berries before grinding will bring out a fuller flavor.

Why love it

Universally popular, in small doses vanilla adds a perfumed sweetness, but amp it up and you get a spicy, almost savory depth of flavor in stark contrast to the blandness its name has come to mean.

Match with

Bean: chocolate, white chocolate, coffee
Nut: chestnut, walnut, hazelnut, peanut, coconut
Sweet fruit: cherry, strawberry, pineapple, apple, banana, apricot, peach, blackberry, raspberry, blueberry
Tart fruit: rhubarb, orange
Spice & herb: anise, nutmeg, allspice, clove, bay, mahleb
Sweet: caramel, brown sugar, honey, malt syrup, maple syrup

Extract the flavor

To keep the wine-like nuances of the vanilla bean, don't cook on a high heat. Use the seeds as soon as they are scraped and save empty pods to infuse into sugar.

Why love it

The lacquered beans hold a complex scent with tones of vanilla, almond, and smoke. A perfumer's dream, and the perfect match for cream.

Match with

Bean: chocolate, white chocolate
Nut: almond, chestnut
Sweet fruit: cherry, blackberry, apple, strawberry, apricot, plum
Sweet: honey, caramel

Extract the flavor

Grate the beans fresh as you would a nutmeg. Avoid cooking at a high heat so as not to destroy the many shades of flavor.

ANISE: ANISEED, FENNEL, STAR ANISE

Medicinal · Licorice · Penetrating · Citrusy · Sweet · Warm

LICORICE

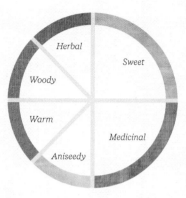

Herbal · Sweet · Woody · Warm · Medicinal · Aniseedy

CARAWAY

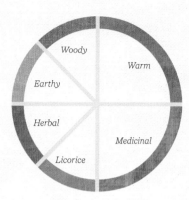

Woody · Warm · Earthy · Herbal · Medicinal · Licorice

Why love it

The compound anethole that is present in all the licorice-breathed spices excites the tongue's sweetness receptors 13 times more than sugar, making it a powerful tool in sweet cookery. Fennel seed has an additional herbal hue.

Match with

Bean: chocolate
Nut: almond, coconut, walnut
Sweet fruit: plum, apple, pear, grape, melon, pineapple, strawberry, banana, fig
Tart fruit: lemon, orange, rhubarb, quince, blackcurrant
Spice & herb: cinnamon, saffron, vanilla, basil, mint
Sweet: honey, caramel, coconut sugar

Extract the flavor

To release the sweetening effect, fat or alcohol is needed. Try sizzling the spices in oil or butter before using in a bake, as in the Wrinkled chocolate & anise cookies (page 112).

Why love it

Use sparingly to infuse a lingering sweetness and rounded medicinal quality.

Match with

Bean: chocolate, coffee
Sweet fruit: fig, raspberry
Tart fruit: blackcurrant, orange, rhubarb
Spice & herb: juniper, ginger, mint
Sweet: caramel

Extract the flavor

Steep roots in hot water—the longer, the stronger. They can also be used to flavor sugar.

Why love it

With both powerful licorice notes and warm orangey spice, caraway is much used in Eastern European baking and combines harmoniously with rye.

Match with

Bean: coffee
Nut: pine nut, pistachio, almond
Sweet fruit: plum, orange
Spice & herb: anise, cinnamon, ginger, nutmeg
Sweet: brown sugar

Extract the flavor

Seeds are often used whole for an earthy anise crunch. Toast before use to amp it up. If using ground, use a smaller quantity and add later in cooking.

MASTIC

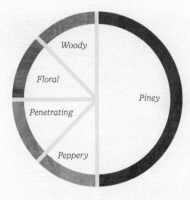

Woody

Floral

Penetrating

Peppery

Piney

ROSE

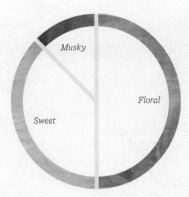

Musky

Sweet

Floral

Why love it

Translucent tears of resin with a pine-like aroma, they combine especially well with flower waters.

Match with

Bean: coffee
Nut: almond, pistachio
Sweet fruit: fig, apple, peach, watermelon
Spice & herb: orange blossom, rose, cardamom, fennel
Sweet: honey

Extract the flavor

Don't add whole mastic to liquids as it will turn to an impossible gluey gum. Rather, grind the tears with sugar to prevent sticking and help disperse it throughout a dish.

Why love it

Rose can lean toward incense, a quality magnified with pairings like cardamom, saffron, or quince, or it becomes more herbal and delicate next to the sharpness of lemon or a crisply tart apple. Use as petals or distilled as rose water. Other flower waters include orange blossom, violet, lavender, geranium, and kewra.

Match with

Bean: chocolate, white chocolate, coffee
Nut: pistachio, almond
Sweet fruit: strawberry, cherry, apricot, apple, melon
Tart fruit: rhubarb, orange, lemon, quince, pomegranate
Spice & herb: cardamom, saffron, orange blossom, pepper, pink peppercorn, anise, juniper, allspice, clove
Sweet: honey, caramel, pomegranate molasses

Extract the flavor

Rose waters vary in strength enormously, from the gentle water-based infusions used generously in the Middle East to the potent oil-based extracts sold in small dark bottles. Add judiciously and taste as you go so as not to overpower.

SAFFRON

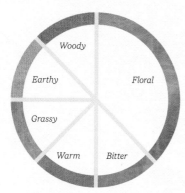

Woody · Floral · Earthy · Grassy · Warm · Bitter

MAHLEB

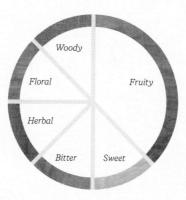

Woody · Fruity · Floral · Herbal · Bitter · Sweet

PANDAN

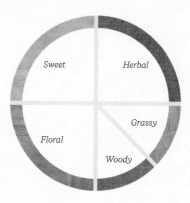

Sweet · Herbal · Floral · Grassy · Woody

Why love it

Treasured as much for the enchanting buttercup color it stains pale creams as for its inimitable bittersweet honeyed flavor. Combines well with flavors that share its bitter notes, like lemon, rose, and almond.

Match with

Bean: white chocolate
Nut: almond, pistachio
Sweet fruit: peach, apricot, pineapple
Tart fruit: orange, lemon, rhubarb, quince
Spice & herb: cardamom, nutmeg, rose, orange blossom, anise
Sweet: honey

Extract the flavor

To extract the precious flavors, crumble or grind the strands then steep in warm water or milk for at least fifteen minutes. The color and aroma both leach out more amenably in water than in fat.

Why love it

Ground mahleb kernels add a sweet and almondy complexity to baking that sits gently in the background. How alluring.

Match with

Nut: pistachio, almond
Sweet fruit: cherry, plum, peach, apricot, dried fruits
Spice & herb: vanilla, tonka bean, nutmeg, rose, sesame
Sweet: honey

Extract the flavor

The kernels are best bought whole to preserve their fragrance. Dispel bitter notes with a few tricks: set aside for a few minutes after grinding to let phenols evaporate; add before cooking; and use in combination with fats.

Why love it

Often referred to as the "vanilla of Asia," pandan leaves lend a sweet, grassy subtlety.

Match with

Nut: coconut
Sweet fruit: banana, pineapple, mango
Tart fruit: passion fruit, lime
Spice & herb: cinnamon, cardamom, clove, nutmeg, lemongrass, lime leaf, ginger, turmeric
Sweet: palm sugar

Extract the flavor

Scrunch and knot fresh or frozen leaves and add early to infuse. Blend for a stronger flavor and an intriguing green tint. You can also buy pandan extracts, which may or may not be colored a deep forest green.

BAY

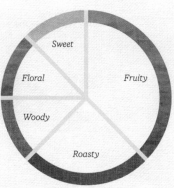

(flavor wheel segments: Warm, Herbal, Citrusy, Floral, Medicinal, Woody)

COFFEE

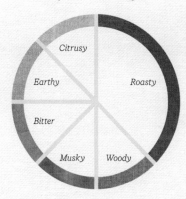

(flavor wheel segments: Sweet, Floral, Fruity, Woody, Roasty)

WATTLESEED

(flavor wheel segments: Citrusy, Earthy, Roasty, Bitter, Musky, Woody)

Why love it

Bay leaves infuse a subtle, fragrant warmth. In savory cooking this is often more noticeable by its absence than presence, but sweet cooking gives the opportunity to pair it with a neutral palette like a set cream, letting bay's flavor come to the fore.

Match with

Bean: chocolate
Sweet fruit: apple, pear, pumpkin, blueberry, peach, plum
Tart fruit: orange, lemon, rhubarb, quince
Spice & herb: cardamom, nutmeg, clove, rose, cinnamon, pepper, thyme
Sweet: caramel, maple syrup

Extract the flavor

The oils within the leaf need extracting by long cooking or a quick sizzle in oil. Dried is as good as fresh.

Why love it

We've diverted coffee away from the spice cupboard for a higher purpose, but it technically qualifies for the spice category and its roasty flavors work beautifully in desserts alongside booze and chocolate.

Match with

Bean: chocolate
Nut: pecan, hazelnut, walnut
Spice & herb: cardamom, cinnamon, ginger, rose, vanilla, coriander, clove, licorice
Sweet: caramel, date syrup, malt syrup, maple syrup

Extract the flavor

Use either the ground beans or strongly brewed coffee. Choose a dark roast for sweet, rich nuttiness, or a lighter roast for a more fruity, floral acidity.

Why love it

Roasted during processing, these Australian seeds bring a delightful coffee-like taste with notes of nut, smoke, and popcorn. Pairs especially well with dark chocolate and coffee.

Match with

Bean: chocolate, coffee
Nut: macadamia, hazelnut
Sweet fruit: banana, pear, persimmon, dried fruits
Spice & herb: vanilla, cinnamon, lemon myrtle
Sweet: brown sugar, honey

Extract the flavor

Cook with fats to reduce bitterness and bring out the citrusy, nutty notes. Or infuse in liquid for a more bitter, coffee flavor.

CACAO

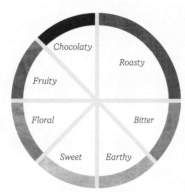

CUMIN

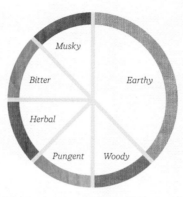

TURMERIC

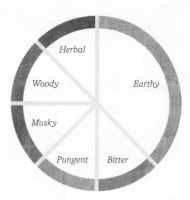

Why love it

One of nature's most complexly flavored ingredients, cacao nibs don't melt like chocolate (made from the same seed), so can add a nutty crunch to sweet bakes.

Match with

Bean: chocolate, coffee
Nut: hazelnut, almond, macadamia, pecan, coconut
Sweet fruit: banana, pumpkin, cherry
Tart fruit: orange
Spice & herb: wattleseed, pepper, vanilla, mahleb, ginger, bay, cinnamon, chili
Sweet: maple syrup, honey

Extract the flavor

Usually sold roasted, otherwise they need toasting to fade the bitterness and bring the nutty chocolaty tones forward.

Why love it

Cumin is not often used for sweet cooking, but can give a tantalizing earthiness to sweet-savory bakes.

Match with

Sweet fruit: mango, apricot, date
Tart fruit: lemon, lime, tamarind
Spice & herb: coriander seed, lemongrass, orange blossom, mint
Sweet: honey, brown sugar

Extract the flavor

Cumin demands toasting before grinding to release its earthy aromas. If you buy ground cumin, it will already have been toasted.

Why love it

Turmeric's earthiness serves to bind other flavors together and give depth.

Match with

Nut: coconut, almond, pistachio, pine nut
Tart fruit: lemon, lime, tamarind, pomegranate
Spice & herb: ginger, nutmeg, cinnamon, anise, sesame
Sweet: honey, palm sugar, coconut sugar

Extract the flavor

To keep turmeric's vibrancy, store away from the light and use alongside an acid such as lemon juice to make the yellow color pop.

SESAME

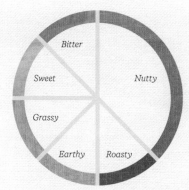

Bitter · Nutty · Roasty · Earthy · Grassy · Sweet

CORIANDER

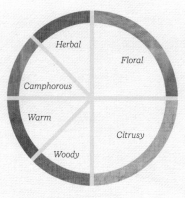

Herbal · Floral · Citrusy · Woody · Warm · Camphorous

LEMONGRASS

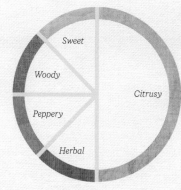

Sweet · Citrusy · Herbal · Peppery · Woody

Why love it

White sesame is subtle and sweetly nutty, while sesame paste or tahini has a creaminess useful in vegan baking. Black sesame has a heavier, earthier flavor with a more pronounced flicker of bitterness.

Match with

Nut: pine nut, almond
Sweet fruit: apple, banana
Tart fruit: tamarind
Spice & herb: vanilla, poppy seed, wattleseed, bay, turmeric, sumac, mahleb, ginger
Sweet: honey

Extract the flavor

Offering little taste raw, as soon as sesame is toasted its alluring nutty flavors come to the fore.

Why love it

The pretty, lemony notes of coriander seed are perfect to layer with other citrus flavors. They both brighten and deepen buttery bakes.

Match with

Bean: coffee
Nut: pistachio
Sweet fruit: blueberry, apple
Tart fruit: orange, lemon, quince
Spice & herb: cardamom, cumin, orange blossom, lemon thyme, ginger
Sweet: honey, caramel

Extract the flavor

For savory cooking, the seeds are often toasted to bring out an earthy nuttiness, whereas for sweet you may want to use them raw to keep the floral delicacy. Choose according to the ingredient pairing.

Why love it

There is a generous quantity of lemon-scented oils held deep within the stem. Try poaching fruit with bruised lemongrass in place of citrus zest.

Match with

Bean: chocolate
Nut: coconut
Sweet fruit: peach, pear, lychee
Tart fruit: quince, rhubarb, lemon, lime, passion fruit
Spice & herb: lime leaf, turmeric, ginger, coriander, allspice, rose, pandan
Sweet: palm sugar

Extract the flavor

For long cooking, bruise the stem, tie in a knot to expose the fragrant oils, and toss in the pot. For quicker release, slice or pound to a paste—but do keep the cooking quick or the flavor will be lost.

LIME LEAF

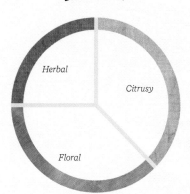

Herbal · Citrusy · Floral

DRIED LIME

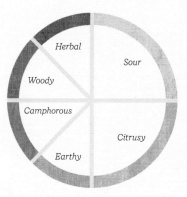

Herbal · Sour · Woody · Camphorous · Citrusy · Earthy

VERBENA BERRY

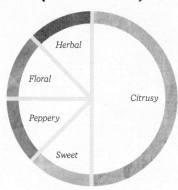

Herbal · Floral · Citrusy · Peppery · Sweet

Why love it

Leaves from the makrut (also known as kaffir) lime tree infuse food with both citrusy brightness and heady, floral fragrance. A beautiful combination.

Match with

Nut: coconut
Sweet fruit: pineapple, lychee, papaya, melon, strawberry
Tart fruit: lime, lemon, tamarind
Spice & herb: lemongrass, pandan, basil, dried lime, turmeric, ginger
Sweet: palm sugar

Extract the flavor

Fresh leaves are vastly superior to dried. Store in the freezer and scrunch before use to release the fragrance.

Why love it

Light as a sigh but intense in flavor. Brined limes are dried either until pale and sour with a musky, fermented edge, or matured until black, richer, and earthier.

Match with

Bean: dark chocolate, white chocolate
Sweet fruit: watermelon, mango
Spice & herb: chili, vanilla, mahleb, fennel, ginger, cardamom, coriander, lime leaf, rose
Sweet: honey, sugar syrup

Extract the flavor

Whole dried limes need liquid to rehydrate and draw out their full potential. Or buy as a powder for a quick, sharp release.

Why love it

Also known as mountain pepper, this Southern Chinese seed has an alluring whiff of spa. Use to add lemony zip to tea infusions, fresh fruit salads, or jellies.

Match with

Sweet fruit: berries, pineapple, stone fruit
Tart fruit: lemon, rhubarb
Spice & herb: lemongrass, ginger, turmeric, fennel
Sweet: palm sugar

Extract the flavor

Just before using, crush the berries with a pestle and mortar to release the fresh, lemongrass-like bouquet.

SUMAC

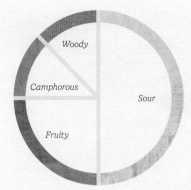

Woody

Camphorous

Sour

Fruity

Why love it

The tart, fruity brightness
of sumac can lift a flat dish
and cut sweetness. Like salt,
it will enhance the flavors
of food it is added to.

Match with

Nut: pistachio
Sweet fruit: strawberry,
cherry, fig
Tart fruit: pomegranate,
lemon, grapefruit
Spice & herb: sesame, rose,
orange blossom, vanilla,
saffron, mint
Sweet: date syrup, brown sugar

Extract the flavor

Use at the end for maximum
effect. Sumac doesn't need
cooking, so the ground berries
can be sprinkled over food
as a finisher.

PASSION BERRY

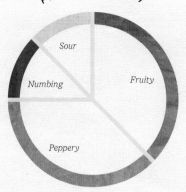

Sour

Numbing

Fruity

Peppery

Why love it

A sparkling combination
of passion fruit aroma with
mouth-cooling pepperiness
all locked into olive-green,
Ethiopian dried berries. Smell
them and let your mind
wander to possibilities.

Match with

Bean: dark chocolate
Sweet fruit: strawberry,
mango, melon, peach,
pineapple, apple, stone fruit
Tart fruit: passion fruit,
lemon, lime
Spice & herb: ginger,
lemongrass,
tonka bean, vanilla
Sweet: ginger syrup

Extract the flavor

Grind and dust over
desserts to add zing.

JUNIPER

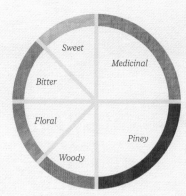

Sweet

Medicinal

Bitter

Floral

Piney

Woody

Why love it

Juniper brings a
bittersweetness that dances
at the back of your tongue
and a whiff of evergreen forest.
Counterintuitively, it shines
when layered with other
bitter flavors.

Match with

Bean: dark chocolate
Sweet fruit: plum, grape
Tart fruit: rhubarb,
quince, orange, lemon,
blackcurrant, grapefruit
Spice & herb: licorice,
rose, mint
Sweet: honey, maple syrup

Extract the flavor

The berries don't need toasting
but should be crushed to
release their piney fragrance.

GINGER

- Medicinal
- Penetrating
- Woody
- Citrusy
- Herbal
- Hot

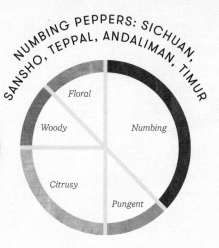

PEPPERS: BLACK PEPPER, LONG PEPPER, CUBEB

- Floral
- Herbal
- Woody
- Citrusy
- Pungent
- Hot

NUMBING PEPPERS: SICHUAN, SANSHO, TEPPAL, ANDALIMAN, TIMUR

- Floral
- Woody
- Citrusy
- Numbing
- Pungent

Why love it

The rasping heat of the raw rhizome is intensified when dried and ground, but lessened again by cooking, leaving warmth that can be layered by using ginger in multiple forms.

Match with

Bean: chocolate, coffee
Nut: almond, hazelnut
Sweet fruit: apricot, melon, mango, apple
Tart fruit: rhubarb, lime, lemon, orange
Spice & herb: pepper, cinnamon, cardamom, clove, chili, turmeric, mint, vanilla
Sweet: treacle, date syrup, honey, maple syrup, malt syrup, caramel, palm sugar

Extract the flavor

Buy ginger both fresh and ready ground. The two ingredients have different qualities and are lovely married together. (And do try peeling fresh ginger with a teaspoon, a revelation!)

Why love it

The fragrant warmth of pepper serves to enhance other flavors. It makes strawberries taste more of themselves. Black peppercorns are most common, but there are plenty of different grades and varieties to excite. Look out for my favorite, Indonesian long peppers—catkin-shaped with a captivating floral tone.

Match with

Bean: white chocolate, dark chocolate
Sweet fruit: strawberry, banana, plum
Spice & herb: cinnamon, allspice, ginger, cardamom, clove, vanilla
Sweet: maple syrup, honey, caramel

Extract the flavor

The fragrance lies in the wrinkled dark coating, while the heat is held in the pale center. (As white peppercorns have the surface removed, heat is all they offer.) Pepper should be ground just before use to keep the edges to its flavor.

Why love it

Fruits of various Asian shrubs, these "peppers" all share a tongue-tingling quality, causing a thrilling clash of cool and hot in the mouth.

Match with

Sweet fruit: pineapple, strawberry
Tart fruit: lemon, blood orange, grapefruit
Spice & herb: galangal, ginger, cardamom, lemongrass, coriander, star anise, nutmeg, fennel, cloves
Sweet: sugar, honey, palm sugar

Extract the flavor

The black glossy seeds inside Sichuan peppercorns can be discarded as the prickly husk holds all the power.

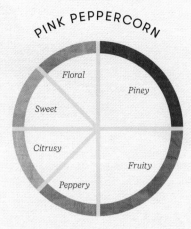

PINK PEPPERCORN

Floral · Piney · Fruity · Peppery · Citrusy · Sweet

GRAINS OF PARADISE

Earthy · Peppery · Pungent · Fruity · Floral · Bitter

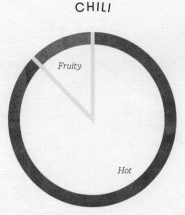

CHILI

Fruity · Hot

Why love it

A pretty pretender—no relation to pepper at all. The sharp, delicately piney flavor of brittle-skinned pink peppercorns is good with berries but use in moderation.

Match with

Bean: white chocolate
Sweet fruit: strawberry, raspberry, cherry, pear, plum, pineapple
Tart fruit: cranberry, rhubarb, pomegranate, passion fruit, lemon
Spice & herb: rose, cardamom, clove, nutmeg, cinnamon, saffron, ginger, lavender
Sweet: honey, pomegranate molasses, caramel

Extract the flavor

Use whole for their beauty or lightly crush to help release the aroma—a little hot, a little sour, a little fruity.

Why love it

West African seeds from the ginger family (like cardamom). They were popular in Medieval Europe for spicing wine and beer with their light, peppery heat and fruity-floral undertones.

Match with

Sweet fruit: apple, pear, stone fruit, strawberry
Tart fruit: lemon, orange
Spice & herb: black pepper, ginger, cinnamon, allspice
Sweet: brown sugar, honey

Extract the flavor

Fat or alcohol is needed to bring out the best from the flavor compounds. Try infusing cracked seeds in butter.

Why love it

Chili heat adds an extra dimension on the palate that can be balanced with sweet, salty, and sour for exciting, rounded dishes. When dried, a sweet smokiness is amplified. Different varieties offer different heat, fruitiness, and complexity. For instance, pasilla is richly raisin-like while ancho is sweet and earthy.

Match with

Bean: chocolate
Nut: coconut, peanut
Sweet fruit: pineapple, mango, watermelon, papaya, pumpkin, grape, apricot, kumquat
Tart fruit: tamarind, lemon, lime, orange, pomelo
Spice & herb: ginger, mint
Sweet: honey, maple syrup, caramel, date syrup, pomegranate molasses, palm sugar

Extract the flavor

Dried chili has more heat than fresh of the same variety. Frying intensifies the flavor as the fiery compound capsaicin is oil-soluble.

Food & Fragrance

The pleasure of flavor is twofold. Firstly, there is taste experienced on the tongue (think of a rush of sweetness or sourness that makes your mouth water). We have five tastes: joining sweet and sour are salty, bitter, and savory (umami). Then there is *fragrance*, an infinitely broader category of airborne compounds sensed by the olfactory receptors in our nose. This is how we pick up on the nuances that elevate a food beyond its leading characteristics.

Try this with dark chocolate: hold your nose and put a piece in your mouth, letting it melt slowly on your tongue. You'll be able to pick up sweetness, bitterness, maybe a little acidity. Now release your nose and notice how the full chocolatiness washes over you.

The joy of eating comes from combining multiple tastes and aromas to lead a charge on the senses.

Spices are largely about fragrance; they are some of the most complexly aromatic ingredients available and open up a world of flavor possibilities as you combine and blend them. Perfumers know this as well as cooks. Smell is the sense most closely associated with memories and emotions, and the human brain responds to aromas even quicker than to pain. The evoked response varies by culture. Take the scent of laundry detergent, concocted to conjure feelings of comfort and homeliness. In Greece it may have a fruity scent, in France it is overwhelmingly floral and in America it is often labeled lavender but actually perfumed with vanillin. Familiarity is a strong predictor of our approval, and so it is with food.

Our preference for spices shows distinct regional variations. Licorice is loved in Nordic countries, flower waters rule in the Arab world, aniseed liquors are close to the heart in Southern Europe and Northern Americans are unique in their fondness for root beer. Cardamom has pockets of love: South Asia, Scandinavia, the Middle East. What is curious is that these spicy flavors that are so adored can also be aversive. It seems the world of sweets is more polarizing than the savory sphere. It's often a love or hate thing. Or is it? Maybe exposure, and a little culinary adventure, is all we need to win us over.

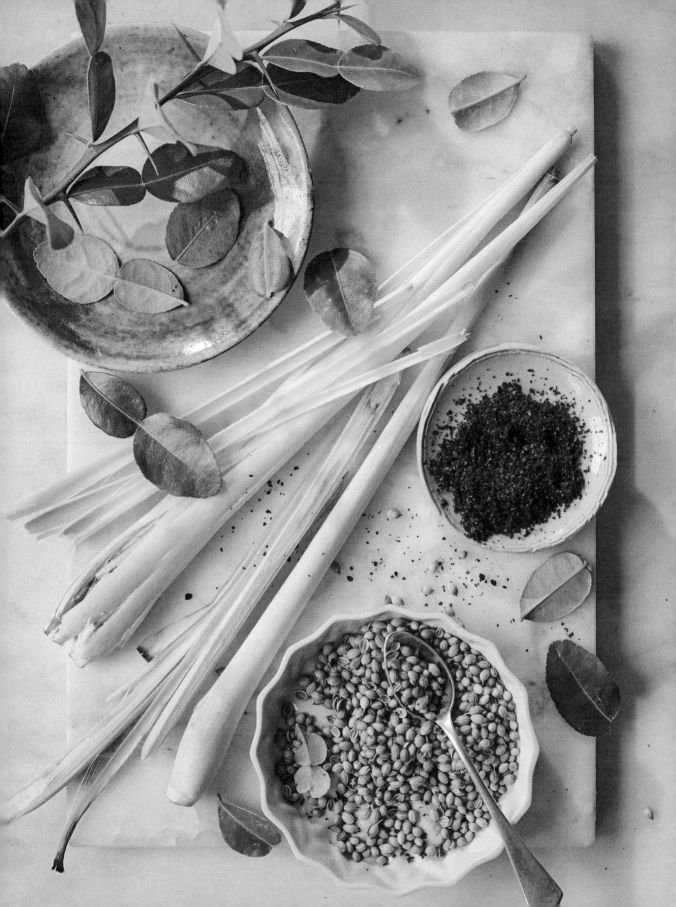

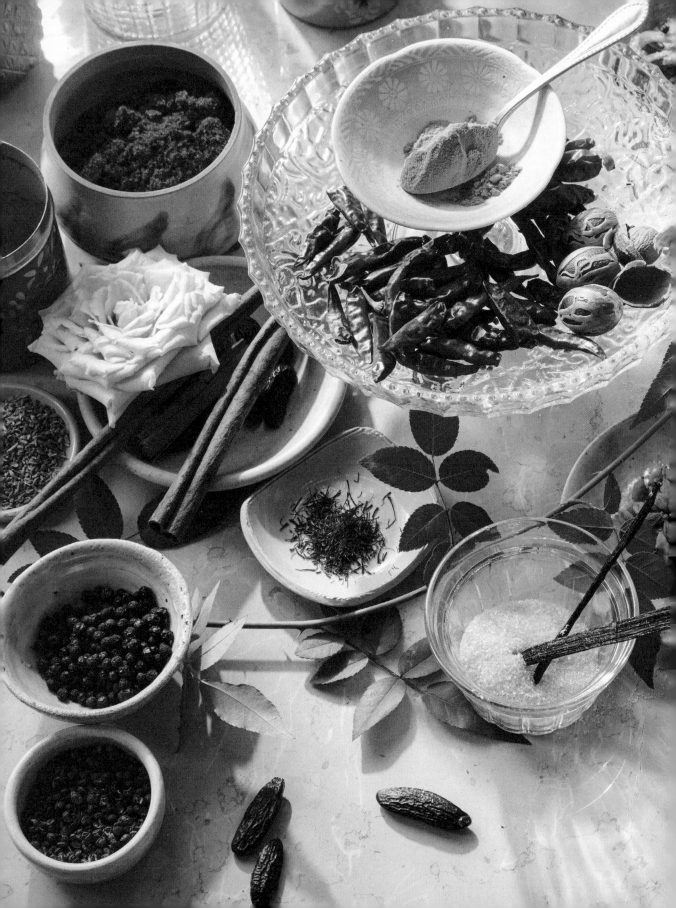

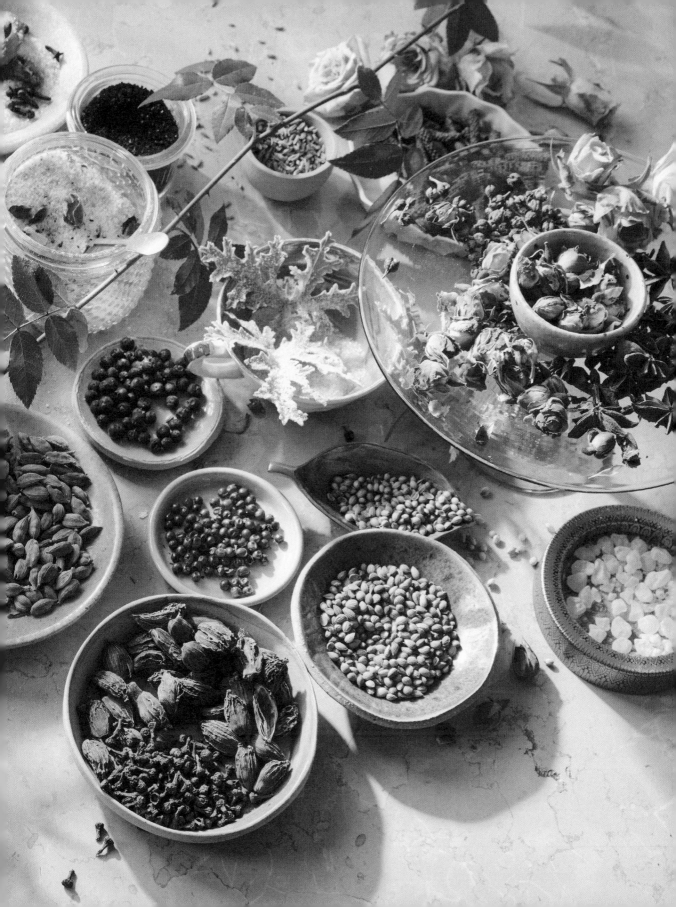

KITCHEN SKILLS
Getting the Most Out of Spice

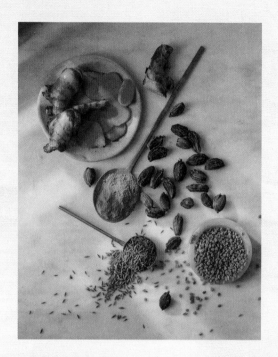

CHOOSING & STORING

Think of spices like coffee: there are different grades of quality and freshly ground is always best. Good, young spices will be rich in essential oils but these precious aromas drift away with age, especially once ground.

Ideally, you should buy spices whole, in small quantities, and grind as needed. There is still a place for convenient pre-ground, but refresh often and be aware that their intensity may be dulled. (With ground cardamom, for instance, you will need twice as much as if you grind the seeds fresh, and the taste can't compare.) Store in airtight containers away from heat and light. Finally, old spice must go! Smell: there should be an intense and appealing fragrance; there should never be a dusty disappointment.

GRINDING

Ground spices release their aroma more quickly into a dish as all the flavor compounds and volatile oils are exposed. First choose the texture you want. For a fine, even grind, an electric spice grinder is best. Using a pestle and mortar gives you more control, so is good when you want cracked spices or a coarser grind, and is also convenient for small quantities. Adding a little sugar to act as an abrasive and an absorbent can be helpful, especially for oily cardamom seeds and cloves or sticky mastic.

TO TOAST OR NOT TO TOAST?

Most spices benefit from toasting as the heat brings the essential oils to the surface, intensifying the flavors and revitalizing old stock. It also makes them more brittle

and easier to grind. Be aware though that toasting can alter their character, usually bringing out more nutty, roasted notes while softening floral and herbal flavors, so consider what effect you want in your finished dish. Coriander seeds in particular show a very different personality toasted than they do raw.

Spices should be toasted whole before grinding, not once ground, when they are quick to burn. Use a dry frying pan over a medium heat and stir the spices until very fragrant.

BLOOMING

Many spice aromas are soluble in fat, not water, so cooking them with oil or butter allows the flavors to intensify and infuse into the oils to distribute throughout the food. This can be done by sizzling spices in oil in a technique known as blooming, or more simply by combining spice and butter in a bake, where the oven does the work of bringing them together.

INFUSING

Whole spices can be used to create powerful flavor infusions then removed from the finished dish— good when you want something clean and pure like an ice cream or posset. Time and heat are the drivers to coax out flavors. For dense rhizomes and barks like ginger and cinnamon, decocting (simmering) extracts the buried flavor molecules; for tender botanicals such as tea leaves, steeping is good; and for the most delicate flower petals, a slower cold infusion is better (heat can alter the flavors, but, rather miraculously, cold infusions can be heated after straining and retain their brightness). Alcohol and fat are particularly effective carriers, so cream, butter and spirit infusions are great; sugar and syrups are two other options.

ENHANCING YEAST

A traditional German baking tip is that a pinch of ginger helps yeast. The science bears up—adding ground ginger, nutmeg, cardamom, allspice, cinnamon, or caraway to yeasted bakes will boost the fermentation, whereas mustard seed will inhibit it.

FINISHING WITH SPICE

A finishing dusting of spice will give a different effect to blending the spice into a batter. It gives a pure hit of aroma and a contrast to what lies beneath. Cinnamon and nutmeg both work particularly well as dusting spices.

HOW MUCH TO USE?

This depends on the spice you are using and what sorcery you want to perform. Are you after something decidedly spicy with a thrum of ginger or a punch of cinnamon leading the charge? Go bold and layer spices with each other. Or do you want something hauntingly beautiful in the background to enhance the other ingredients? Then be restrained and leave a fragrance to yearn for. Floral spices are usually best in this role. The recipes in this book lie across the spectrum, from whispers to shouts.

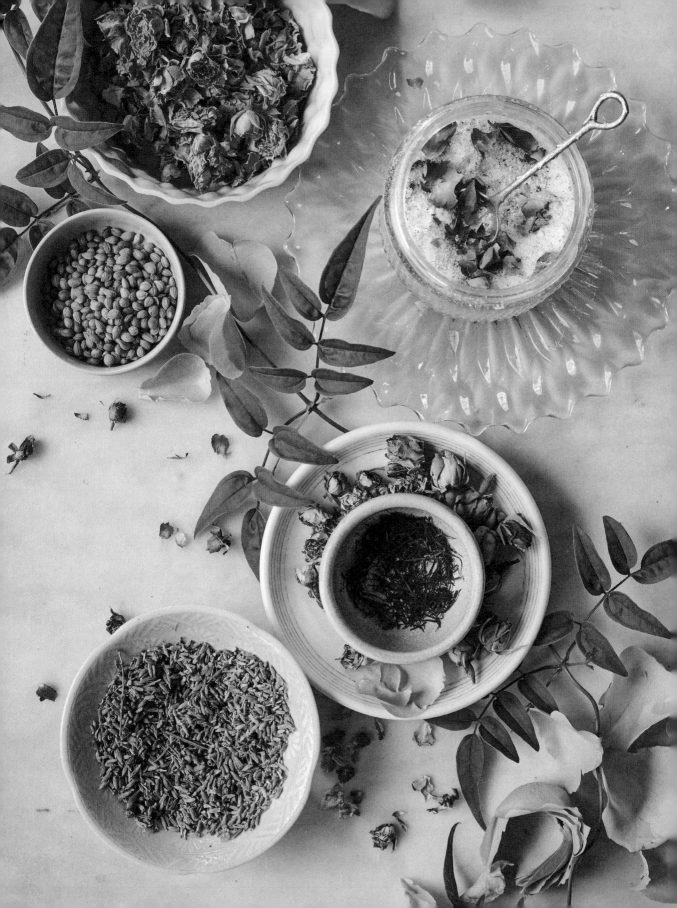

Building a Dish

When choosing, cooking, or creating a sweet dish, both texture and flavor need to be considered.

Are you after something smooth and singular as a blank canvas for flavor? A gently wobbly panna cotta, perhaps, or a clean sorbet? Or do you want a contrast of crunch or chew, like nubs of dark chocolate in an ice cream or a shell of caramelized sugar to break through before reaching the soft custard below? In cakes and bakes, you might want ethereal lightness; a more buttery sponge; or something damp, squidgy, and rich with flavor.

Flavor is our main concern in this book, how ingredients, and spices in particular, can be blended and layered to create something nuanced and special.

You can pair flavor profiles that have a natural affinity: citrusy lemongrass with lemon; woody sweet cinnamon with nutmeg; vanilla with chocolate. Or choose flavors to play off each other: the sweet muskiness of rose with puckery rhubarb; heady cardamom with the buttery smoothness of pistachio.

Each spice will bring something different, whether sweetness, fragrance, sourness, piquancy, or nuttiness. Combining them creates complexity, and you can layer the same or different spices to greater effect by using multiple techniques in a single dish. This way you can create base notes, middle notes, and top notes. Start with more robust spices that can stand up to cooking, and finish with more ephemeral flavors to preserve their delicate magic. You can also do this with a single spice. For instance, adding nutmeg early will allow its sweet warmth to permeate, but an additional grating at the end will bring its subtleties to the fore.

Clever spice use lets us cut back on sugar as spice can sweeten in other ways, whether through its chemicals (aniseed) or its learned associations (vanilla). To my mind, the best foods aren't an unrelenting onslaught of sweet anyway. Chinese culture tends to agree with this sentiment and a common compliment of a dessert is "It's not too sweet." The palate quickly tires of saccharine intensity (even if the brain forgets to pass the message on soon enough!).

A more pleasing dish comes when there is a persistent push-pull: of sweet and sour, sweet and salty, sweet and bitter, sweet and spicy.

For this we have the flavor enhancers. Just as spices can add sweetness, depth, and warmth to baking, so can sugar, salt, acid, and heat bring out character. Use them to balance a dish, tasting as you go. Sugar doesn't just sweeten, it intensifies the flavors of fruit and spice. The warming heat of ginger, pepper, or chili excites the tongue. Even a few drops of acid, such as citrus juice or vinegar, will brighten a dish. And don't

forget salt in sweet cookery. Sometimes you want it there distinctly—delicate flakes on bitter chocolate or a lip-smackingly saline caramel—but more generally, a pinch of salt will discreetly enhance and balance flavors just as it does in savory cooking. Combine sweet, hot, sour, salty, and aromatic in harmony and you will create a dish that arouses every sense.

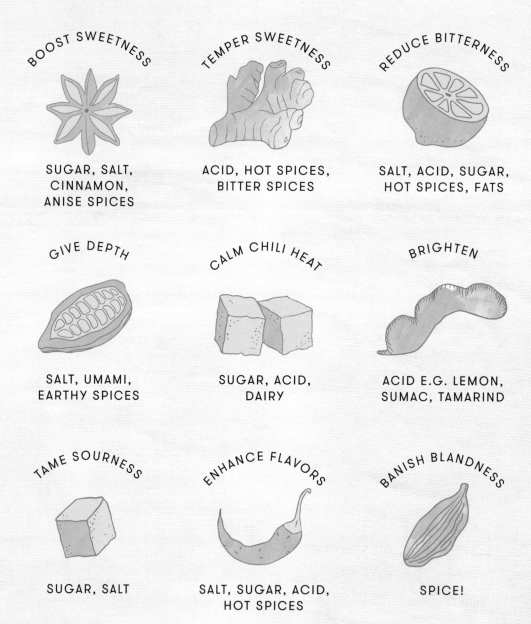

BOOST SWEETNESS

SUGAR, SALT,
CINNAMON,
ANISE SPICES

TEMPER SWEETNESS

ACID, HOT SPICES,
BITTER SPICES

REDUCE BITTERNESS

SALT, ACID, SUGAR,
HOT SPICES, FATS

GIVE DEPTH

SALT, UMAMI,
EARTHY SPICES

CALM CHILI HEAT

SUGAR, ACID,
DAIRY

BRIGHTEN

ACID E.G. LEMON,
SUMAC, TAMARIND

TAME SOURNESS

SUGAR, SALT

ENHANCE FLAVORS

SALT, SUGAR, ACID,
HOT SPICES

BANISH BLANDNESS

SPICE!

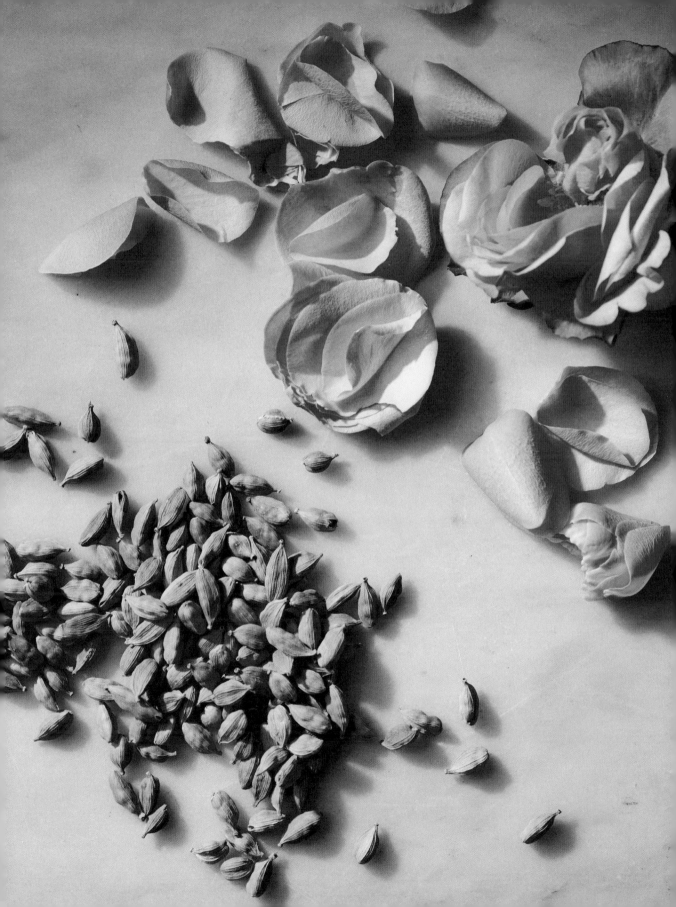

Meet the Sugars

Most sugars are extracted from either the tropical plant sugarcane or the temperate plant sugar beet. The juices are processed and concentrated to form crystals—the liquid left over is called molasses. Different processes affect the color, texture, and flavor.

Like salt, sugar is a seasoning that brings out flavors such as fruitiness and spiciness. It also balances or masks sourness and bitterness. In desserts like rice pudding or baked fruits, you can happily adjust quantities and sugar types to taste. In cakes and ice creams, sugar also plays a structural role, so adjustments should be made with care.

	VARIETIES	USES
White	Sugar at its most refined is crystalline white and the different types are simply grades of size. Coarsest is **granulated (regular)**, which is formed directly from the crystallization of the syrup. **Castor sugar (superfine)** has finer crystals that melt more quickly, particularly useful in baking. **Confectioners' sugar (icing)** is ground to a powder and as such absorbs water thirstily, making smooth icings and dense bakes. Other tweaks of texture make **preserving sugar** (for jams), **sugar crystals** (for decorating buns) and **candy sugar** or **rock sugar** (often served with coffee).	Clean, neutral sweetness that acts as a blank canvas for other flavors. Choose white over golden when color matters, such as in meringues and snowy icings.
Golden	Processed in a way that keeps in some molasses. As with white, it is available as granulated, castor, and confectioners' sugar. **Demerara** is a partly refined (raw) cane sugar with large, golden crystals. **Turbinado** is similar but a little more refined and so paler.	Gentle caramel flavor. Use when you want a little more character than white. Great in sponges and crumbles.
Brown	Most brown sugars are refined white sugar with molasses added back in. **Light brown sugar** has a smaller proportion of molasses than **dark brown sugar**. They can be dried to crystals, or softer and slightly damp.	Fuller, richer flavor, which can be sickly if overused, but pairs beautifully with autumn fruits and warm spice. The damper sugars give a fudgy or chewy texture to bakes.

	VARIETIES	USES
Unrefined	**Muscovado (Barbados sugar)** is unrefined and its dark, moist grains hold a toffeed intensity. Similar are **Chinese brown sugar (red sugar)** and various **black sugars** including the highly sought Japanese kokuto. **Panela (rapadura)** is a Latin American sugar made by drying evaporated sugarcane juice to a solid block. Similar is South Asian **jaggery**, which can be whole cane sugar or date palm sugar that has been solidified into cakes.	Deep, rich flavor and damp fudginess. Solid sugars should be shaved or grated into cooking.
Palm sugars	Unrefined sugars made from the sap of a variety of palm trees that can come in solid or granulated forms. **Pale palm sugars** have a gently sweet, caramel taste. **Dark palm sugars**, like Indonesian **gula jawa**, have a more intense, savory smokiness to match the sweetness. **Coconut sugar** is made from the coconut palm and has no coconutty taste.	Caramel sweetness and depth. When used in quantity, can play a prominent role in the taste of a dish.
Syrups	Some syrups occur naturally, such as **maple, birch, agave,** and **palm syrup**. **Blackstrap molasses** is a syrup drained from sugarcane, while the similar **black treacle** is a refined syrup used in gingerbread. To perhaps state the obvious, **date nectar** is a concentration of dates, **rice syrup** is made from brown rice, and **malt syrup** comes from malted barley.	Each syrup brings its own character, from delicately sweet rice syrup with its butterscotch edge to intense, almost savory treacle.
Inverted sugars	**Inverted sugar** is a liquid sweetener made by combining glucose and fructose. Two products much used in commercial baking are **golden syrup** and **corn syrup**—the former is a refined by-product of sugar-making and the latter is made from maize. **Honey** is a natural sweeter with similar properties and can be used in its place.	Used by pastry chefs and in commercial food production to retain moisture in cakes and give an elastic texture to ice creams.

Baking Tips

I have long disliked the maxim *Cooking is an art, baking a science*—it downplays the artistry and fun one can have with sweet cookery. If you dream up cardamom-scented apple cake or want cinnamon in your pavlova, go for it! One of the easiest ways to be creative is with your spicing. For every recipe in this book, I have offered "spice switch" suggestions so you can transform the character of each dish to your taste or, instead, let your culinary flights of fancy be guided by the flavor wheels on pages 23–35.

The science part holds true though. For most of history, sweetmeats were a treasured commodity and their preparation limited to highly skilled practitioners. Indeed, we still have specialist chocolatiers, confectioners, and pastry chefs turning out exquisitely wrought delights, quivering mousse towers and fragile patisserie. I am very much not one of them, rather a home cook interested in big flavor over frippery. In this collection, I've created and curated my favorite spiced recipes that are simple, achievable, and there to be played with. Even so, respecting some kitchen lore will enhance your baking.

INGREDIENT TEMPERATURE MATTERS

For cakes and meringues, work with everything at room temperature as the ingredients will emulsify more easily and eggs will whip up to a greater volume than when chilled. To bring eggs up to temperature quickly, sit them in their shells in a bowl of warm water for a few minutes. Conversely, for pastry, things need to be kept icy cool to stop the butter melting into the flour. Butter temperature matters most of all as its consistency alters dramatically. Cold butter is key for most pastries, piecrusts, and scones to create pockets of steam in the oven and a flaky texture (if the dough gets too warm, the effect is lost). Soft—but not melty-soft—butter is needed for cakes and buttercreams so it can be incorporated smoothly and trap air in its creamy bulk. Melting butter breaks its emulsion and can be put to use when you want a dense, fudgy texture.

BE CAREFUL WITH SUBSTITUTIONS

Baking relies on a careful calibration of protein, acidity, moisture, and leavening. Other than flavor switches or playing with additions such as dried fruits or chocolate chips, I don't recommend making key ingredient substitutions. Different flours vary in gluten levels; butter spreads have a high water percentage; sugars don't all behave the same. All these will impact the texture of your bakes.

WEIGH AND MEASURE

For the reasons above, ingredients should be measured carefully to ensure tender-crumbed cakes and delicate biscuits. I suggest weighing both dry and wet ingredients over cup measures for accuracy. A tablespoon refers to a level 15ml (½fl oz) measure, a teaspoon to a level 5ml (⅛fl oz).

EGGS

Buying cage-free eggs is recommended as the most humane option. For most of the recipes in this book, medium or large eggs can be used interchangeably. Lean toward the largest ones in the box for baking, especially where whipped eggs are used to lighten the mixture.

UNDERSTANDING RAISING AGENTS

Anything fluffy, from cake to mousse, needs a raising agent. This might be chemical, e.g. baking soda, or purely air whipped into eggs. Baking soda (also known as bicarbonate of soda) works by reacting with acid to create carbon dioxide, causing existing air bubbles to expand and your bake to rise. It needs an acid in the mix such as buttermilk, yogurt, or cocoa to help it work and neutralize its soapy taste. Baking powder is baking soda with an acid already mixed in —cream of tartar. I like to use baking powder rather than self-rising flour so I can control the amounts (add 1 teaspoon baking powder

to 100g or ⅔ cup plain flour to make it self-rising). The key is to ensure it is fresh. If you have a tough bake, the most likely reasons are overmixing or out-of-date baking powder that has lost its oomph.

MIXING SKILLS

Follow the order set out in a recipe. Dry ingredients will often be whisked or sifted together first to avoid overmixing once wet ingredients are introduced. This fluffing and aerating will help the batter blend together quickly. For cakes and pastries, mixing the flour in until "just incorporated" makes for light and tender results. (Making bread is the opposite, where you work the flour with kneading to develop chewy gluten strands.) "Creaming" together butter and sugar helps dissolve the sugar and create air pockets—do this for longer than you think for soaring sponges, 3–4 minutes in an electric mixer. It would take a lot to overbeat, but you are looking for pale and airy, not molten. When using whipped egg whites in meringues and mousses, a gentle "folding" action helps keep the precious air bubbles in.

BAKING EQUIPMENT

If you want to get technical about things: a thin aluminum baking sheet that heats quickly is good for browned, crisp-bottomed biscuits and pastries; insulated or stainless-steel baking sheets bake slower and make for squidgy cookies and delicate shortbreads. Light colored tins produce pale bakes; dark ones absorb the oven's heat faster and so encourage more browning. Flexible silicone pans stop sticking but don't conduct heat well, meaning less browning and fewer crisp edges.

MASTERING YOUR OVEN

Ovens are mercurial and each has its own temperament (and temperature, often unrelated to the one on the dial). I have given standard and convection oven temperatures as a guide, although the difference between these has reduced in modern machines. Consider buying an in-oven thermometer and getting to know your oven's quirks. If your cakes are coming out with a volcano-domed top and darker than golden edges, your oven is running hot so turn down the dial. The best advice is to follow the recipe descriptions more closely than the suggested cooking times.

There has been much debate among the British Guild of Food Writers about the received wisdom that an oven should be preheated. Many have been testing and championing the idea that a cold start works for everything—yes, even cakes, even soufflés! Anything with a cooking time longer than about 10 minutes. To test it for yourself, turn the oven on as you put in the food and add about 5 minutes to the total cooking time for convection ovens or 8–10 minutes for gas or conventional ovens.

For standardization, in the recipes that follow I have suggested heating ovens in advance, but do consider the energy you can save by not warming yours prematurely. Whichever way you choose, try not to open the oven door too early or too often to avoid temperature fluctuations, but do check toward the end of the cooking time to judge how things are progressing and prevent dry overbakes.

LET IT COOL

Unless instructed otherwise, baked items should be left to cool completely before wrapping or decorating. Covering while there is residual warmth creates steam and makes for a damp, soggy texture—something you may want to harness in a gingerbread, say, but is not usually desirable. A few hours' resting time also helps flavors develop and the crumb on a cake become less fragile. Try to decorate a warm cake and the icing or cream will slump right off as unjust punishment. Patience is in order!

STORING

Cakes are best kept covered at room temperature. If you have added cream or another perishable filling, store in the fridge but bring out a few hours before serving. Plain cakes can also be frozen, tightly wrapped, and defrosted before use. Keep biscuits crisp in an airtight tin, or here is a tip for something squidgy like a cookie: add a slice of bread to the tin with them. The bread will dry out and the cookies will stay soft and sumptuous.

ENJOY IT!

No dish is worth stress or drama. Cooking should be a joy, especially sweet cooking, which, after all, is all about pleasure. If today doesn't feel like the day for baking, turn to Fruit ♡ Spice on page 232 for speedy, no-cook ideas.

Spice Blends

The world has a dizzying array of spice blends for savory cookery, from tangy Indian chaat masala to fragrant Persian advieh. When it comes to designated sweet spice mixes, most have European origins and there is striking consensus across regions and history.

All the blends call on spices with sweet and warming flavor profiles, so cinnamon dominates with an almost inevitable backing chorus of nutmeg and clove. Both British mixed spice and American pumpkin pie spice add ground ginger and sometimes a heady hit of allspice. In the French cake pain d'épices, aniseed joins the trio, whereas in the Italian baking blend pisto, coriander seed lends a pretty, lemony note. For a more complex mix, look to Dutch speculaas, where you can find all of the above along with a thwack of black pepper.

In Medieval and Renaissance Europe, spiced cookery reached its local zenith and the lines between savory and sweet dishes blurred. Three spice blends prevailed and, yet again, cinnamon, nutmeg, and clove featured in each. "Sweet powder" also had sugar, ginger, and galangal. "Strong powder" got its strength from ginger and black pepper. "Fine powder" had additional exotic treasures, such as saffron, mace, cubeb, long pepper, and grains of paradise. A sweet spice blend called hawaij, popular in Yemen, combines cardamom, ginger, cinnamon, and clove, sometimes with a flicker of anise. It is traditionally used in coffee and is also wonderful in baking.

Undoubtedly, layering spices increases complexity and excites more flavor receptors, so can be a powerful tool. However, I'd like to point out the risk that things can begin to taste a bit generic, leading to a muddy uniformity of winter bakes that are simply "spiced." In this book I have largely chosen recipes where individual spices have starring roles and get to show their personalities.

When you do want a blend, I hope you try this one, which has the character of a full orchestral assembly.

Sweet spice mix

Taking the time to toast and freshly grind spices exposes their full power, capturing those ephemeral flavors that drift away all too quickly. (I use pre-ground cinnamon and ginger as they are hard to grind finely enough at home.) Add a spoonful of this sweet mix to crumble toppings, pies, pancake batter, or cookie doughs, or dust over hot chocolate . . .

10 green cardamom pods
5 cloves
½ nutmeg
1 teaspoon fennel seeds
1 teaspoon allspice berries
½ teaspoon mahleb kernels
½ teaspoon coriander seeds
1 tablespoon ground cinnamon
1 teaspoon ground ginger

In a dry frying pan over a medium heat, toast the whole cardamom pods, cloves, nutmeg, fennel seeds, allspice berries, mahleb kernels, and coriander seeds. Stir for a few minutes until they smell toasty, sweet, and very fragrant.

Leave to cool then transfer to a spice blender. Grind to a fine powder then combine with the cinnamon and ginger. Store in an airtight jar in a cool, dark place, where it will keep for several months. several months.

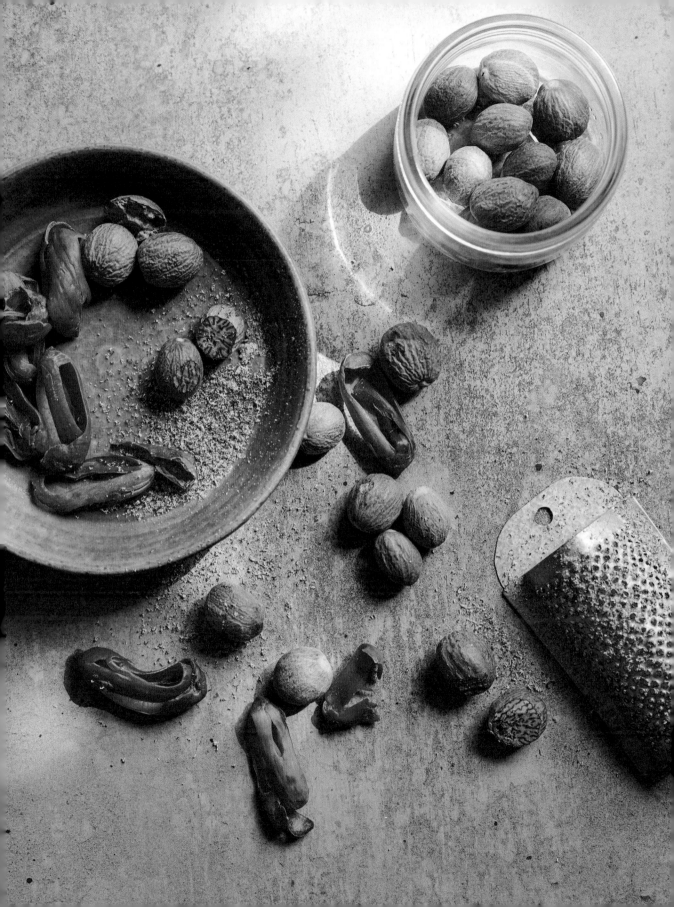

AN ODE TO CARDA

MOM

Perfumed roast figs

Sweet honey, sour vinegar, and heady cardamom combine to give a beguiling flavor to these quickly roasted figs. No dessert could be simpler to make yet look so splendid—the beauty provided by the fruit itself is only bolstered by its spicy syrup glaze.

Serves 4

For the roast figs
8 black figs
4 green cardamom
 pods, seeds ground
2 tablespoons honey
2 tablespoons balsamic
 vinegar

*For the orange
 blossom cream*
100g (3½oz)
 mascarpone
75ml (⅓ cup) heavy
 cream
1 generous tablespoon
 honey
½ teaspoon orange
 blossom water

SPICE SWITCH

In place of the cardamom, use 3 whole star anise and a good grinding of black pepper.

Heat the oven to 350°F.

Trim the stalks from the figs and cut a cross about two-thirds of the way down each, keeping the bases intact. Gently squeeze their bottoms so they open up slightly like blooming flower buds. Arrange in a single layer in a small roasting dish.

Mix together the ground cardamom, honey, and balsamic vinegar. Spoon into and over the figs.

Bake for 10–15 minutes, until the figs have just softened. When they are done, use the syrup pooled at the bottom to baste the fruit.

Meanwhile, whip together the mascarpone, cream, honey, and orange blossom water for a couple of minutes until the whisk leaves trails in a thick cream. (This could also be made in advance and chilled until needed.)

Serve the figs still just warm, alongside the cream and with the fragrant syrup drizzled over the top.

Maple cardamom ice cream with crackable chocolate

An undertone of cardamom makes the woody, almost caramelized flavor of maple syrup shine. Here the pair are combined in a simple, no-churn ice cream. The clincher is a brittle chocolate lid that you crack through with a spoon to reach the luscious, velvety smoothness beneath.

 As an optional extra, add a few drops of cardamom extract to the molten chocolate to amp up the flavor without disrupting its texture. To make your own cardamom extract, lightly crush a handful of green cardamom pods and put in a jar. Cover with vodka, leave for 3 days, then strain. (And do try it in a simple sponge cake in place of vanilla or in the Nutmeg cake on page 79.)

Serves 6

150ml (generous ½ cup) heavy cream
75ml (⅓ cup) evaporated milk
75ml (⅓ cup) maple syrup
3 green cardamom pods, seeds ground
90g (3¼oz) best dark chocolate, 70%
Sea salt flakes (optional)

SPICE SWITCH

The maple ice cream would pair well with a dash of any of cinnamon, vanilla, black pepper, long pepper, or allspice.

The day before serving, use an electric whisk to whip the cream, evaporated milk, maple syrup, and ground cardamom together for a few minutes until the mixture thickens a little and becomes airy.

Pour into six small freezer-proof ramekins or glasses. Freeze.

The next day, or after at least 5 hours once the ice cream has set, melt the chocolate. Break into pieces and put in a bowl set over a pan of simmering water. Leave to cool before spooning over the ice cream pots in even layers. Return to the freezer for about 5 minutes to set.

Serve scattered with flaky sea salt, if desired.

The lightest pistachio biscuits

These are by Gloria Ford, my husband's cousin, a talented chef and maker of the most ethereal biscuits imaginable (her secret is the rice flour). When she made a batch for a family gathering, I know I wasn't the only one who asked for the recipe. They are that good!

If you want to experiment with spicing, this is the perfect biscuit to do it with, so I have listed a myriad of spice switch ideas.

Makes 24 biscuits

60g (2¼oz) shelled pistachios
125g (½ cup) unsalted butter, softened
55g (¼ cup) castor sugar, plus more for dusting
4 green cardamom pods, seeds ground
55g (⅓ cup) rice flour
115g (4oz) plain flour
Pinch of fine sea salt

SPICE SWITCH

In place of the cardamom, you could try any of the following:
1 teaspoon toasted cumin seeds
1 teaspoon ground cinnamon
1 teaspoon mixed spice
1 teaspoon speculaas
¾ teaspoon freshly grated nutmeg
Seeds scraped from 1 vanilla pod
2 teaspoons ground jasmine tea
2 teaspoons ground rose tea
Pinch of ground saffron, infused in 1 tablespoon warm milk
1 tablespoon fresh lavender flowers, finely chopped

Use a food processor or bag and rolling pin to bash the pistachios, aiming for mainly ground with some larger bits for texture.

In a stand mixer, or with a wooden spoon and a strong arm, cream together the butter, sugar, and cardamom until light and pale. Gently work in both flours and salt just until it comes together. Then mix in the pistachios.

Tip the dough onto a piece of baking parchment and shape it into a triangular prism (think Toblerone box). Wrap in the parchment and chill in the fridge.

Heat the oven to 350°F. Line a baking sheet with baking parchment.

Slice the chilled dough into ¼-inch-thick triangles and spread out on the baking sheet. Cook for 15 minutes.

Dust with a sprinkling of sugar while hot from the oven. After a couple of minutes, transfer to a rack to finish cooling.

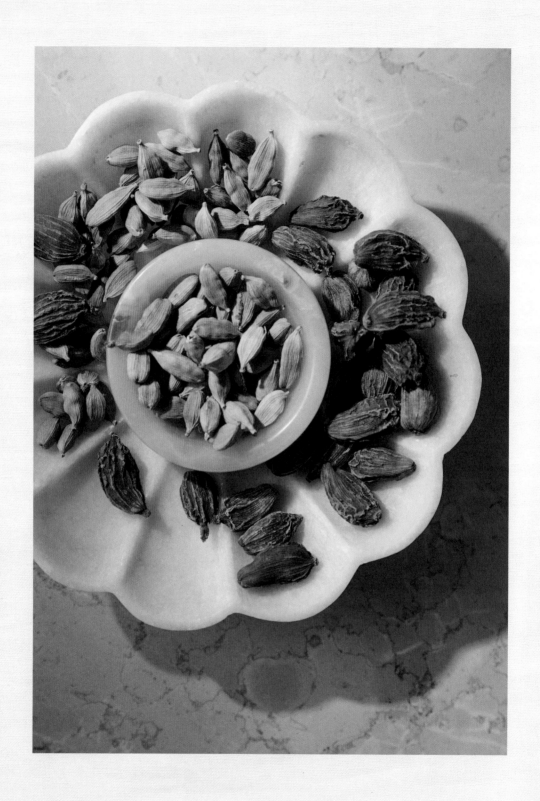

CARDAMOM

Surely the most sensuous of spices, green cardamom has a sweet floral fragrance that can subtly transform a dish. It is always tempting to add a little more to harness its mysterious flavor, but use too much and the musky aroma is replaced by a medicinal taste.

Like all seductive perfumes, it is best used sparingly.

Hailed in its native India as "queen of spices" its use dates back to the fourth century BC. Its popularity spread and more than two millennia ago the pods joined shipments of ivory, gemstones, monkeys, and peacocks bound for Greece and Rome. Cardamom plants were said to grow in the Hanging Gardens of Babylon, ancient Egyptians chewed on the seeds as a breath freshener and Vikings held the festival of cakes in honor of this, their favorite spice. The Vikings came upon cardamom in Constantinople and took it to Scandinavia, where it remains loved to this day. Bedouin and other Arabian cultures also hold it in high esteem and it features as an aphrodisiac in the tales of the *Arabian Nights*. Before a traditional wedding in Iran, the bride is given items including cardamom seeds, rose water, and sugar cones—a perfect combination.

For a spice with such an ancient and romantic history, its use remains surprisingly regionalized. Cuisines tend to love it or ignore it. Cardamom perfumes many Indian sweetmeats, including laddus and burfi, and buttery Somalian crepes called malawax. A popular treat during Afghan Ramadan is gosh-e-fil, fried "elephant ear" pastries doused in cardamom sugar. Northern Europeans employ the spice in gingerbread, Dutch "windmill" biscuits, Danish pastries, and many other Scandinavian bakes. It also scents mulled wines, aquavit, and some Russian liquors. A large portion of the world's cardamom pods end up in Arabian coffee pots, gahwa being a symbol of hospitality.

It is the sticky black seeds that hold the intense fragrance (ditch any that are pale and dusty). In "true" cardamom, these are encased in a pale green pod, either the Malabar variety or the more desirable and fragrant Mysore cardamom. Other spices we call cardamom all come from the same Zingiberaceae botanical family (also home to ginger, turmeric, and galangal). Black cardamom is from a different genus to green and is grown across the Himalayan belt, China, and Indonesia. Inside their tough, dark pods, the seeds have a blunter medicinal flavor, often combined with a haunting smokiness from the drying process. There are also African "cardamoms," which offer their own unique flavors, including korerima (smoky, peppery, herbal) and grains of paradise (floral, fruity, peppery). White cardamom is simply green pods bleached for aesthetic reasons.

Cardamom's name derives from the Arabic "to warm." This warming quality is the result of both floral and eucalyptus-like aromatics, more than 25 essential oils stored beneath the seeds' surface.

As these flavors are so volatile, always buy whole pods and crush only when required to capture the full, fleeting beauty. (If you do use pre-ground, double up to compensate.) The whole pod can infuse a milder flavor, or grind only the seeds when intensity is desired. In this case, usually discard the papery skins as these offer little—though if you are using a spice grinder to make a complex blend, there is no harm leaving them in. A little sugar in your mortar can help break the resinous seeds down and capture all those oils. Cardamom is not soluble in water and so combines best with fat or alcohol to lure out its precious aromas. Try a pinch whipped softly into cream, perhaps with a splash of booze for good measure, to bring a whisper of magic to anything it accompanies.

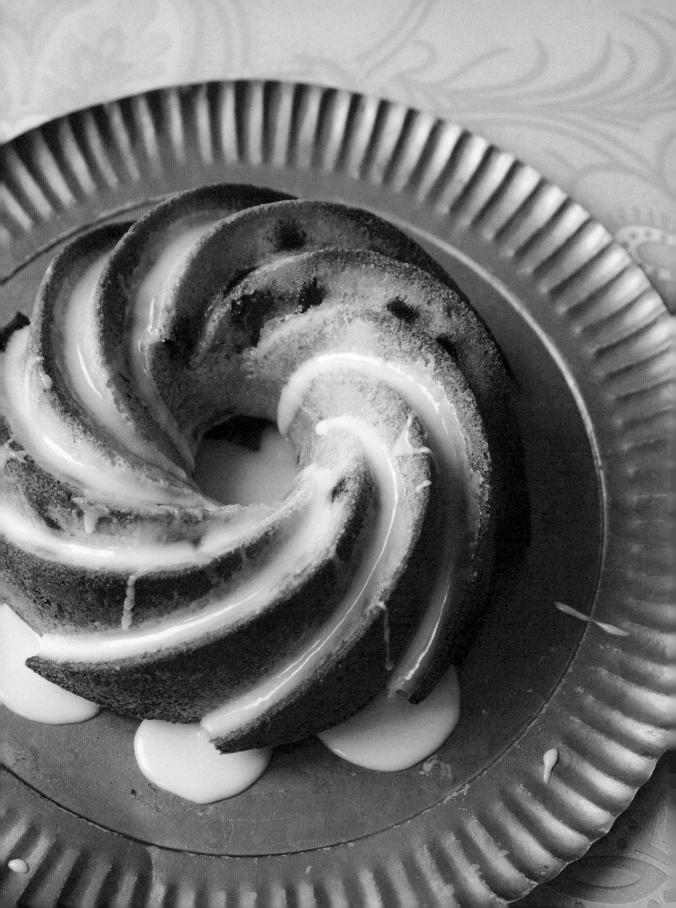

Cardamom, marzipan, & cherry Bundt

I've put all my favorite flavors together in one beautiful velvety cake with buttery crisp edges. Cherries and marzipan are a classic union, only enhanced by the sweet floral edge of green cardamom.

This is a glorious cake for a gathering, though leftovers are no hardship as it keeps well in a tin for quite a few days, getting squidgier rather than drying out. It also works with the quantities cut down to a third and cooked for 20–30 minutes in an 8-inch round cake tin for a more everyday affair. If you're going down this route, forgo the icing (it is there for a decorative flourish more than anything else) and instead scatter untoasted flaked almonds directly onto the top before baking.

Serves 12 or more

Cake
300g (10½oz) marzipan
250g (1 cup) unsalted butter, at room temperature, plus more for greasing
100g (3½oz) castor sugar
½ teaspoon fine sea salt
15–20 green cardamom pods, seeds ground

6 eggs, at room temperature
1 teaspoon almond extract
150g (1 cup) plain flour, plus more for dusting
2 teaspoons baking powder
100g (3½oz) maraschino, amarena, or cocktail cherries

Icing (optional)
200g (7oz) confectioners' sugar
2 tablespoons cherry liqueur, amaretto, or water

SPICE SWITCH

Exchange the cardamom for 2 teaspoons vanilla extract and 2 teaspoons ground allspice.

Grease a 6-cup Bundt tin extravagantly with melted butter or oil and dust with flour, tipping out the excess. Heat the oven to 325°F.

Cut the marzipan and butter into chunks and put in a food processor with the sugar, salt, and cardamom. Process until smooth, stopping to agitate and scrape as needed. Add the eggs, almond extract, flour, and baking powder and blitz again to an even batter.

Drain the cherries and dry on a paper towel. Dust with a little flour and toss (which will help prevent them sinking).

Scrape about three-quarters of the batter into the tin, scatter over the cherries and top with the remaining batter. Rap on the work top a few times to knock out any air holes and level the surface.

Bake for 45–55 minutes, until the top is golden and springy and a skewer inserted into the middle comes out clean. Leave to cool in the tin for 15 minutes before gently pulling the cake from the edges. Turn out onto a rack to cool completely.

Mix the confectioners' sugar with just enough of your chosen liquid to make a runny icing, then drizzle and swirl over the cooled cake.

Rhubarb, cardamom, & ricotta parcels

These are very quick to make using ready-made puff pastry. Shape the parcels in any way you want—fold squares into triangles, circles into half-moons, or go as I have with rectangles that fold into fat little pillows. Their stuffing is gently sweet, tart, and creamy with a waft of green cardamom.

Eat these parcels as a pastry with coffee or serve with lemony whipped cream to make into a dessert.

Makes 8 parcels

100g (3½oz) ricotta, drained
7 green cardamom pods, seeds ground
50g (¼ cup) granulated sugar, plus more for sprinkling
Pinch of fine sea salt

150g (5½oz) rhubarb, thinly sliced
320g (11¼oz) sheet all-butter puff pastry
8 teaspoons ground almonds
1 egg, beaten

SPICE SWITCH

Use 8 ground juniper berries instead of the cardamom, which offer a similarly sweet, medicinal flavor with a suggestion of forest floor.

Line a baking sheet with baking parchment.

Mix together the ricotta, ground cardamom, sugar, and salt, then add the rhubarb.

Unfurl the puff pastry and cut into eight rectangles. Scatter each with a teaspoon of ground almond and top with a spoonful of the rhubarb mixture. Fold the pastries in half to make fat pillows and crimp the edges together using the tines of a fork (dust the fork with flour if it is sticking). Chill in the fridge for about 15 minutes or more.

Heat the oven to 400°F.

Brush the parcels with egg, then sprinkle over sugar with lavish abandon. Bake for 20–25 minutes, until golden and puffed.

Serve warm or at room temperature, though they are best on the day they're made.

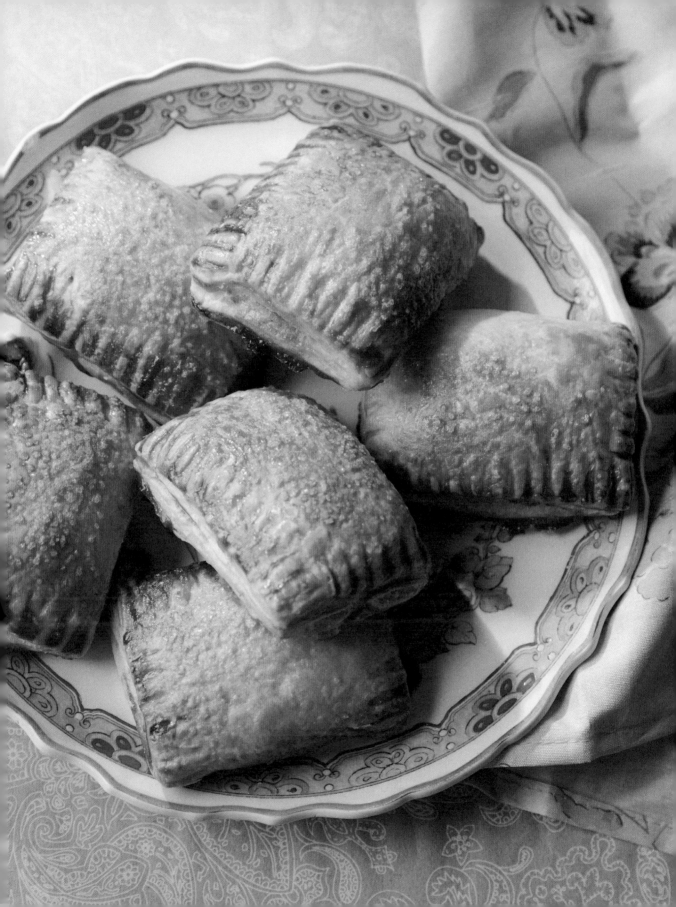

Summer red fruits with rose & cardamom

The simplest preparation—a blueprint more than a recipe as you can take both the fruits and the aromatics in many directions. See the switches below for spice and botanical combinations that will all amplify the sweet-floral notes in summer berries. The key is using a little sugar to draw the full flavor out of your chosen spice and helping to distribute it evenly. Leaving the cherries and strawberries to macerate briefly creates a puddle of fragrant, lipstick-red syrup.

Serves 6

350g (12oz) red
 cherries, pitted
350g (12oz)
 strawberries, hulled
4 green cardamom
 pods
1–3 tablespoons golden
 castor sugar
Finely grated zest and
 juice of a small lemon
Handful of organic
 unsprayed fresh rose
 petals (optional)

SPICE
SWITCH

In place of the cardamom and rose petals,
you could try any of the following:
Lightly toasted and ground coriander seeds
with elderflower petals
Black pepper and a chiffonade of basil
Fennel pollen, brown sugar, and a couple
of pinched lavender flowers
Confetti of cracked pink peppercorns
and garden mint
Crushed passion berries and lime zest
Ground grains of paradise and lemon zest

Tear most of the cherries in half, leaving a few whole. Quarter the strawberries. Tumble all the fruit into a large bowl.

Grind the seeds from the cardamom with a little of the sugar into a powder using a pestle and mortar. Stir in the remaining sugar, adjusting the amount according to the sweetness of your fruit.

Toss the spiced sugar, lemon zest, and juice with the fruit, then gently turn through half the rose petals. Leave to macerate for 15 minutes.

Transfer the fruits and their sweet red juices to a serving dish. Scatter with the remaining rose petals.

SUGAR ♡ SPICE

Spiced sugars

When it comes to infused sugars, your imagination is your limit. Some tips:

♥ Simply mix the sugar and spice in a jar and forget it for a few weeks. They will keep indefinitely.

♥ White sugar won't get in the way of delicate aromas. Brown sugar imparts its own flavor, which can work alongside punchier spices like allspice and clove.

♥ Use dry rather than moist sugars and use dried botanicals to prevent clumping.

♥ A ratio of up to one part spice to four parts sugar works well (you can be a bit bolder with cinnamon).

♥ Either blend the spices in or add them whole to infuse their flavors more subtly (also keeping the sugar white).

♥ Sift before use if it contains whole spices. You can top up the jar a few times with more sugar to extract all the precious flavors.

Opposite are some flavor ideas.

Spiced honey

Warm **honey** in a pan, add the flavoring/spice and leave to infuse for a few hours before using.

Dried spices like **pepper, coriander seeds, cassia buds,** or **fennel seeds** should be toasted and cracked first. Fresh aromatics like **lavender blossoms, pandan leaves,** or sliced **chilies** can be added straight to the pan.

Cinnamon sugar

A jar of fragrant spiced sugar is a glorious thing to have in the cupboard. Beautiful, economical, a great gift. Use it sprinkled over fruit or poffertjes, tossed with buttered popcorn, stirred into porridge, as a crunchy topping for a sponge cake, whipped into cream, or on hot buttered toast lightly caramelized under the broiler . . .

2 x 4-inch cinnamon sticks
½ nutmeg, freshly grated
5 black peppercorns
4 green cardamom pods
3 cloves
2 allspice berries
1 bay leaf
500g (2¼ cups) golden
 castor sugar
½ teaspoon fine salt

In a dry frying pan over a medium heat, toast the cinnamon sticks, nutmeg, black peppercorns, whole cardamom pods, cloves and allspice berries. Stir for a few minutes until they smell toasty and fragrant.

Leave to cool then transfer to a food processer with the bay leaf. Blend to a rubble. Add the sugar and whiz again. Spread out on a baking sheet to dry for a few hours, then pass through a sieve and store in an airtight jar.

VANILLA

Infuse with

Split vanilla pods (saved after scraping the seeds for another use)

Match with

Hot chocolate

LICORICE ROOT

Infuse with

Whole licorice root, bruised

Match with

Strawberries

LAVENDER & LEMON

Infuse with

Dried lavender flowers and strips of lemon zest

Match with

Blueberry pancakes

CHRISTMAS

Infuse with

Douglas fir sprigs, coriander seeds, and cloves

Match with

Mince pies

CARDAMOM

Infuse with

Ground seeds of green cardamom

Match with

Coffee

COFFEE

Infuse with

Whole coffee beans

Match with

Chocolate cake

CRYSTALLIZED GINGER

Infuse with

Crystallized ginger, chopped small

Match with

Homemade lemonade

CAYENNE & LIME ZEST

Infuse with

Ground cayenne, grated lime zest

Match with

Margarita glass rims

CORIANDER & MINT

Infuse with

Blend in mint leaves, then add whole coriander seeds

Match with

Oranges

LIME LEAF

Infuse with

Whole fresh lime leaves, gently scrunched

Match with

Coconut cream

MACE & CLOVE

Infuse with

Lanterns of mace and a few cloves

Match with

Rice pudding

ROSE GERANIUM

Infuse with

Layer with fresh rose geranium leaves

Match with

Summer berries

ROSE PETAL

Infuse with

Blend in dried rose petals and a few drops of rose water

Match with

Victoria sponge

SICHUAN PEPPERCORN

Infuse with

Grind together with toasted Sichuan peppercorns

Match with

Peaches & cream

FOUR SPICE

Infuse with

Grated nutmeg, ground ginger, cloves, black peppercorns

Match with

Porridge

FIVE SPICE

Infuse with

Whole spices: star anise, cloves, cassia, Sichuan peppercorns, fennel seeds

Match with

Shortbread

Shimmering silvered burfi

A lyrical Hindi phrase "munh meetha karna" (sweetening the mouth) is used in India when joyful events happen, such as marriage or the birth of a baby. It means there is something to celebrate, so let's savor the happiness and share sweets.

Sugar was refined and used in the Indian subcontinent from 500BC, long before anywhere else in the world, ingraining the regional sweet tooth. Mithai shops are a joy, with towering displays of fritters glistening with sugar syrup, stuffed crepes, knotted jalebis stained with turmeric, and fat balls of rose-scented gulab jamun. Riotous rainbow colors are joined by edible gold and silver leaf, leaving you in no doubt that these are foods for celebration.

Like many Indian sweets, burfi (pictured on page 74) is essentially just milk and sugar. Traditionally it should use mawa (also known as khoa), made by evaporating milk over the fire for hours until thick with toasty hints of caramel. This shortcut method uses dried milk powder to achieve the soft, fudgy texture in minutes.

Makes about 24 pieces

220g (2 cups) pure milk powder, sifted
200ml (generous ¾ cup) whole milk
100g (3½oz) castor sugar
Pinch of saffron threads, ground

5 green cardamom pods, seeds ground
40g (3 tablespoons) unsalted butter
Edible silver leaf

SPICE SWITCH

Use saffron alone or exchange the saffron for a generous grating of nutmeg, in which case keep the cardamom.

Line a medium baking tin or dish with baking parchment.

Whisk together the milk powder, milk, and castor sugar to ensure there are no lumps. Add the saffron and cardamom.

Melt the butter in a nonstick frying pan, then turn the heat to medium–low. Use a silicone spoon to scrape in the milky mixture, then stir and scrape constantly for about 10 minutes as it slowly thickens. It is ready when it just comes together into a pliable dough the color of pale honey—you are after something softer and creamier than fudge.

Smooth into the lined tin and leave for a couple of hours to set.

Turn the burfi out onto a board and peel off the baking parchment. Press sheets of silver leaf over the surface and slice on a sharp diagonal into shimmering diamonds.

Cardamom & nutmeg nankhatai

A sandy, melt-in-the-mouth butter cookie popular across a swathe of North India, Bangladesh, Pakistan, and Myanmar. Nankhatai (pictured on page 74) are said to have originated in sixteenth-century Gujarat at a time when the Dutch and Indians were key players in the spice trade and cultures melded in traders' towns. A former Dutch bakery was taken over by Parsis, who adapted the products to appeal more to local tastes. What they developed certainly has had staying power. Serve with a cup of steamy masala chai.

Note: you can substitute butter but ghee gives a superior result.

Makes 12 cookies

90g (3¼oz) plain flour
45g (1½oz) confectioners' sugar
30g (1oz) gram flour
4 teaspoons fine semolina
Pinch of fine sea salt
¼ teaspoon freshly grated nutmeg

10 green cardamom pods, seeds ground
90g (3¼oz) ghee, at room temperature
Chopped almonds and/or pistachios, to top

SPICE SWITCH

Swap the nutmeg for a splash of kewra (screw pine) essence or a pinch of ground saffron.

Line a baking sheet with baking parchment.

In a large bowl, mix together the dry ingredients including the salt and nutmeg but only half the cardamom. If there are any lumps, use a whisk to break them.

The ghee should be semi-solid but not molten. Use the fingers of one hand to rub it into the flour. It will slowly come together to the texture of damp sand, which will clump when squeezed. If your dough is very crumbly, add a nub more ghee, but go carefully.

Press together ping-pong balls of dough, flatten slightly between your palms, and smooth the edges.

Lay on the baking sheet and repeat with the remaining mixture, spacing them well apart. Chill in the fridge for an hour or more.

Heat the oven to 350°F.

Cut a cross into the top of each nankhatai and sprinkle with the remaining cardamom. Tuck a small crumble of almonds and pistachios into the middle.

Bake for 15 minutes to a pale biscuit with a lightly golden base. Leave to cool on the tray. They will keep in an airtight tin for a few weeks.

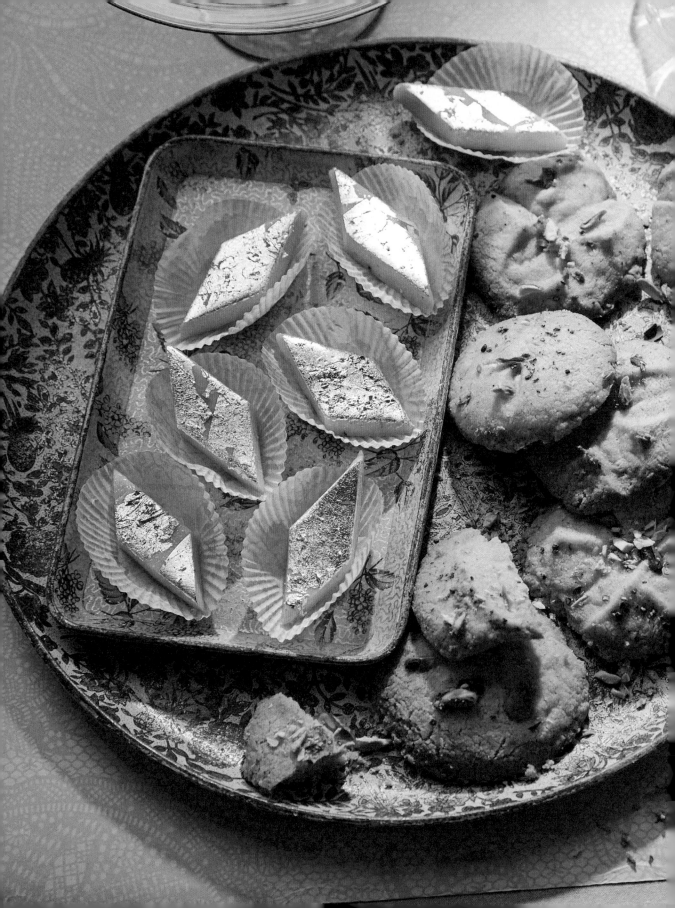

Far left: Shimmering
silvered burfi;
left: Cardamom &
nutmeg nankhatai

SWEET & WARMING

Bramley apple & clove cake

Apple married with clove is as intrinsically autumnal as soft golden sunlight and papery leaves. As this loaf cake cooks, it will fill the kitchen with a rich, warm scent to wallow in.

It is rare for clove to get solo star billing in baking—it's usually buried below cinnamon and ginger. Teddy Roosevelt, though, clearly knew a good thing as he favored a clove cake above all others. In his case, it was one dark and sticky with molasses and dried fruit. This is an altogether gentler affair with a delicate crumb and brightness from the soft chunks of apple (pictured on page 81). I use Bramley, or choose another variety with a tart, green profile.

To turn the cake into a dessert, slice warm and serve with cream softly whipped with a splash of Calvados or spiced rum.

Serves 8

1 teaspoon ground clove
225g (1½ cups) plain flour
3 teaspoons baking powder
225g (8oz) castor sugar
½ teaspoon fine sea salt
150g (5½oz) unsalted butter, melted

2 eggs, at room temperature
2 large Bramley apples (about 500g/1lb 2oz), peeled, cored, and sliced into wedges
2 tablespoons light muscovado or light soft brown sugar

SPICE SWITCH

2 teaspoons Sweet spice mix (page 52) or speculaas would work well in place of the clove. Or use 1 teaspoon vanilla extract (just in the cake batter). Alternatively, simply warm things up with an additional grinding of white pepper.

Heat the oven to 315°F. Grease and line a 3lb loaf tin.

In a large bowl or stand mixer, combine ¾ teaspoon of the ground clove with the flour, baking powder, sugar, salt, butter, and eggs. Beat together to make a smooth batter.

Spread a layer of the batter into the loaf tin, tumbling it over most of the apple wedges (it will seem like a lot, go with it). Dollop on a little more batter, add the remaining apple, then spoon over the rest of the batter. Knock the tin on the work top a few times to help fill the gaps, but don't worry unduly.

Mix the brown sugar with the remaining ¼ teaspoon of ground clove and sprinkle the mixture over the loaf. Bake for 1¼–1½ hours. When ready, the top should be golden and a skewer inserted into the middle should come out clean.

Leave to cool in the tin for 15 minutes before turning onto a rack to cool, or serve warm.

Nutmeg cake

Why was nutmeg pushed out of the mainstream of Western cooking? Once the wrinkled brown seeds with their curious swirled centers were so essential to fine dining that the fashionable English gentleman would carry a silver grater and a nutmeg in his pocket, but the fad waned as the spice became more attainable.

Don't let vanilla and cinnamon steal all the glory in baking. A nutmeg cake (pictured on page 80) is still a very fine thing, especially here with an upper crust of meringue swirled into the batter before baking.

Serves 8

130g (4½oz) plain flour
1 teaspoon freshly grated nutmeg
½ teaspoon baking powder
½ teaspoon baking soda
¼ teaspoon fine sea salt
230g (8oz) castor sugar

60g (¼ cup) unsalted butter, at room temperature
1 egg, at room temperature
120ml (½ cup) buttermilk, at room temperature
2 egg whites (70g/2½oz), at room temperature

SPICE SWITCH

Ground mace offers a similar flavor profile to nutmeg and can be used in the same quantity.

This is also a good recipe for putting any homemade spice extracts to use. See page 58 for Cardamom extract and page 133 for Homemade vanilla extract. Add 1 teaspoon in place of the nutmeg.

Make sure all the ingredients are at room temperature. Grease and line an 8-inch loose-bottomed cake tin. Heat the oven to 400°F.

Whisk together the flour, nutmeg, baking powder, baking soda, and salt, then set aside.

With a stand mixer, beat together 130g (4½oz) of the sugar with the butter at medium speed. Keep going for 3–4 minutes until it becomes really pale and fluffy. Beat in the egg, adding a spoonful of the spiced flour if it starts to curdle. With the mixer speed on low, add the flour mixture in two batches, alternating with the buttermilk. Stop the mixer after each addition when just combined. Spread into the cake tin.

Whisk the egg whites in a clean bowl until they start to foam. Add the remaining sugar, spoonful by spoonful, whisking all the time. Continue whisking at high speed for a few minutes until the mixture is very thick and shiny and a pinch between the fingers feels smooth.

Spread the meringue directly over the batter in the tin, then use a knife to slightly swirl the two layers together.

Bake for 35–40 minutes. It can be tricky to tell exactly what's what, but a skewer poked through the meringue to the cake underneath should come out with no batter clinging to it (a little meringue squidge or cake crumb is fine).

Cool in the tin for about 20 minutes before unmolding and leaving to cool completely.

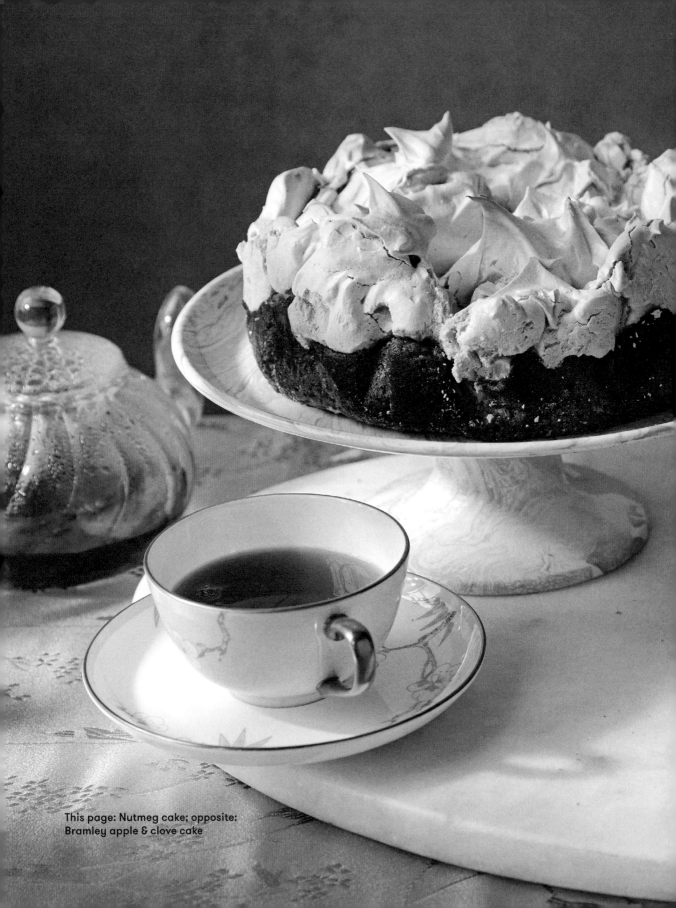

This page: Nutmeg cake; opposite:
Bramley apple & clove cake

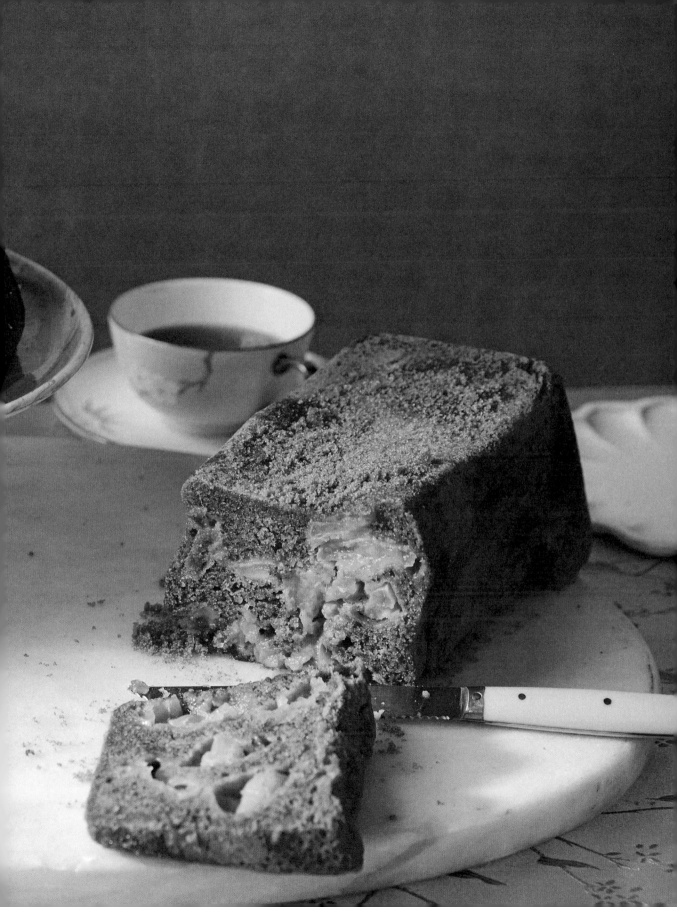

CINNAMON

I have perfumed my bed with myrrh, aloes, and cinnamon. Come let us take our fill of love until the morning and abandon ourselves to delight.

Proverbs 7

This verse from the Hebrew Bible at first appears romantic, but the line that follows reads, "My husband is not home." Written as a warning against the fatal temptation of adulterous women, cinnamon stood for all that is heady, pungent, erotic, and dangerous.

In the ancient world, spice was often seen this way. Its exotic otherworldliness imbued it with powers of magic, of medicine, of aphrodisiac effect.

Myth maintains that the Phoenix sets itself alight atop a pyre of cinnamon bark. It was used as a perfuming agent during Egyptian embalming and taken as a rejuvenator in China. Writing in the fifth century BC, the Greek historian Herodotus recounted tales of fearsome birds using cinnamon for their mountaintop nests. To gather the precious spice, people would lure the birds down to collect hunks of donkey meat so large they would destabilize the nests and cause the sticks to fall.

A great tale, but completely untrue. It seems Arab traders who plied the seas carrying cinnamon from East to West wove elaborate yarns to drive up the price and hide the true origins of their exports. What is unclear is whether the spice was cinnamon from Sri Lanka or cassia from China. The two are closely related and often used interchangeably to this day.

True cinnamon is from an evergreen laurel tree and has a sweet warmth with delicate top notes of citrus and flowers, slightly medicinal. At two years old, the tree is coppiced and the new shoots harvested during rainy season. They are stripped of their bark, the inner layer of which is then peeled off and dried in the sun to curl. These are then stacked and rolled to create the dried quills we use in cooking (broken pieces are called quillings). Thin bark is a mark of quality.

Cassia, from a related laurel, has coarser bark and a gutsier flavor to match, tinted with slight bitterness. There are different varieties from China, Vietnam, Indonesia, and India. Curiously, the trees create their warm, woody scent as a defensive chemical against predators and as a way to communicate the danger to nearby trees. Often what is sold in the West as ground cinnamon is actually cassia. Tell the difference by the color: cassia is reddish brown, cinnamon a paler tan.

A rarer spice is cassia buds (sometimes sold as cinnamon berries), which combine a potent cinnamon aroma with a peppery kick. They are used in pickles in the Far East and also appeared in Medieval European recipes for gingerbread and mulled wines. Native to Australia is the shrub known as cinnamon myrtle, for the cinnamon-like aroma of its leaves, which can be used to add fragrant warmth to pastries and herbal tea.

Cinnamon doesn't itself taste sweet but enhances the sweetness of whatever it is paired with, making it invaluable as a baker's spice.

Before vanilla entered the fray, cinnamon ruled Europe. The cinnamon-scented line-up includes Viennese strudel, Venetian hooped biscuits, Spanish milk puddings lifted with lemon zest, Scandinavian cinnamon rolls (obviously), Austrian star cookies, and quivering Portuguese custard tarts. In Algeria, cinnamon might be paired with oranges and orange blossom water; in Turkey it carpets sweet drinks like boza and salep; in Mexico it dusts churros.

A point of common unity the world over is that cinnamon and rice pudding are made for each other. One could write a book on the world of rice puddings, but see page 88 and notice how often

cinnamon features. It seems the Turkish took the marriage to Italy, then to Spain. Spanish sailors dropped the idea off in Normandy, creating teurgoule, and also carried it with them to the New World. Cinnamon can be cooked, but doesn't need to be, giving it power as a dusting spice to finish and transform something gentle and creamy like rice cooked in sweet milk.

If you want to improve your day right now, make cinnamon toast. Mix one part ground cinnamon with three parts sugar, sprinkle on buttered toast and broil until melted. While you wait, smell your cinnamon jar—it should be strong and fragrant. The flavor drifts away with time and I know from experience how a fresh stock can improve your cooking.

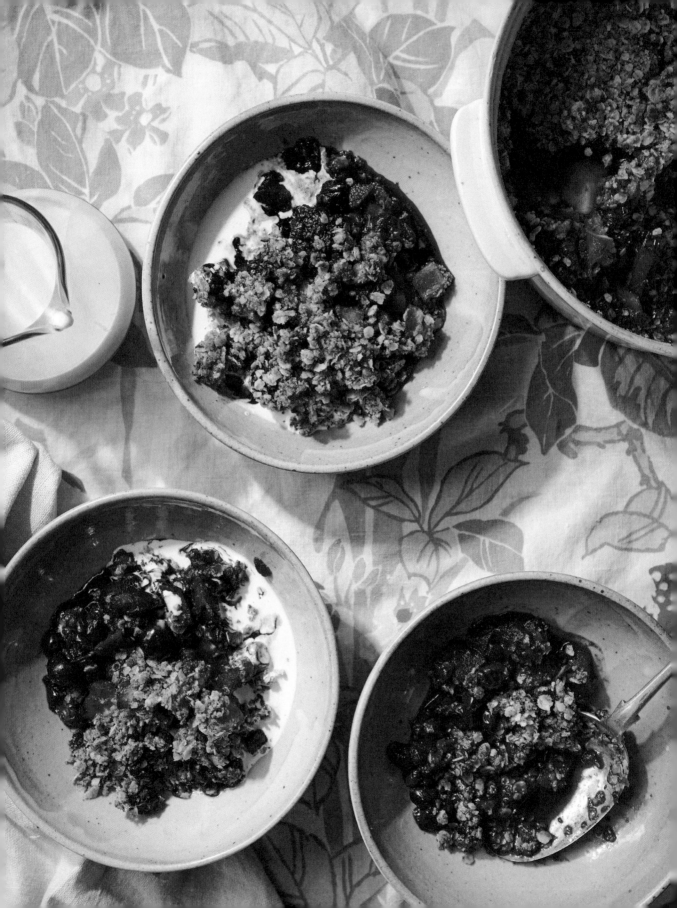

Spiced blueberry crumble

Crumble purists, look away. This is more a formless flapjack of a topping, heavy on oats and gingery spice. But it is our house crumble recipe (known always simply as grumble) and we wouldn't have it any other way.

Serves 6

For the crumble topping
100g (3½oz) oats
100g (3½oz) whole wheat spelt flour
40g (1½oz) light muscovado or light soft brown sugar
40g (1½oz) dark muscovado or dark soft brown sugar
2 teaspoons Sweet spice mix (page 52)
½ teaspoon ground ginger
⅓ teaspoon fine sea salt
80ml (⅓ cup) mild olive oil

For the filling
500g (1lb 2oz) frozen blueberries, thawed
4 Granny Smith apples, peeled, cored, and cut into ½-inch pieces
50g (1¾oz) castor sugar

SPICE SWITCH

Use another sweet spice mix, such as pumpkin pie spice, mixed spice, hawaij, or speculaas.

Fennel crumble: 2 tablespoons whole fennel seeds instead of the sweet spice mix—great with apples or plums.

Ginger crumble: substitute 1 tablespoon ground ginger, ½ teaspoon ground allspice, and a twist of black pepper—particularly good for a mixture of rhubarb and apple.

To make the crumble topping, stir together all the ingredients to make a loosely clumped rubble.

Mix the ingredients for the filling in a 6-cup baking dish. Scatter over the topping.

Put in the oven, then turn the temperature to 350°F. Bake for 45 minutes. The crumble should be golden and the fruit below soft and bubbling.

Leave to cool for 15 minutes before serving, to let the fruit set. Serve with too much cream, custard, or crème fraîche.

Apple & allspice puddle pudding

Puddle puddings are a culinary miracle. You pour hot sugared water over cake batter and it looks a bit wet and unpromising, but then it emerges from the oven with the layers reversed. There is now a vanilla and allspice-scented sponge on top and a delectable sticky toffee sauce below. Perfect for winter family meals.

Serves 4

100g (⅔ cup) plain flour
1 teaspoon baking powder
1½ teaspoons allspice
¼ teaspoon fine sea salt
50g (4 tablespoons) unsalted butter, at room temperature
60g (2¼oz) castor sugar
1 egg
50ml (scant ¼ cup) milk

1 teaspoon vanilla extract
2 medium Bramley apples, peeled, cored, and cut into wedges or rounds
80g (2¾oz) dark muscovado or dark brown soft sugar
1 tablespoon golden syrup

SPICE SWITCH

For an apple and ginger puddle pudding, switch the allspice and vanilla for 2 teaspoons ground ginger, ½ teaspoon ground clove, and 2 diced balls of stem ginger in syrup.

Find an ovenproof dish about 8 cups in capacity. Heat the oven to 375°F.

Mix together the dry ingredients—flour, baking powder, allspice, and salt.

In a stand mixer, cream the butter and castor sugar until light and fluffy. Beat in the egg, then briefly mix in the spiced flour. Finally, add the milk and vanilla to make a smooth batter. Spread into the oven dish and sit the apple on top.

Mix the brown sugar and golden syrup with 165ml (⅔ cup) just-boiled water and stir to dissolve. Pour over the top of the pudding.

Bake for 35 minutes or until the apple is tender, the sauce bubbling, and the sponge set and springy to the touch.

Cool for about 10 minutes before serving the warm pudding with cold cream.

Tipsy cherries with Barbados cream

Three blissfully simple layers. Cherries poached in gently spiced rum make a syrupy base. The middle has yogurt lightened with a cloud of whipped cream. Then a blanketing layer of molten muscovado brings toffee depth and a murmur of smoke. Few single ingredients offer such incredible complexity as muscovado —no need to burn sugar or make caramel, it does it all for you by simply melting into the cream below.

Serve with cookies, or perhaps a slice of Seed cake (page 118).

Serves 4

For the tipsy cherries
75ml (⅓ cup) dark or white rum
50g (1¾oz) granulated sugar
½ teaspoon ground allspice
Good pinch of ground clove
Pinch of fine sea salt
300g (10½oz) dark cherries, pitted and halved

For the Barbados cream
150ml (generous ½ cup) heavy cream
150ml (generous ½ cup) Greek-style yogurt
50g (¼ cup) dark muscovado sugar

SPICE SWITCH

Add 1 teaspoon vanilla paste or a grated tonka bean to the rum syrup in place of the allspice and clove.

Put the rum, sugar, spices, and salt in a pan and bubble over a medium–high heat to melt the sugar to a thin syrup. Add the cherries and cook at a lively bubble for about 5 minutes until the cherries are tender but not completely collapsed and the syrup reduced to a spiced glaze. Tip into a shallow serving dish or individual glasses and leave to cool.

Whip the cream to soft peaks, then fold in the Greek-style yogurt. Drape this over the cooled cherries and scatter the top with dark muscovado sugar. Chill well in the fridge until the sugar has melted to a dark topping.

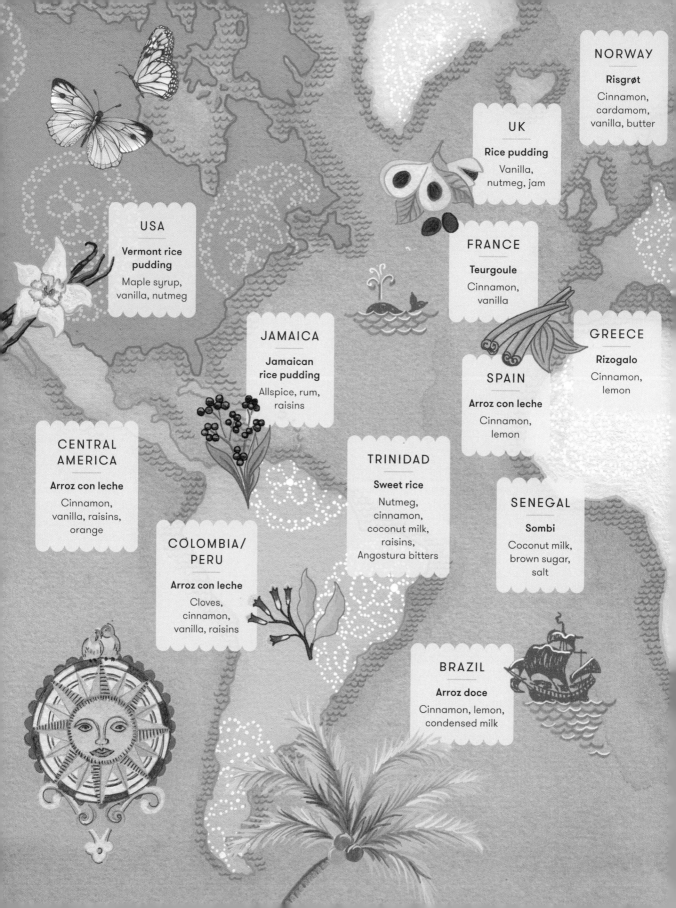

NORWAY
Risgrøt
Cinnamon, cardamom, vanilla, butter

UK
Rice pudding
Vanilla, nutmeg, jam

USA
Vermont rice pudding
Maple syrup, vanilla, nutmeg

FRANCE
Teurgoule
Cinnamon, vanilla

JAMAICA
Jamaican rice pudding
Allspice, rum, raisins

GREECE
Rizogalo
Cinnamon, lemon

SPAIN
Arroz con leche
Cinnamon, lemon

CENTRAL AMERICA
Arroz con leche
Cinnamon, vanilla, raisins, orange

TRINIDAD
Sweet rice
Nutmeg, cinnamon, coconut milk, raisins, Angostura bitters

SENEGAL
Sombi
Coconut milk, brown sugar, salt

COLOMBIA/PERU
Arroz con leche
Cloves, cinnamon, vanilla, raisins

BRAZIL
Arroz doce
Cinnamon, lemon, condensed milk

RICE ♡ SPICE

RICE PUDDINGS OF THE WORLD

POLAND
Ryż z jabłkami
Cinnamon, apples

MACEDONIA
Lapa
Black poppy seeds

RUSSIA
Risovaya kasha
Vanilla, dried fruit, butter-fried breadcrumbs

TURKEY
Sütlaç
Cinnamon

IRAN
Sholeh zard
Saffron, rose water

CHINA
Ba bao fan
Dried fruits, nuts, red bean paste

INDIA
Kheer
Cardamom, nuts, rose water, saffron, jaggery

LEVANT
Riz bi haleeb
Rose water, mastic

PHILIPPINES
Champorado
Chocolate, dried salted fish

SRI LANKA
Pongal
Lentils, jaggery, coconut milk, cinnamon, cardamom, sultanas

LEBANON
Meghli
Aniseed, caraway, cinnamon

INDONESIA
Bubur injun
Black glutinous rice, palm sugar, pandan, salted coconut milk

Norwegian rizcrem

Having created a rice pudding map of the world, how ever to choose a rice pudding to feature? I turn to my favorite, a recipe from talented author and my dear friend Matilda Culme-Seymour. She writes:

"Cinnamon is a spice I associate strongly with my Norwegian heritage. Every Christmas Eve, we would eat this rice pudding—rizcrem—to determine who opened the first present; a blanched almond was hidden in the clouds of ambrosial rice, and if you found it you would be the lucky winner. It was an unwritten rule that you had to hide the almond until everyone had finished their last spoonful. Thus, it was not an option not to like rice pudding!"

Serves 4–6

750ml (3 cups) whole milk
60g (2¼oz) short-grain pudding rice
Knob of butter
2 tablespoons golden castor sugar, plus more to serve
Nutmeg, for grating
125ml (½ cup) heavy cream
Ground cinnamon, for sprinkling

SPICE SWITCH

Use vanilla sugar and ground green cardamom. Or grind a few pieces of mastic to a powder with sugar and stir in at the end with a splash of rose water. Or turn to the map on pages 20–21 for more flavor inspiration.

Bring the milk to simmering point in a heavy-bottomed saucepan. It will start to look faintly frothy on top just before it boils over —catch it before it does! When hot, pour in the rice in a steady stream, stirring with a wooden spoon. Bring back to the simmer and cook at a low heat, stirring occasionally, for 45 minutes to an hour, until the rice has absorbed most of the liquid—it will be creamy but still quite loose while it thickens as it cools. Add the walnut-sized knob of butter, golden castor sugar, and a generous grating of nutmeg. Stir, then cover and leave to cool.

Whip the cream to a soft, pillowy thickness and fold gently into the cooled rice before chilling in the fridge. When cold, serve in bowls with an extra sprinkling of golden castor sugar and a generous pinch of ground cinnamon.

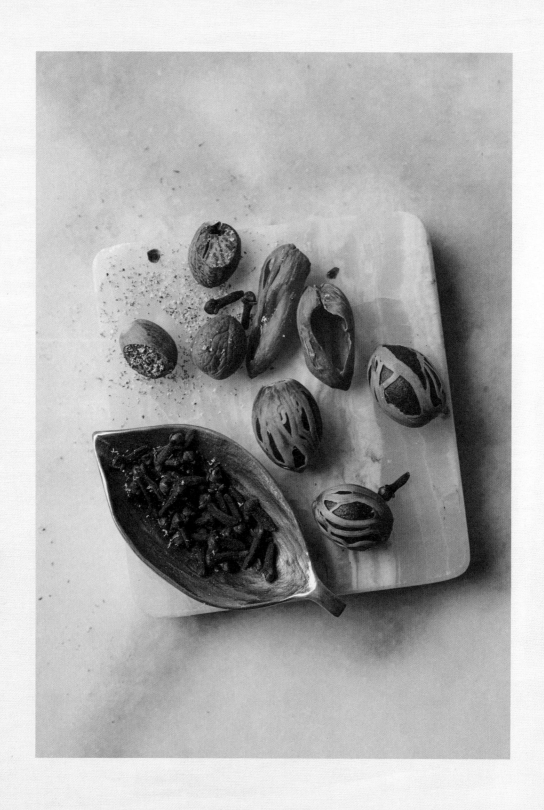

NUTMEG, MACE, & CLOVE

You may not have heard of Rhun, a tiny tropical isle in the Banda Sea of Eastern Indonesia where the air hangs thick with fragrance. But you are sure to have heard of the island it was traded for in 1667: Manhattan, New York.

The British and Dutch colonial powers that made this exchange deemed Rhun so valuable because it was home to the nutmeg tree. It was the seventeenth century and the allure and price of spice had reached a dizzying peak. None was more craved than nutmeg. (See my book *The Nutmeg Trail* for more on the spice trade and the brutal lengths the Dutch went to in commodifying these ridged little kernels.)

Also from the Banda archipelago came clove and mace, binding these three spices by geography and history. Two of them are literally bound, for break open the apricot-like fruit of the *Myristica fragrans* tree and the brown pip is embraced in a web of bright vermillion, which will dry to a lantern of brittle orange: you have found nutmeg and its aril, mace. Cloves are the dried flower buds of a different evergreen tree. It is hard to fathom how a seed, an aril, and a flower once grown only in this remote corner of the world came to take dominant roles in almost every global cuisine.

How lucky they did, for they all share a sweet, spicy warmth and delightful complexity well suited to desserts. Clove has a strong medicinal edge from its key component, eugenol (also in nutmeg and cinnamon). It is best used sparingly. Nutmeg too can be penetrating with a slight tongue-numbing coolness, but is highly aromatic and blends well with other spices. Its lacy coating, mace, is similar in flavor and intensity but a little less tannic.

The nuances of these spices are quickly lost, so grind fresh and add late to cooking.

Nutmeg remains a standard seasoning in many Dutch recipes. Across Europe it finds its way into honey cakes, mulled wines, panforte, steamed fruit treats, and enriched Easter breads. It is well suited to apples, giving an autumnal kiss to apple pies, and also custard, where it's the perfect bittersweet counterpoint to velvet richness. Parsi weddings serve a baked custard scented with nutmeg and cardamom then loaded with dried fruits, nuts, and rose petals. Cooks once took a more generous hand—old English cake recipes calling for two to three nuts—but a lighter touch allows fragrance without such a medical hit. Try just a little nutmeg grated over French toast or into hot chocolate.

Clove hums perfectly with nutmeg and the duo are often found together. Gingerbreads of all creeds and Caribbean black cake would be lacking without them. Clove is also paired with cardamom in carrot halvah and with cinnamon in Turkish roast quince. They can be stuck into foods like nails in upholstery. (It is no surprise that in many languages, cloves and nails share a root word.) This could be to pierce the center of a Greek butter cookie, stud an orange pomander for Christmas, or to form the pupils in the Brazilian coconut-stuffed prunes known as mother-in-law's eyes.

Cloves have long been associated with love and protection. On the spice islands of Indonesia, there's a tradition of planting a clove tree to mark a child's birth so it stands as a protector throughout their life. In Medieval India, a secret infatuation could be revealed by giving a bundle of cardamom, nutmeg, and cloves wrapped in red thread and sealed with wax. The headiness of nutmeg does tend to lead to the more sensual side of love. It is used as a stimulant in Chinese medicine and invigorating nutmeg porridge is cooked for brides in Zanzibar. Taken in a large enough quantity, nutmeg is hallucinogenic, a fact that means the spice is illegal in Saudi Arabia to this day.

Milk chocolate tart with nutmeg pastry

Chocolate tarts tend to be dark, decadent, and as rich as Croesus. For something sweeter and more delicate, a milk chocolate custard is the way to go, but the risk is to veer toward cloying. The reason this recipe works is that nutmeg's fragrant astringency both cuts the sweetness and enhances the chocolate. Be generous with it.

Serves 8–10

For the nutmeg pastry
170g (6oz) plain flour
45g (1½oz) confectioners' sugar
½ teaspoon grated nutmeg
Pinch of fine sea salt
85g (3oz) unsalted butter, chilled and cubed

1 tablespoon ice cold water
1 egg, beaten

For the milk chocolate filling
350g (12oz) best milk chocolate, at least 30%

50g (1¾oz) best dark chocolate, at least 70%
100ml (scant ½ cup) whole milk
300ml (1¼ cups) heavy cream
3 eggs
Pinch of fine sea salt
Nutmeg, for grating

SPICE SWITCH

Cinnamon and milk chocolate are lovely together, but it is a combination to be reserved for those with a sweet tooth as it will amplify rather than temper the sweetness. Or use exclusively dark chocolate (400g/14oz).

First make the pastry. Combine the flour, confectioners' sugar, nutmeg, salt, and butter in a food processor. Pulse the mixture to crumbs. Add the water and half of the beaten egg and pulse again just until the pastry starts to clump together. Turn the pastry out onto a work surface and form into a flat disk, working it as little as possible. Wrap in plastic wrap and refrigerate for at least an hour (or overnight).

On a lightly floured surface, roll out the pastry to a circle about 1/16-inch thick. Use it to line a 9-inch loose-bottomed tart tin with high sides. Tuck it into the edges and leave an overhang of pastry. Put in the freezer to chill briefly.

Heat the oven to 350°F. Put a baking sheet in the oven.

Line the tart case with tin foil, shiny side up, and weigh down with baking beans (or in the absence of these, use a generous mound of sugar; when you are finished, parcel it in the foil and save for future tarts). Sit on the baking sheet and blind-bake for 25 minutes. Remove the foil and trim the overhang. Brush the remaining egg over the pastry and return to the oven for 10 minutes.

While the pastry is baking, make the filling. Break the chocolates into pieces and put in a heatproof bowl. Bring the milk and cream to a simmer, then pour over the chocolate and stir to melt. Leave to cool for 5 minutes then beat in the eggs and salt. Pass the mixture through a fine sieve into a jug.

Grate most of the whole nutmeg into a small bowl.

When the pastry is golden, turn down the oven to 275°F. Pull out the oven rack with the tart case on it and pour the mixture into the shell, ensuring it doesn't spill over the top of the pastry. Sprinkle nutmeg liberally over the top using at least half a seed. Push gingerly back into the oven and bake for 40–50 minutes. The chocolate custard should be set with a slight wobble in the center. Leave to cool fully before removing from the tin. Add a final flourish of nutmeg before serving.

Basque cheesecake with sweet spices

An obsession with Basque cheesecake overtook the UK in 2021, leading *The Times* to dub it "the pudding that broke the internet." Such a rise in fashion invites an inevitable fall, but I am sure that long after the hype has gone this tender-bellied beauty with a bittersweet, burnished top will be received at any table with relish. Maybe, like salted caramel, it will move from modish to classic.

My version is a cheesecake no Basque would recognize, but is a happy fusion of the usually pared-back cream cheese and a quintet of sweet spices. Cardamom, nutmeg, ginger, cinnamon, and clove have a natural affinity, a popular blend in both The Netherlands and the spice islands of Indonesia, two countries with a culinary bond forged in their colonial past.

Serves 8–10

- 560g (1lb 4oz) full-fat cream cheese, at room temperature
- 280ml (generous 1 cup) sour cream, at room temperature
- 165g (¾ cup) golden castor sugar
- ¼ teaspoon fine sea salt
- 3 eggs, at room temperature
- 1½ tablespoons corn starch
- 1½ teaspoons ground cinnamon
- ½ teaspoon grated nutmeg
- ½ teaspoon ground ginger
- ¼ teaspoon ground clove
- 3 green cardamom pods, seeds ground

SPICE SWITCH

Switch the spices for 2 teaspoons vanilla extract.

Line a high-sided 8-inch cake tin with a large sheet of parchment paper, going up the sides and into a crinkled overhang. Heat the oven to 410°F.

Drain any liquid off the cream cheese and sour cream. In a food processor or using a stand mixer with a paddle, beat the cream cheese until smooth. Mix in the sour cream, then the sugar and salt. Beat slowly for a few minutes, until light and smooth. If you pinch a little between your fingertips, it shouldn't feel grainy. Add the eggs one at a time. When all are incorporated, mix in the corn starch and spices.

Pour into the lined tin and knock on the surface a few times to remove any air bubbles.

Bake for 40–50 minutes. The cheesecake should be risen and dark on the top but still very wobbly and jiggly underneath. It will carry on cooking as it sinks and cools to a soft set.

Leave to cool for 2–3 hours in the tin and serve at room temperature. It's very good alongside a rhubarb or blueberry compote made with a whisper of cardamom.

Glühwein plum & cherry jam

Wine has been mulled with warming spices since second-century Rome, most often with cinnamon and cloves. The habit spread across Europe with many countries adding their own name and twist. The Dutch add lemons; the Swedish cardamom and almonds; the Moldovans black pepper and honey. Here I've turned a German glühwein into a soft-set, jeweled, jellied jam—the perfect Christmas present, for yourself or otherwise. Do try it with pancakes.

Makes 6 jars

180ml (¾ cup) red wine
4 cloves
2 star anise
1 cinnamon stick
½ teaspoon ground
 allspice
600g (1lb 5oz) plums,
 stoned and sliced

300g (10½oz) cherries,
 stoned and halved
900g (2lb) jam sugar
 (with pectin)
1 tablespoon lemon
 juice

SPICE SWITCH

To give a Nordic accent, add 4 bruised cardamom pods in place of the star anise. Stir a scattering of whole blanched almonds into the finished glögg jam.

Pour the red wine into a small pan with the spices. Warm gently, just below simmering, for 10 minutes. Remove from the heat and leave the spices to infuse for about half an hour.

Chill a saucer in the freezer.

Put the plums and cherries in a large pan and add the mulled wine. Bring to a simmer then cover and cook for 15 minutes or longer, until the fruit is well softened into the wine.

Add the jam sugar and lemon juice and stir over a low heat until dissolved. Turn up the heat and boil, uncovered, until a sugar thermometer reads 220°F.

Test the set by spooning a little jam onto the cold saucer then tilting it to see how it runs— you are aiming for a slow creep, not a runny mess.

Meanwhile, sterilize six 12oz jam jars by washing them well, then heating in the oven for 5 minutes.

Leave the jam to stand for 10 minutes to let the fruit settle before skimming off the foam and optionally removing the whole spices, though I leave them for rustic charm. Ladle into the warm, sterilized jars and seal. Unopened, they will keep for a year. Once opened, store in the fridge.

Masala chai snickerdoodles

Americans don't take themselves too seriously in baking, as evidenced by the whimsical name snickerdoodle for soft cookies crusted in spiced sugar. That is not to suggest a lack of serious attention to the craft—on the contrary, blog posts abound as to how to achieve the perfect snickerdoodle (an extra yolk to keep them squidgy; cream of tartar for tang and chew; careful spice to sugar ratio)—rather a fearless creativity and playfulness with flavors and adaptations. I have therefore taken license to adapt this US classic with the heady spices of South Asian masala chai, which makes for an irresistible combination (pictured on page 100).

Makes 20 cookies

For the spiced sugar
2 teaspoons ground cinnamon
½ teaspoon green cardamom seeds, ground
½ teaspoon fennel seeds, ground
¼ teaspoon cloves, ground
¼ teaspoon black peppercorns, ground
5 tablespoons granulated sugar

For the cookie dough
340g (12oz) plain flour
Finely ground tea leaves from 2 teabags
1 teaspoon baking soda
1 teaspoon cream of tartar
½ teaspoon fine sea salt
225g (8oz) unsalted butter, at room temperature
140g (⅔ cup) granulated sugar

100g (½ cup) light muscovado or light soft brown sugar
1 egg, plus 1 egg yolk

SPICE SWITCH

For a classic snickerdoodle, omit the tea leaves and use 1 tablespoon ground cinnamon split between the sugar and the cookie.

We want a fine, even grind on the spices, so pound, grind, or mix them together to achieve this (they don't need toasting). Put 1½ teaspoons of the mix in a large bowl for the cookies and stir the remainder into the sugar. Set the spiced sugar aside.

Line two large baking sheets (insulated if you have them) with parchment paper. Heat the oven to 350°F.

In the bowl with the reserved spices, mix the flour, tea, baking soda, cream of tartar, and salt.

In a stand mixer or bowl, cream together the butter and both sugars until well mixed but not fluffy. Mix in the egg and egg yolk then, at low speed, add the flour mix until it just comes together in a stiff dough.

Scoop up balls of cookie dough and drop into the spiced sugar—I do this with a 1¾-inch ice cream scoop or weigh 45g (1½oz) each. Use a light touch of the fingers to roll them into rough balls with a generous jacket of sugar. Space well apart on the baking sheets, remembering they will spread to large cookies when they grow up. (If you want to bake in batches, ball and chill the remaining dough, but sugar-coat just before baking. Any left over spiced sugar is good in hot chocolate.)

Bake for 12–13 minutes, until the centers are still soft and the edges golden and crisp—just underbaking ensures the signature soft chew of a snickerdoodle. Cool completely on the baking sheets then store in an airtight tin.

Cinnamon sugar palmiers

Palmiers (pictured on page 101) are one of the simplest biscuits—they take more effort to explain than to make. The only two ingredients required are ready-made puff pastry and sugar, but spike that sugar with cinnamon and a background note of cardamom and they become utterly irresistible.

Makes 18 palmiers

¾ teaspoon ground cinnamon
6 green cardamom pods, seeds ground
100g (3½oz) castor sugar
Pinch of fine sea salt
250g (9oz) all-butter puff or rough puff pastry

SPICE SWITCH

Use one of the Spiced sugars from page 70.

Mix the cinnamon, cardamom, and sugar (I grind the cardamom seeds with a pinch of the sugar to help break them down). Put a tablespoon of the spiced sugar into a small cup, add the salt, and set this aside until time to bake.

Let the pastry slightly soften at room temperature. The aim is to end up with a rectangle about 14 inch x 10 inch with the spiced sugar pressed into both sides. Use most of the sugar to generously coat the work surface and sprinkle more on top. Roll the pastry, flipping occasionally and redistributing the sugar as needed.

Lay the rectangle with its long side facing you and trim the edges to neaten. Fold the sides toward the center so they go halfway toward the middle. Fold again so they very nearly meet at the middle, like the pages of an open book. Press down lightly to remove any gaps between the layers, then fold one half over the other to close the book. Try to incorporate any spiced sugar left on the work surface as you go and also press it into the outside of the roll, but there will probably be some left over. Refrigerate unwrapped or loosely wrapped for 15–30 minutes.

Heat the oven to 410°F. Line two baking sheets with parchment paper.

Cut the pastry roll into ½-inch slices and space them cut-side down on the baking sheets. The ribbony pieces will bloom into heart shapes in the oven.

Bake for 10 minutes, or until the palmiers are turning golden on the bottom. Use a spatula to carefully turn each over (don't burn yourself!), sprinkle with the reserved salted-spiced sugar and return to the oven. Cook for 5–10 minutes more until the palmiers are golden brown and caramelized on both sides.

Transfer to a rack to cool. They will keep in a tin for at least a week.

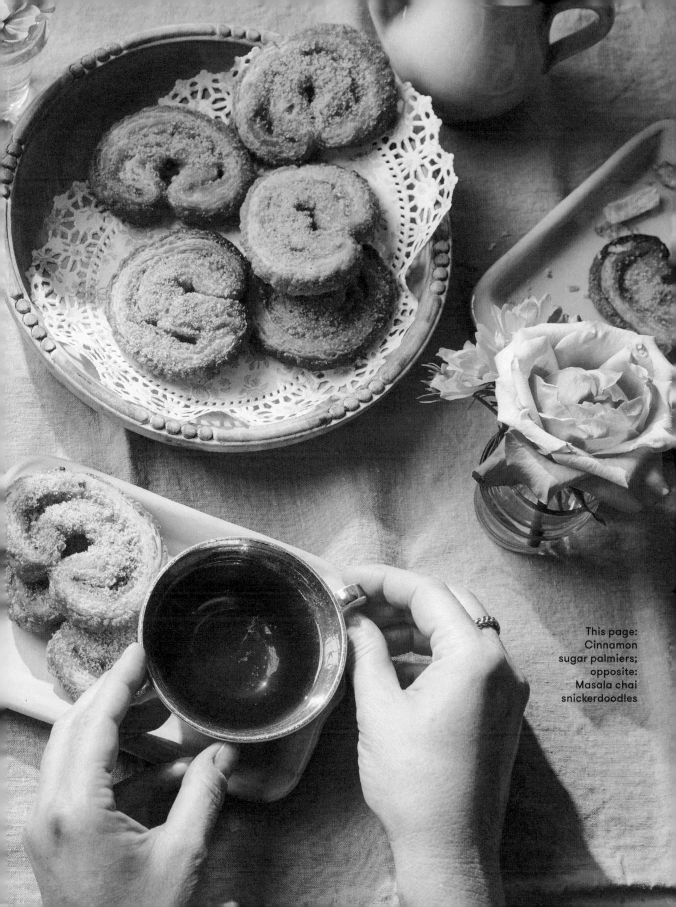

This page:
Cinnamon
sugar palmiers;
opposite:
Masala chai
snickerdoodles

Apple custard & sweet spice tarts

The sharpness of Bramley apple (or choose another similarly sour variety) and the woody warmth of spice make these custard tartlets a textural and flavor delight. Nutmeg and mace have a natural affinity as they come from the same plant: crack open its golden fruit and you will find a hard pip of nutmeg ensnared in red, lacy mace. The two also pair well with cinnamon as they share many of the same flavor notes, including the medicinal-tasting compound eugenol, also found in clove, allspice, licorice, and black cardamom.

Makes 12 tarts

Confectioners' sugar, for dusting
320g (11¼oz) sheet all-butter puff pastry
1 teaspoon ground cinnamon
½ teaspoon ground mace

1 egg, plus 3 egg yolks
70g (2½oz) castor sugar
80ml (⅓ cup) heavy cream
1 Bramley apple (about 200g/7oz)
Nutmeg, for grating

SPICE SWITCH

To conjure Scandinavian bun vibes, swap the mace for the ground seeds of 2–3 green cardamom pods, then dust the custard tops with more cinnamon when they come out of the oven.

Dust a work surface liberally with confectioners' sugar. Lay out a rectangle of puff pastry and sprinkle the top with the cinnamon and mace. Roll the pastry back up tightly lengthwise and cut into 12 pieces.

Sit each pastry disk on its flat side and use a rolling pin dusted with confectioners' sugar to roll it into a thin, spice-spiraled circle. Press each into a 12-cup muffin tin so the pastry comes up and slightly over the sides. Chill in the fridge for 15 minutes.

Heat the oven to 425°F.

Whisk together the egg, egg yolks, castor sugar, and cream to make a custard.

Peel, core, and cut the apple into very small cubes, about ¼ inch. Divide among the pastry cases, pushing the pieces down below the rim, then pour the custard on top. Finish with a good grating of nutmeg.

Bake for 20 minutes, or until the custard is puffed up and set and the pastry golden at the edges. Move straight away to a rack to cool. They are best eaten still slightly warm on the day you make them.

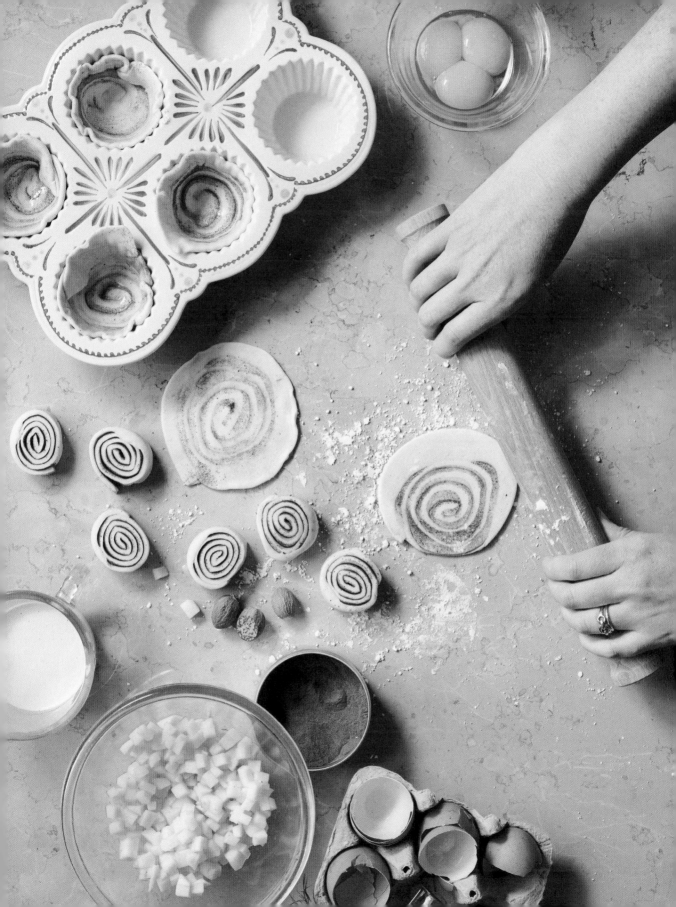

New Zealand ginger crunch

Imagine scaling a hill of indulgence. At the base is the American granola bar, sturdy, oaty, and understated, forming a reliable foundation. Climb up a stage and there are British flapjacks, the oats bound by buttery golden syrup. If you reach the summit, you'll find New Zealand's ginger crunch bars. Here a spicy cookie base, somehow crunchy yet chewy, is matched with a thick, fudgy ginger topping. Utter extravagance—you will need to scale an actual hill to justify eating a second.

If you don't have a super sweet tooth, consider halving the quantity of fudgy topping. But then it won't be ginger crunch.

Makes 16 bars

For the oaty base
110g (3¾oz) rolled oats
240g (8½oz) plain flour
200g (1 cup) light muscovado or light soft brown sugar
1 tablespoon ground ginger

1 heaping teaspoon baking powder
¼ teaspoon fine sea salt
180g (6½oz) unsalted butter
70g (2½oz) golden syrup

For the fudgy topping
90g (⅓ cup) unsalted butter
50g (1¾oz) golden syrup
190g (6¾oz) confectioners' sugar
2 teaspoons ground ginger
¼ teaspoon fine sea salt

SPICE SWITCH

I've never tried playing with the spices (the instruction is firmly in the name) but I do wonder if speculaas might work in place of ginger.

Line an 8-inch square tin with parchment paper. Heat the oven to 375°F.

In a large bowl, mix the oats, flour, brown sugar, ginger, baking powder, and salt. Melt together the butter and golden syrup then mix into the bowl of dry ingredients. Press into the base of the tin in an even layer.

Bake for 25–30 minutes, until it has a good golden crust. Leave to cool completely in the tin.

For the topping, melt the butter and golden syrup together. Sift the confectioners' sugar, ginger, and salt into a large bowl then add the molten mixture. Beat with an electric whisk on medium–high speed for 2–3 minutes until it is thick and fudgy. Spread over the cooled base, gently rippling the surface, and leave to set.

Remove from the tin and cut into 16 squares or bars. They will keep in a tin for a few days but will lose a little of their crunch.

A
IS FOR
ANISEED

Licorice meringue kisses with rose cream

Licorice is one of those polarizing ingredients (alongside marzipan, glacé cherries, and rose water). Minds are set firmly to love or hate and I am not here to try and convince opponents otherwise. But for lovers of both licorice and rose, here is an enchanting pairing of aniseedy depth and floral romance.

Staining the meringue kisses with stripes is an optional step—dollop white spoonfuls onto the baking tray if you prefer keeping the drama to the taste alone —but it is easy enough and does make them rather splendid. These are good eaten with red berries.

Makes 20 couplets

For the licorice meringue kisses
2 large egg whites (80g/2¾oz), at room temperature
75g (⅓ cup) castor sugar
50g (1¾oz) confectioners' sugar, sifted

1½ teaspoons ground licorice root or a few drops of licorice extract, to taste
Black gel food coloring (optional)

For the rose cream
80ml (⅓ cup) heavy cream
½–1½ teaspoons rose water

SPICE SWITCH

*Licorice also marries well with warming spices.
In the cream, exchange rose water for ½ teaspoon ground cinnamon and a generous grating of fresh ginger.*

Line two baking sheets with parchment paper. Heat the oven to 275°F.

Whisk the egg whites to soft, billowy peaks then add the castor sugar, a spoonful at a time, continuing to whisk until the mixture is thick, very glossy, and smooth. There should be no sugar graininess. Fold in the confectioners' sugar and either the ground licorice or licorice extract, to taste. You can go bold or subtle here.

For swirling striped meringues, use a paintbrush to add three vertical stripes of food coloring gel along the inside of a piping bag. If piping is not for you, dip a skewer in the food coloring and simply ripple the black through the mixture. Pipe or spoon meringue kisses about 1¼ inches in diameter onto the parchment paper.

Put in the warmed oven and lower the temperature to 235°F. Bake for 1 hour, or until firm, crisp, and easy to lift from the parchment. Cool and store in an airtight tin until ready to fill and serve.

For the rose cream, whip the cream and rose water together to form soft peaks (add according to taste as rose waters vary wildly in strength). Use dollops of the scented cream to sandwich together the meringue kisses in pairs. Serve any extra cream alongside.

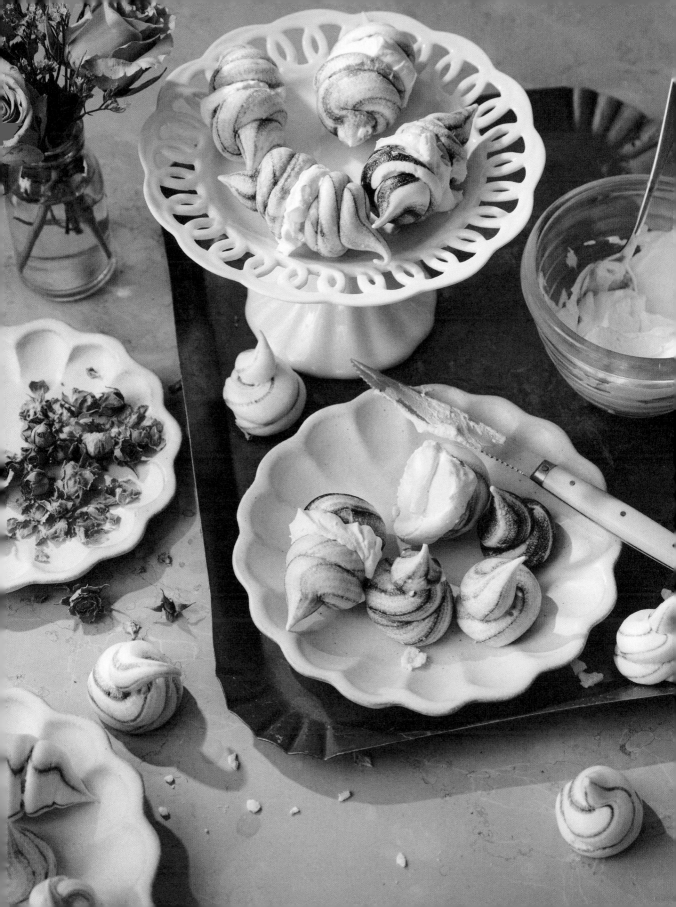

Sweet roast plums with five spice

Chinese five-spice powder is a blend of contrasts: warm and sweet from anise and cassia, cool and complex from fennel and clove. The five in the name is not a nod to the number of spices, but rather the five principal flavor notes of Chinese cuisine that the mix combines. It also works beautifully with plums.

Serves 6

2½ tablespoons light muscovado sugar
2 tablespoons ground almonds
40g (3 tablespoons) unsalted butter, softened, plus more for greasing

Finely grated zest of ½ orange or lemon
1½ teaspoons Chinese five spice
Pinch of fine sea salt
10 ripe plums, halved and stoned
Handful of sliced almonds

For the ginger crème fraîche
2 tablespoons grated fresh ginger
250ml (1 cup) crème fraîche
50g (1¾oz) castor sugar

SPICE SWITCH

Use ¼ teaspoon ground cardamom, ¼ teaspoon ground mahleb, and ¼ teaspoon ground grains of paradise instead of the five spice.

Heat the oven to 400°F.

Mix together the sugar, ground almonds, butter, zest, five spice, and salt.

Choose an oven dish that can accommodate the plums snugly, and grease with a little butter. Lay out the plums cut-side up. Spoon a nub of the sweet-spiced paste into each and scatter sliced almonds over the top.

Bake for 15 minutes, or until the plums are tender and the almonds golden. Leave to cool—I think they are best eaten at room temperature.

For the ginger crème fraîche, extract the intense juice from the ginger by squeezing it through a thin paper towel or other kitchen paper. Mix the ginger juice with the crème fraîche and sugar, then beat with a whisk until thick and fluffy. Serve with the plums.

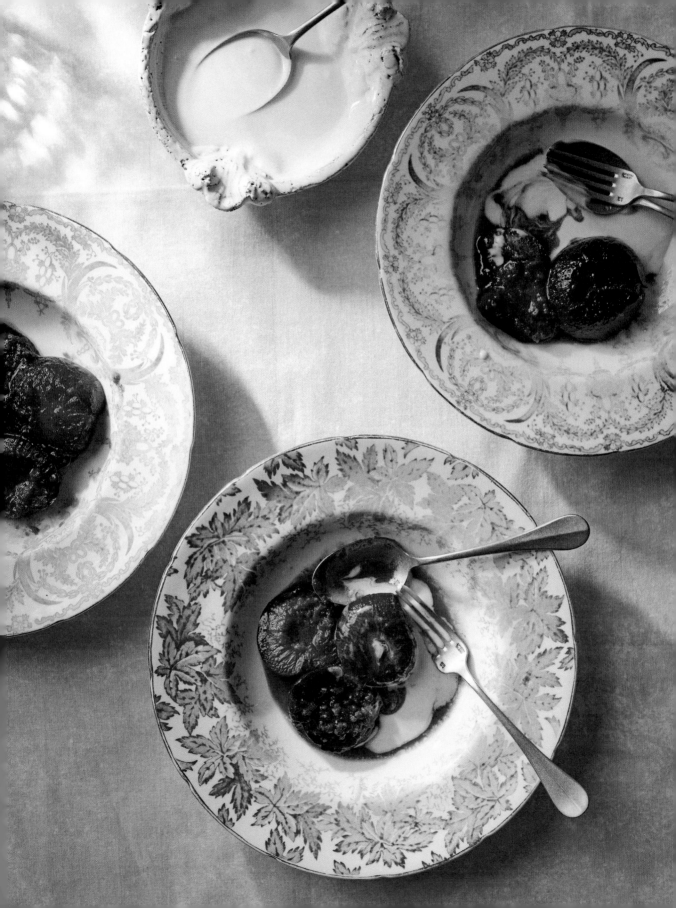

Wrinkled chocolate & anise cookies

Star anise does not live up to its starry name here; rather, it's very much the support act. The flavor is hard to put your finger on—challenge people to see if they can taste it. What they will notice is how it intensifies the dark chocolate, bringing out the umami and giving an almost smoky depth. Spicing is a great trick to make average chocolate taste more expensive.

These very grown-up, chewy, salty-not-too-sweet chocolate cookies are some of the best around, and so simple to make. You can make the dough in advance and chill it until you're ready to cook.

Serve with strong coffee or, better still, caffè corretto (coffee with a splash of sambuca) to up the anise ante.

Makes 20 cookies

60g (¼ cup) unsalted
 butter
4 star anise
60g (2¼oz)
 unsweetened cocoa
 powder
200g (7oz)
 confectioners' sugar
¼ teaspoon fine sea salt
2 large egg whites
 (80g/2¾oz)
150g (5½oz) best dark
 chocolate, 70%
Sea salt flakes,
 for sprinkling

SPICE SWITCH

The butter is the carrier for flavor so you could try variations with any whole spices: black and pink peppercorns; bay leaves; cardamom; juniper; lemongrass and cumin; lavender flowers; chili. Don't expect the spice flavor to be strong; it will intermingle with the complexity of chocolate. Alternatively, add a teaspoonful of Chinese five-spice powder to the cookie dough.

Melt the butter with the star anise over a medium heat. Heat for a few minutes to let the butter sizzle and foam, swirling to keep the milk solids from burning. Leave to cool and infuse for 30 minutes, then scoop out and discard the stars.

Heat the oven to 350°F. Line two baking sheets with baking parchment.

Sift the cocoa powder and confectioners' sugar into a large bowl and mix in the fine salt. Stir through the infused butter and egg whites to make a thick paste.

Chop the chocolate into a rubble with both finer dust and larger shards, then add to the mixture.

Dollop spoonfuls of the batter onto the baking sheets, each about 1½ inches, spacing them to allow the cookies to flatten and spread. Sprinkle with a little flaky sea salt.

Bake for 8–10 minutes or until the tops look glossy, wrinkled, and just set. Leave to cool completely on the tray. They'll taste just as good the day after baking.

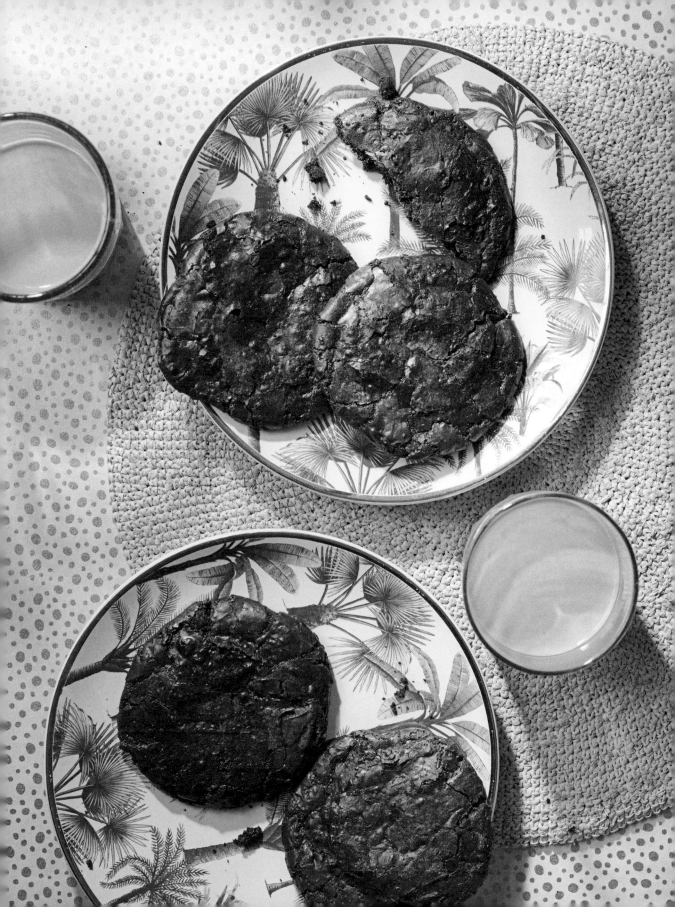

ANISE SPICES

Sweetness is one of life's great pleasures. Desire for it is not a weakness akin to tobacco addiction; on the contrary, it is woven into our genes through natural selection.

We are born with a sweet tooth to draw us to our mother's milk, while being able to seek out honeyed fruits was an evolutionary strength for our foraging forebears, for in nature they signal safe, high-energy foods.

But these sweet-seeking taste buds of ours can be tricked. The plant compound anethole reads as thirteen times sweeter than sugar without all the calories—useless for foragers but a boon in today's confectionery manufacture. Its other lead characteristic is a strong anise flavor.

Anethole is found in a blended family of spices, linked by taste rather than botany: aniseed, star anise, fennel, licorice, anise myrtle, dill seed, and caraway. All share the ability to sweeten foods as well as lending licorice depth. As the flavor compound is especially soluble in alcohol, anise-scented liqueurs are an obvious way to enjoy them.

Greek ouzo, French pastis, Italian sambuca, Turkish raki, and Levantine arak all share a breath of anise, perfect for cutting the olive-oil richness of the region's food. It is thought that across the Eastern Mediterranean, aniseed has been used to flavor alcohol for longer than history is recorded.

Aniseed (also known as green aniseed or simply as anise) is a small green-brown seed with a gentle, fruity-bitter dimension. It was used by ancient Egyptians for snakebites, by Romans in wedding cakes, and by Cretans in spiced wines, alongside coriander and juniper. Today, Italians fold it into yeasted cakes, sweet breads, and doughnuts. It spices German pressed biscuits, Portuguese chestnuts, and Lebanese custards. In Britain we have aniseed balls, the bullet-hard sweet of my childhood, though I haven't seen one in years.

While aniseed rules Europe, Asia has star anise.

The fruits of a tall tree native to China and Vietnam are dried to leathery, star-shaped pods holding glossy dark seeds. Count the points, for it's said that any more than eight is lucky. The Latin name for the plant is *Illicium*, meaning "allurement" and with its intense, sweet-peppery taste, it's easy to see why. More usual in savory cooking, they can also scent syrups and sweet tea. In The Netherlands, stars are infused into warm milk with vanilla sugar as a drink to soothe ill children.

Fennel seeds combine a mild aniseed flavor with citrusy, herbal notes. Gladiators would bite on the green pips for courage before entering the Colosseum, and in India they are chewed as a digestive and breath freshener. They make a wonderful partner for almond biscuits or plum jam, and in Puglia are packed in dried figs with almonds and lemon zest to create "married figs." Brew a spoonful of fennel seeds in hot water for a lovely tisane.

Licorice is a woody root and the flavor extracted from it is bittersweet, salty, and strongly anise-like. Long a medicine before it was a sweet, for more than two millennia it has been consumed in China where it is seen a preserver of youth and strength. It was taken as a sex tonic in early India, the roots chewed by Babylonians for vigor, and brewed into a stimulating drink for the Egyptian pharaohs. It wasn't until 1760 that the first black sweets were made, now favored in Nordic countries, where a taste for salty licorice is endemic. The Chinese eat salted dried plums scented with licorice and clove, and in India it is steeped into milky chai.

To get a full and complex anise hit, look to the Chinese five spice blend, which aims to excite all five tastes. Fennel, star anise, and licorice can all feature here alongside cassia, cloves, and Sichuan pepper.

Jeweled quince
with star anise

I once saw quince described as the "ugliest fruit," which struck me as singularly unjust, and one can only assume the author had never seen a bletted medlar. On the contrary, I find great charm in the down-covered, irregular curves of a quince, the raw fruit already scented with an intoxicating mix of rose and honey. But they don't reach their true potential until cooked slowly and patiently through the color spectrum. The heat of the oven coaxes a transformation from hard yellow to softened auburn, finally reaching a beautiful ruby red, at which point the flavor hits its zenith.

This is a Turkish method of slow poaching in sugar syrup until it becomes thick and jellied from the quince's pectin. During a short winter season, ayva tatlisi glint like jewels amid the lines of baklava in the sweet shops of Istanbul. Cloves and cinnamon are the typical pairings, but here I have chosen star anise, which makes a fine match for the perfumed intensity.

Serves 8

4 quinces
1 lemon, zest pared
 in strips
440g (2 cups) castor
 sugar
6 star anise

To serve
Kaymak or clotted
 cream
Finely ground
 pistachios

SPICE SWITCH

For a more traditional Turkish spicing, use 12 cloves and a snapped stick of cinnamon. Alternatively, try a split vanilla pod and 3 scrunched bay leaves.

Heat the oven to 350°F.

Peel the quinces and halve lengthwise. Rub with a cut lemon as you go to keep the flesh from browning. Leave in the cores but remove the stems and any pockets of dirt or loose seeds.

Find an ovenproof pan or dish that will hold the quinces in a snug layer (or close enough as they will give out liquid and shrink as they cook; I use a 12-inch shallow cast-iron pan). Spread half the sugar over the base then scatter with the star anise and pared lemon zest. Lay the quince halves on top, cut-sides down, and scatter over the remaining sugar. Add 250ml (1 cup) water and squeeze in the lemon.

Cover with a tight-fitting lid or foil. Roast in the oven for 3–4 hours, basting the quinces every hour to start and more frequently toward the end. Quinces are mercurial and will be ready at their own whim. You are looking for deep red, tender fruit in a toffee-like syrup. Be careful that the sugar doesn't catch and boil too fiercely in the final stages. Baste again to glaze as they cool.

Serve at room temperature, a half for each person topped with a spoonful of kaymak or clotted cream and a scattering of finely ground pistachios.

Exceptionally good seed cake

A pleasingly old-fashioned, barely sweet cake. So old-fashioned in fact that it has been around since medieval times, gratifying the English for centuries with the herbal-licorice hint from caraway seeds that give it its name. Mrs. Beeton, Victorian cooking doyenne, had no less than four seed cake recipes in her cookbook, including a "Common Seed Cake" and a "Very Good Seed Cake," which rather begs the question, who would choose the former?

Serves 8

170g (6oz) plain flour
50g (½ cup) ground almonds
2 teaspoons baking powder
1 tablespoon caraway seeds
½ teaspoon grated nutmeg
½ teaspoon fine sea salt

170g (6oz) unsalted butter, at room temperature
170g (6oz) golden castor sugar
3 eggs, at room temperature
4 tablespoons milk
2 tablespoons demerara sugar

SPICE SWITCH

To make a seedier cake, use 1½ teaspoons caraway seeds, 1 teaspoon aniseed and 1 tablespoon poppy seeds.

Line a loaf tin with parchment paper. Heat the oven to 350°F.

Whisk together the dry ingredients: flour, ground almonds, baking powder, caraway seeds, nutmeg, and salt.

In another bowl or stand mixer, cream together the butter and castor sugar until very light and fluffy. Beat in the eggs one at a time, adding a spoonful of the flour mixture if it threatens to curdle. Beat in the remaining flour. Finally, loosen the batter with the milk.

Spoon into the loaf tin, level the top, and dredge with the demerara crystals. Bake for 55 minutes, or until it has a good golden crust and a skewer poked in the middle comes out clean.

Cool in the tin for 10 minutes, then turn out onto a rack to cool. It keeps well in a tin for a few days.

Caraway sherbet dip

Not the sherbet that is a sorbet nor the Middle Eastern drink, I'm talking about the fizzy sherbet of old-fashioned English sweet shops. It is incredibly easy to make and a fun, frivolous way to make people smile. I like to bring this out after dinner with an array of things to dip. Toasted caraway and aniseed add complexity, but certainly not enough to make it too grown-up!

Serves 4

½ teaspoon caraway seeds
½ teaspoon aniseed
100g (3½oz) castor sugar
2 teaspoons fine citric acid crystals
1 teaspoon baking soda

Things to dip
Sweet apples, cut into wedges
Ripe pears, cut into wedges
Sticks of black licorice
Lollipops

SPICE SWITCH

1 teaspoon ground sumac and 1 teaspoon ground dried rose petals or 2 teaspoons Aleppo pepper (no need to toast any of these).

Toast the caraway and aniseed in a dry frying pan over a medium heat. Stir for a minute or two, just until they smell nutty and aromatic. Tip into a mortar and crush to a rough, fragrant powder.

Mix the spices with the sugar, citric acid, and baking soda.

Divide into a tiny bowl for each guest and serve with a selection of fruit wedges, licorice sticks, or colorful lollipops to dip.

ALCOHOL ♡ SPICE

Alcohol is an excellent vehicle for extracting flavor and drawing out the essential oils from deep within woody spices, a quality put to use in the spirits industry. This chart gives just a small taste, a snifter if you will, of the many spiced liquors the world has embraced. I've also included a few ideas for home infusions.

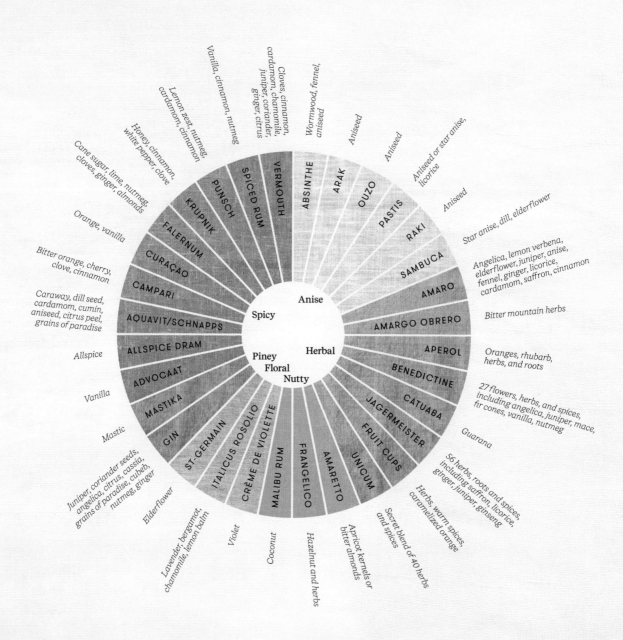

Vanilla, cinnamon, nutmeg
Cloves, cinnamon, cardamom, chamomile, juniper, coriander, ginger, citrus
Wormwood, fennel, aniseed
Aniseed
Aniseed
Aniseed or star anise, licorice
Aniseed
Star anise, dill, elderflower
Angelica, lemon verbena, elderflower, juniper, anise, fennel, ginger, licorice, cardamom, saffron, cinnamon
Bitter mountain herbs
Oranges, rhubarb, herbs, and roots
27 flowers, herbs, and spices, including angelica, juniper, mace, fir cones, vanilla, nutmeg
Guarana
56 herbs, roots and spices, including saffron, licorice, ginger, juniper, ginseng
Herbs, warm spices, caramelized orange
Secret blend of 40 herbs and spices
Apricot kernels or bitter almonds
Hazelnut and herbs
Coconut
Violet
Lavender, bergamot, chamomile, lemon balm
Elderflower
Juniper, coriander seeds, angelica, citrus, cassia, grains of paradise, cubeb, nutmeg, ginger
Mastic
Vanilla
Allspice
Caraway, dill seed, cardamom, cumin, aniseed, citrus peel, grains of paradise
Bitter orange, cherry, clove, cinnamon
Orange, vanilla
Cane sugar, lime, nutmeg, cloves, ginger, almonds
Honey cinnamon, white pepper, clove
Lemon zest, nutmeg, cardamom, cinnamon

Center categories: Anise, Spicy, Herbal, Piney, Floral, Nutty

Wedge labels: ABSINTHE, ARAK, OUZO, PASTIS, RAKI, SAMBUCA, AMARO, AMARGO OBRERO, APEROL, BENEDICTINE, CATUABA, JAGERMEISTER, FRUIT CUPS, UNICUM, AMARETTO, FRANGELICO, MALIBU RUM, CRÈME DE VIOLETTE, ITALICUS ROSOLIO, ST-GERMAIN, GIN, MASTIKA, ADVOCAAT, ALLSPICE DRAM, AQUAVIT/SCHNAPPS, CAMPARI, CURAÇAO, FALERNUM, KRUPNIK, PUNSCH, SPICED RUM, VERMOUTH

Ginger sloe gin

Wash 250g (9 oz) ripe **sloes** and prick each with a skewer. Pack into a 4-cup glass jar, along with 2 fat slices of fresh **ginger**. Add 125g (4½oz) **sugar** and 500ml (2 cups) **gin**. Seal and shake well. Tuck away somewhere dark and shake every day for a week, then forget about it for a couple of months. Strain and decant into a bottle for a sweet, warming liqueur with a plummy taste.

Browned butter & allspice rum

Fat-washing rum gives a deep, buttery flavor with no greasiness. Melt 100g (3½oz) unsalted **butter** over a medium heat. Cook, stirring often, until the milk solids turn nut brown. Toward the end, add ½ teaspoon of crushed **allspice berries**. Remove from the heat and add 250ml (1 cup) **rum**. Cool, transfer to a container, and refrigerate for 2 days. Skim off the solidified butter and strain the rum through a coffee filter. Use within 2 weeks in the following Barbadian cocktail formula: one of sour, two of sweet, three of strong, four of weak (perhaps 1 lime, 2 sugar syrup, 3 butter & allspice rum, 4 water).

Rose petal vodka

Capture the fresh scent of roses. Pack a jar with organic, well-scented **petals**. Cover with **vodka** and leave to infuse somewhere dark, giving it a daily shake. After 3 days, taste to see if you like the strength or leave for up to a week longer to keep infusing. Strain into a bottle and serve exceedingly well chilled. You can use the same method with sprigs of **lavender** or, for a spicier punch, add a couple of **chilies** and a few **juniper berries** and infuse for a month.

Vanilla or tonka brandy

Scrape **vanilla seeds** into a jar of **brandy** and add the **pod** too. Alternatively, add a couple of cracked **tonka beans**. Stir in a spoonful of **honey**. Put it in a dark cupboard and forget about it for a month or more. No need to strain. Drizzle over **ice cream** or use to take **brandy butter** to the next level.

Nectar des dieux

For this French "nectar of the gods" steep 300ml (1¼ cups) **eau de vie** or **vodka** with 1 tablespoon of **coriander seeds** and another of **aniseed**, along with 3 **cloves** and a **cinnamon stick**. Strain after a month then add 300ml (1¼ cups) **sugar syrup** and 300ml (1¼ cups) **white wine**. Bottle and mature for another 2 to 3 months. Drink as an aperitif.

Black cardamom whiskey

Fill a jar with **whiskey**, add a few **black cardamom pods** and leave to infuse somewhere dark. Taste after 24 hours to see if you like the level of smoky bitterness or want to leave it for another day or two. Strain. Make a smoked cardamom old-fashioned by mixing a double shot of the infused whiskey with a teaspoon of **maple syrup** (no need for bitters here, the cardamom will lend bitter complexity). Serve over ice with a twist of **orange**.

Smoked cinnamon glasses

Use a blowtorch to fire a small **cinnamon** or **cassia stick**. Wet the inside of a glass then set it upside down over the smoking spice while you make your favorite cocktail, possibly something with **dark rum** or **whiskey.** Decant into the still-smoking glass and serve with the heady aroma wafting over you.

Boozy sugar lumps

Suck on one of these as a digestive, the perfect end to a rich meal. Layer **white sugar** lumps in a jar with fresh **mint leaves**. Add a scattering of **fennel seeds** and a few **peppercorns**. Pour over enough grain alcohol (at least 90 percent proof) to cover. Store for a month or longer in a dark cupboard. Serve on a spoon, light with a match, then quickly blow out the flame for a milder alcohol hit.

Note: For all homemade infusions, use sterilized jars (see page 97) and high-proof alcohols.

Quick strawberry jam with vanilla & aniseed

The confiture aisle of a good French food hall is a spectacle to rival Mont-Saint-Michel. Expect a wall of glass jars in every jewel tone from scarlet fraise de bois to lucent jellies of soft-set violet petals. Black cherry, white peach, purple fig, and four varieties of plum in four rainbow shades. Then come lines of exotically spiced jams: rhubarb and cardamom, apricot with lavender or thyme, rum-spiked raisin and banana, and darkly reduced apples cooked with Calvados and salted butter. Vanilla is often used to perfume the fruits, as it is in this special combination, where aniseed also brings a delicate, licorice sweetness.

My take is a fresh jam, the sort to make in small batches as needed as it only lasts a couple of weeks in the fridge, but it's quick to prepare and bright in taste. Use it to sandwich sponge cakes, or it is particularly good dolloped into a bowl of fromage blanc, fromage frais, or faisselle—something with a lactic tang to play off the sweet fruit.

Fills a 400ml (14fl oz) jar

500g (1lb 2oz)
 strawberries
70g (2½oz) granulated
 sugar
Pinch of fine sea salt
4 teaspoons lemon juice
1 teaspoon aniseed
1½ teaspoons vanilla
 paste

SPICE SWITCH

Add 2 teaspoons lavender flowers to the strawberries as they cook. Or grate in ½ tonka bean along with a few drops of rose water.

Blitz the strawberries in a food processor until coarsely chopped.

Transfer to a frying pan with the sugar, salt, lemon juice, and aniseed. Cook over a medium–high heat, stirring nearly constantly. Once the surface is completely covered in bubbles, it will take about 10 minutes to thicken to a loose jam consistency (and will thicken more as it cools).

Leave to cool then stir in the vanilla paste. Store in a jar in the fridge for up to 2 weeks.

Fennel marzipan–stuffed dates

In Greece, wild fennel is called "marathon" and lent its name to the region where the plant grew abundantly. When the Greeks triumphed over the invading Persians in 490BC, legend has it that a young soldier, Pheidippides, ran the fatally long distance from Marathon to Athens clutching a fennel stem to announce the victory, and so inspired the eponymous run.

Fennel seeds, with their enchanting herbal-licorice taste, pair beautifully with almonds and the caramel stickiness of dates. These sweetmeats make a lovely nibble to end a meal—you'll probably want just one each—and take 10 minutes to make.

I wouldn't try and trim it down to 5 minutes with store-bought marzipan as this homemade almond paste is less sweet and better here.

Makes 8 dates

8 medjool dates
50g (⅓ cup) blanched almonds or ground almonds
50g (1¾oz) castor sugar
1 teaspoon fennel seeds, ground
Small pinch of fine sea salt
½ teaspoon almond extract
Chopped pistachios or walnut halves, to decorate

SPICE SWITCH

Cinnamon and ginger dates: in place of the fennel, use ½ teaspoon ground cinnamon then knead 2 chopped balls of crystallized ginger into the almond paste.

Slit the dates open lengthwise down one side and squeeze out the stone, so creating a cavity within.

In a food processor, grind the almonds to a powder if they're not already. Add the sugar, fennel, salt, and almond extract and process again for several minutes until the mixture clumps together into a thick paste. (If needed, add a teaspoon of water to help it come together.)

Roll the mixture into eight oval balls and pack into the dates in place of the stones. Press pistachios or walnuts into the tops to decorate.

Frozen pistachio, mastic, & honey creams

I am mad about the taste of mastic: piney and floral with a little minerality. These translucent tears of tree resin come from the Mediterranean region, the Greek isle of Chios particularly famed for its production for more than 2500 years. Ancient Greeks would chew on the gum-like resin and so it lent its name to the word "masticate."

For these delicate frozen creams, I've taken inspiration from the Lebanese dessert Ghazal Beirut by topping them with Arabian cotton candy. You can buy many variations of this sugar confection in Middle-Eastern grocers, including Lebanese ghazal el banet, Turkish pişmaniye, and Iranian pashmak, sometimes sold as Persian fairy floss or floss halvah. It looks like unspun silk and melts in the mouth. In the original dish it tops mastic ice cream made by the labor-intensive process of beating cream with mastic and salep (ground orchid root) until stretchy in texture. This is much easier.

Serves 4

½ teaspoon mastic tears
1 teaspoon granulated sugar
2 eggs
50g (1¾oz) honey
Pinch of fine sea salt
150ml (generous ½ cup) heavy cream

½–1 teaspoon rose water
50g (⅓ cup) pistachios, nibbed or roughly chopped
Arabian cotton candy, to serve (see above)

SPICE SWITCH

Drawing on Iranian flavors, soak a pinch of crushed saffron threads in the rose water for 30 minutes and switch the mastic for the ground seeds from 8 green cardamom pods.

Line four 7fl oz dariole molds or freezer-proof ramekins with overhanging plastic wrap.

Use a pestle and mortar to grind the mastic tears with the sugar to a fine powder.

Set a mixing bowl over a pan of simmering water. Add the eggs, honey, and salt and beat with an electric whisk until pale and moussy. Remove from the heat and either set the bowl in an ice bath or transfer the mixture to a stand mixer. Continue whisking for 5–10 minutes, until the mixture is very thick and the bowl is cool to the touch.

In another large bowl, combine the cream with the ground mastic and rose water (add according to taste as rose waters vary in strength). Whisk to soft peaks. Gently fold through the honey mixture and half of the chopped pistachios. Divide among the dariole molds and wrap the plastic wrap over the top. Freeze for at least 3 hours.

When ready to serve, turn out the frozen creams onto small plates. The plastic wrap should pull off easily. Top each with a large nest of Arabian cotton candy and a scattering of pistachios.

VANILLA
IS NOT A

NEUTRAL

VANILLA

It is my mission to rehabilitate vanilla's reputation. Vanilla ice cream is seen as the neutral choice, vanilla decor is uninspired, and vanilla sex bland. Paint tins would have us believe it denotes a safe buttery cream, the color of the vine's flowers perhaps, but we know really it is the dark pods and their shining black seeds that hold the power and the flavor.

The truth is vanilla is the very opposite of dull.

In fact, no other food can top the complexity, with up to 500 flavor components that make its aroma hard to describe. Notes of tobacco and wood are backlit by sweet, floral richness. What's more, it boosts adrenalin and is mildly addictive.

You may question why I am going out to bat for what is already the world's most popular flavoring. However, I am as much arguing against its use as for it. Vanilla is used so frequently and unthinkingly in baking that its flavor becomes ubiquitous. I'd like to suggest leaving out the small dash in cakes and ice cream. Let a sponge taste of itself—the toasty flour, the browned butter, and oven-caramelized sugar. Let the plain ice cream be milk, tasting richly of good dairy, or give another spice a chance to shine. But when you want vanilla, add it purposefully to experience its spicy, intriguing flavor in full.

Unfortunately, true vanilla is expensive, which means around 99 percent of the vanilla we eat is synthetic. Vanillin, the pod's prominent flavor component, is easy to make from petrochemicals,

clove oil, or from waste materials from paper manufacture. If you are licking a white ice cream cone or breathing in vanilla scent, the chances are it has never seen that exotic bean.

Vanilla stands second only to saffron as the priciest spice due to labor-intensive production. The flowers bloom for just one day a year so farmers must work fast to hand-pollinate them. If successful, 9 months later odorless green fruits are ready to be harvested, blanched in hot water, wrapped in wool, and left to ferment in the sunshine, then cured for 3 more months until shrunken, wrinkled, and highly aromatic.

Vanilla vines, a member of the orchid family, are native to the Mexican jungles where they were first pollinated by hummingbirds. It was the Totonac people who devised the laborious curing techniques. Having caught a taste for the spice, the French tried to naturalize the plant to Madagascar, Réunion, and Mauritius but it wasn't until 1840, when a 12-year-old slave boy called Edmond Albius found a method for hand-pollination, that they bore fruit. His simple technique spread across the globe and plantations sprang up from Indonesia to Tahiti.

Chocolate was vanilla's faithful culinary partner under the Mayans, then the Aztecs. This was how the Spanish conquistadors first used it too when they brought it home from the New World, changing the name from the romantic tlilxochitl (black flower) to vanilla (from the Latin root "vagina"). The exotic combination of chocolate and vanilla was a sensation in Europe, where it was said to transform men into "astonishing lovers."

Elizabeth I's apothecary is credited with first turning vanilla to other foods, creating desserts and sweetmeats that the Queen adored. France soon caught the trend, grudgingly naming vanilla-scented custard "crème anglaise."

Cream remains one of its common pairings, ice cream most obviously, as it shines best on a pure palette.

This is where you can use vanilla boldly, perhaps in a crème brûlée, custard tart, mille-feuille, or quesillo de leche. It can also lend a more background flavor to bakes and compensate for lack of cocoa intensity in cheap chocolate. Fruits such as strawberries, apples, and rhubarb are lovely with a scraping of vanilla seeds, and it pairs well with other sweetly fragrant spices: nutmeg, bay leaf, allspice, clove, aniseed, or mahleb.

Buy vanilla as extract (the flavor extracted in alcohol), paste (an intense, seedy mixture of extract with ground beans and sugar), or powder (the black kind made from pure ground bean). Vanilla essence is synthetic. If using whole pods, look for ones that are dark and plump. Brittleness is a sign of age but a dusty covering of flavorsome crystals is natural and highly desirable. Massage gently then split the pod lengthwise and use the tip of a sharp knife to scrape out the precious seeds. Bury the spent pod in sugar for another use or make your own vanilla extract.

There are three main cultivars. Mexican has notes of wine and fruit. Bourbon (largely from Madagascar and Réunion) is the most common and prized for its rich, earthy, and balanced spiciness. When grown in Asia, vanilla has a gentler flavor and hint of smoke. Finally, Tahitian vanilla is the most expensive and esteemed by chefs for its notes of cherry-chocolate, anise, and woody caramel. Breathe in the scent of any and you'll agree, vanilla is anything but neutral.

Homemade vanilla extract

Roughly chop scraped **vanilla pods**. Put in a small bottle and cover with **vodka** or white **rum** (about 30ml/2 tablespoons per pod is good). Seal and store in a dark place, shaking occasionally. This becomes better and darker over the months. Top up with alcohol as you use it and more scraped pods when you have them.

Vanilla–roasted rhubarb with zabaglione

An elegantly simple dessert. Rhubarb and vanilla were made for each other, the puckery pinkness tamed by balmy floral scent. The other member of the party is zabaglione, a delicate custard cloud formed by beating Italian Marsala into egg yolks. It needs to be made last minute but is simple enough that you can keep up conversation with guests over 10 minutes of nonchalant whisking. If you don't have Marsala, another booze will work—consider a fruity white wine, rosé, prosecco, amaretto, sherry, or sweet vermouth.

Serve as it is, or with amaretti biscuits alongside and strong coffee waiting in the wings.

Serves 4

For the roasted rhubarb
1 vanilla pod
80g (2¾oz) castor sugar
400g (14oz) slender
 pink rhubarb stems

For the zabaglione
4 egg yolks
4 tablespoons castor
 sugar
4 tablespoons Marsala

SPICE SWITCH

Roast the rhubarb with 1 teaspoon grated fresh ginger and a little orange zest.

Split the vanilla pod lengthwise and scrape out the seeds. Mix these with the sugar.

Trim the rhubarb and cut at an angle into short finger lengths. Tumble with the vanilla sugar in a baking tray in which it fits in a single snug layer and add the vanilla pod. Leave to mingle for a few minutes for the sugar to draw out some of the rhubarb's juices.

Heat the oven to 400°F.

Cover the rhubarb with foil and roast for 15 minutes. Remove the foil and give everything a shuffle—the sugar should have dissolved into the pink juices. Return to the oven, uncovered, for 5 minutes, or until the stems are tender but holding their shape and the juices syrupy. Try not to disturb the rhubarb too much or it will break down to stringy mush. You can make up to this stage in advance, but the rhubarb should be served at room temperature, not chilled.

When you are ready to eat, make the zabaglione. Find a heatproof bowl that will sit over a pan of simmering water. Heat the water.

In the bowl off the heat, whisk together the egg yolks and sugar—I find it satisfying to use a balloon whisk but you could also use a handheld electric whisk. Once they are light and fluffy, add the Marsala and set the bowl over the pan. Continue whisking for about 7 minutes to make a frothy custard. It is ready when the whisk leaves ribbon-like trails in the mixture.

Serve the rhubarb in small bowls with the warm zabaglione draped on top.

White & black sticky cake

There is good reason that kladdkaka ("sticky cake") is Sweden's favorite cake. It has top and bottom layers of buttery crunch holding plenty of fudgy squidge between them, almost like a giant, shareable cookie. Usually, it is made with dark chocolate and vanilla. Here white chocolate gives a toasty, caramelized butter flavor, vanilla brings complexity, and black sesame seeds lend nuttiness with an earthy undertone to offset all that sweetness.

Serves 8

20g (¾oz) black sesame seeds
150g (5½oz) unsalted butter
150g (5½oz) best white chocolate, finely chopped
1 vanilla pod, scraped, or ½ teaspoon vanilla powder
2 eggs, at room temperature

180g (6½oz) castor sugar
¼ teaspoon fine sea salt
150g (1 cup) plain flour

Optional toppings
White currants, red currants, cranberries, or raspberries

SPICE SWITCH

Use dark chocolate and the ground seeds of 8–10 green cardamom pods (no vanilla or sesame).

Line an 8½-inch loose-bottomed cake tin with parchment paper. Heat the oven to 350°F.

Toast the black sesame seeds in a dry frying pan for 3–5 minutes, stirring until they turn nutty and fragrant; one or two may start to pop. Be careful as their color hides the browning so you need to rely on your other senses.

Gently melt the butter in a small pan. Remove from the heat and leave to cool a little before tipping in the rubble of white chocolate. Stir to melt, then add the vanilla and black sesame.

In a large bowl or stand mixer, whisk together the eggs, sugar, and salt for a few minutes to a pale, molten cloud. Use a spatula to fold through the flour, followed by the buttery chocolate.

Scrape into the tin and bake for 16–20 minutes. It should be set at the edges, have a crust across the top, and still be very sticky in the middle. If it really wobbles, it needs a little longer, but a soft, under-baked center is key. Leave to cool completely in the tin before unmolding. The center will sink and crumple and that is all right.

Top with a generous layer of berries before serving, if you like something sharp to dance with your sweet.

Chocolate, roasted walnut, & vanilla bean cake

A flourless chocolate mousse cake, the sort for decadent dinner parties when only something rich and densely chocolaty will do. What makes this special is the use of a whole vanilla bean, pod and all, which gives an incredible depth of flavor, almost fruitiness, alongside the roasted nuts.

Serves 6–8

65g (2½oz) walnuts
1 large vanilla pod
135g (4¾oz) best dark
 chocolate, 70%
50g (4 tablespoons)
 unsalted butter, plus
 more for greasing
4 eggs, separated
50g (1¾oz) golden
 castor sugar
¼ teaspoon fine sea salt

SPICE SWITCH

Omit the vanilla and add 1½ teaspoons instant espresso powder when you fold in the ground walnuts. This will play off the complexity of the chocolate.

Grease and line a loose-bottomed 8-inch cake tin. Heat the oven to 350°F.

Put the walnuts on a baking tray and roast for 7–10 minutes, until they are lightly browned and smell wonderful.

Use a sharp knife to very finely chop the whole vanilla pod. Put it into a food processor with the roasted walnuts and blitz to a flour with some nubby texture.

Break the chocolate into squares and melt with the butter in a bowl set above a pan of simmering water. Set aside to cool.

Using an electric whisk and clean bowl, beat the egg whites until stiff. In another large bowl, beat together the egg yolks, golden castor sugar, and salt for several minutes, until the whisk leaves pale, ribbon-like trails.

With a spatula, fold first the ground walnuts into the yolks, then add the melted chocolate. Stir in a dollop of the egg whites to loosen the mixture then gently fold in the rest of the whites.

Scrape into the cake tin. Bake for 18–25 minutes—it should be bouncy to the touch but with the promise of soft moussiness underneath. Leave to cool in the tin before serving either just warm or at room temperature, with lashings of crème fraîche.

CHOCOLATE ♡ SPICE

If there is a food of love, it is surely chocolate. The sensual melt that happens just at the temperature of the human body might have secured chocolate its place as a Valentine gift, or perhaps it was because it has been shown to raise pulses more than a passionate kiss. Cocoa releases a rush of serotonin that induces happiness and contains phenylethylamine, one of the chemicals your brain produces when you fall in love.

Chocolate's relationship with love has always been there, but its flirtation with sugar is a much newer one.

The story starts in Mesoamerica in 1500 BC when the Olmec people harvested, fermented, and roasted cocoa beans for rituals and medicines. Centuries later, Mayans came to revere its potency. The beans were pounded with chili and water to make a drink called xocolatl ("bitter water"), which was drunk ceremonially and by newlyweds to ensure a fruitful night ahead.

Over the years, demand for cocoa in the region spiraled, driving the creation of a vast trading web. So hot was the desire that when the Aztecs conquered, they stipulated cocoa beans as taxes. Chocolate was seen as the symbol of wealth, of power, of sexual prowess, and was drank to honor Xochiquetzal, the goddess of love. Local spices scented the unsweetened drink: vanilla, flower petals, annatto (a red-staining seed), mecaxochitl (an aniseed-like pepper), and mild red chilies.

The emperor Montezuma II enjoyed the resulting blend so much that he was rumored to have fifty flagons a day taken from golden goblets, which he tossed from his palace balcony into the lake below after a single use.

Perhaps this excess fueled him to keep up with another passion: his 4000 concubines. Women at the time were not allowed chocolate because its aphrodisiac properties were considered overwhelming for them.

When the Spanish conquistadors arrived, they were baffled to find beans rather than bullion in the Aztec treasury. Nonetheless, they took them back in their ships and so the European love affair with chocolate began. In Spain, they decided chocolate was easier to pronounce than xocolatl, and tamed its bitterness with honey and cinnamon. It was taken as a love potion and fertility aid. The Catholic Church had internal debates about whether to deplore the depraved concoction or if congregations could sip it during mass for its stimulating benefits. Pope Pius V sampled a cup and decided it was so foul a ban was not necessary. However, it turned out he was in the minority and by the seventeenth century, a molten wave of chocolate spread through Western Europe. Blends became increasingly heady, with sugar, vanilla, aniseed, pepper, cinnamon, nutmeg, ambergris, rose water, and musk.

The French Sun King, Louis XIV, seduced women with gifts of chocolate, while Venetian amorist, Casanova, declared it the "elixir of love."

Debauched pleasure-seekers were not the only ones infatuated. In England, the abstemious Quakers took to drinking chocolate as an alternative to their great moral evil, alcohol, and so Joseph Fry is credited with making the first chocolate bar in 1847. The link with spice was detached and its bond with sugar cemented as bars became increasingly sweet and milky in the twentieth century.

Today, we are seeing a return to darker chocolates with more nuanced flavors and chocolatiers are experimenting again with the transforming effects of different spices as they play off the beans' complexities.

Flavor inspiration from the world's top chocolate houses

COFFEE & STAR ANISE

CINNAMON & MILK CHOCOLATE

JUNIPER & BLACKCURRANT

LEMONGRASS & CUMIN

FEUILLETINE WITH SPECULAAS

BANANA, NUTMEG & RUM

CHILI & CORIANDER PRALINE

JASMINE

CARDAMOM & GINGER

BLACK LIME

ORANGE BLOSSOM

LEMON & CINNAMON

WHITE CHOCOLATE WITH LICORICE & POPPY SEEDS

SALTED CARAMEL WITH BLACK & PINK PEPPERCORNS

FRESH GINGER & HONEY

ORANGE & GERANIUM

PECAN & CINNAMON

MILK CHOCOLATE, CHILI, & LIME

TOBACCO

SPICY DAMSON

FIG & GINGERBREAD SPICES

ROSE & VIOLET CREAMS

CHERRY, LICORICE & CORIANDER SEED

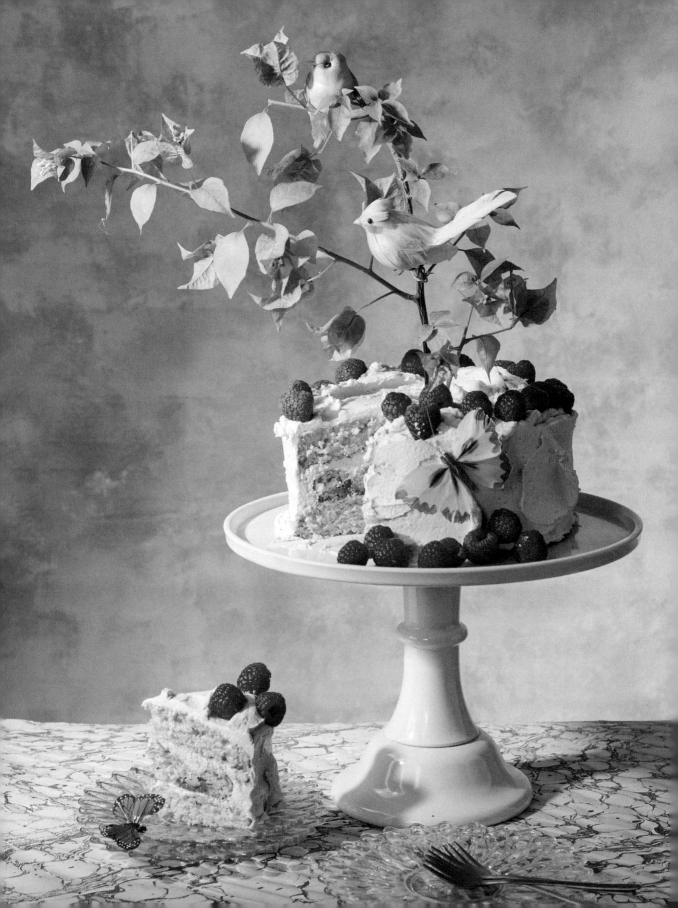

A pink cake for Sylvia

I developed this vanilla and raspberry cake when my daughter requested a sugar pink cake for her fifth birthday, and indeed a pink party to match. The kefir makes the sponge whisper-light and the raspberries stud it with pockets of jammy sharpness. A mound of fluffy frosting was another prerequisite—here its sweetness tempered by fresh fruit, which also stains it a suitably Barbie pink. The other trick for lightness in both the sponge and the frosting is seemingly excessive beating.

Serves 12–16

For the cake
260g (1¾ cups) plain
 flour
1 teaspoon baking
 powder
1 teaspoon baking soda
½ teaspoon fine sea salt
120g (4¼oz) unsalted
 butter, at room
 temperature
260g (9¼oz) castor
 sugar
2 eggs, at room
temperature
2 teaspoons vanilla
 paste or extract
240g (8½oz) milk kefir,
 at room temperature
210g (7½oz) raspberries

For the pink frosting
140g (5oz) raspberries
200g (7oz) unsalted
 butter, at room
 temperature
540g (1lb 3oz)
confectioners' sugar,
 sifted
1 teaspoon vanilla paste
 or extract

Optional toppings
Edible flowers, more
 raspberries, or
 sparkly pink
 decorations on sticks

SPICE
SWITCH

Take it in a floral direction by changing the vanilla for rose water, or you could try a few drops of licorice extract.

Make sure all the ingredients, including the kefir, are at room temperature. Grease and line three 8-inch sandwich tins. Heat the oven to 400°F.

Whisk together the flour, baking powder, baking soda, and salt then set aside.

With an electric mixer, beat together the butter and castor sugar at medium speed. Keep going for 3–4 minutes until it becomes really pale and fluffy. Beat in the eggs and vanilla extract, adding a spoonful of the flour if it starts to curdle. With the mixer speed on low, add the flour in three batches, alternating with the kefir, so you start and end with the flour. Stop the mixer after each addition when just combined.

Scrape into the tins and level. Scatter the raspberries over the top—no need to push them in as they will sink as it cooks. Bake for 20 minutes or until the cakes are golden, springy to the touch, and a skewer inserted into the center comes out without any wet batter clinging to it.

Sit in the tins for 5 minutes before turning out on a rack to cool. Meanwhile, make the frosting.

Purée the raspberries then press through a fine sieve to remove the seeds. The butter should be soft but not melting. You can soften it further in an electric mixer at low speed. Add the raspberry purée and half the confectioners' sugar and beat for 3 minutes. Add the remaining confectioners' sugar and the vanilla paste and beat for another 3 minutes. The frosting should be light and creamy but able to hold its shape. If it is too thick, beat in a dribble of water; too thin, add another spoonful of sugar.

When the cakes are completely cool, spread with the frosting, stacking as you go, then swirl the top and sides with an offset spatula. Decorate with edible flowers, more raspberries, or your choice of pink decorations on sticks. Best on the day it is made.

Vanilla & nutmeg marshmallows

Angels must surely sleep on homemade marshmallows as their transcendent, bouncy lightness is unrivaled. To make the process painless, you will need a stand mixer, a sugar thermometer, and a day without high humidity.

The lead recipe here uses vanilla and a suspicion of nutmeg, making the perfect sort for campfires, hot chocolate, or squidging into s'mores. However, my love for the spice switch—gingerbread marshmallows—knows no bounds. I think you'll need to try them both!

Makes 36 large squares

Oil, for greasing
2 tablespoons confectioners' sugar
2 tablespoons corn starch
16g (½oz) leaf gelatin (8 sheets platinum grade)

500g (1lb 2oz) granulated sugar
¼ teaspoon fine sea salt
2 egg whites (70g/2½oz), at room temperature
2 teaspoons vanilla paste
¼ teaspoon grated nutmeg

SPICE SWITCH

Gingerbread marshmallows: make the sugar syrup with 300g (10½oz) granulated sugar, 150g (5½oz) light muscovado sugar, 3 tablespoons treacle, 3 tablespoons golden syrup, and ¼ teaspoon salt. At the end, whisk in 1 tablespoon ground ginger, ¾ teaspoon ground cinnamon, ¼ teaspoon ground clove, and ¼ teaspoon ground allspice.

Brush an 8-inch square tin with oil. Mix together the confectioners' sugar and corn starch and use a heaping tablespoon of the mixture to dust the base and sides of the tin. Set the rest aside.

Add the gelatin sheets one at a time (to prevent clumping) to a bowl of cold water and leave to soak.

Put the sugar and salt in a pan with 250ml (1 cup) water. Warm over a low heat, stirring until the sugar has completely dissolved. Turn the heat to medium–high and let the syrup bubble without stirring for about 15 minutes.

Meanwhile, in a stand mixer whisk the egg whites to stiff peaks. Turn off until the syrup is ready.

When the sugar syrup reaches 252°F (firm ball stage), set the mixer to low and start adding the hot sugar syrup in a slow trickle. As soon as all the syrup has been added, turn up the speed to high. Squeeze the gelatin leaves dry and add them to the whisking mixture. Beat for 10 minutes at high speed. The mixture should be thick and glossy. Finally, add the vanilla and nutmeg.

Scrape into the tin and level the surface. Dust the top with a little more of the confectioners' sugar mixture. Leave to set at cool room temperature for about 5 hours or overnight.

Slide a knife around the edge of the marshmallow and turn it out onto a board. Use an oiled knife to cut into fat squares. Toss with the rest of the confectioners' sugar mixture. If you want to up the nutmeg flavor, grate a little over the finished marshmallows. They keep well in an airtight tin.

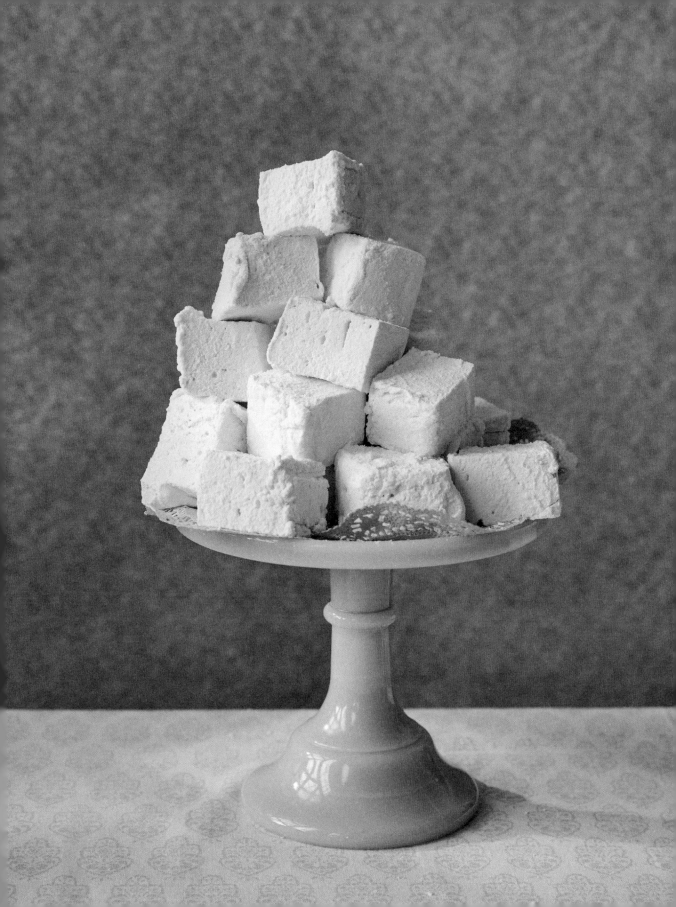

Chestnut & vanilla affogato

Vanilla and chestnut belong together, the floral complexity beautiful with the fudgy nuts. Here is a 5-minute, no-churn ice cream made using the sweetened chestnut purée available in tins or tubes, often sold as chestnut cream. It is then drowned, Italian style, with a shot of espresso so the bitter heat melts and swirls into cold, sweet cream.

Serves 4

125g (½ cup) sweetened chestnut purée
1 teaspoon vanilla paste
1 tablespoon light muscovado or light soft brown sugar

1 scant tablespoon amaretto, rum, or brandy
150ml (generous ½ cup) heavy cream
4 shots of hot espresso coffee

SPICE SWITCH

Cardamom coffee affogato: use vanilla gelato and spill over a shot of strong coffee brewed with green cardamom.

A day in advance, make the chestnut ice cream. Mix the sweetened chestnut purée with vanilla, brown sugar and your chosen spirit (which both adds flavor and gives a scoopable consistency).

Whip the cream to soft peaks. Use a spatula to fold in the chestnut mixture then pack into a freezer tub. Freeze overnight.

Spoon large scoops of chestnut ice cream into four glasses and return to the freezer to chill the glasses well. Serve with shots of hot espresso alongside for diners to pour over at the table.

Oeufs à la neige

As a teenager my father took me to the French Loire Valley and a meal sticks in my mind to this day, or more specifically, a dessert. Oeufs à la neige captured me first with its charming name, meaning "snow eggs" (though it often goes by îles flottantes, "floating islands"). Then, one taste and I was mesmerized.

It is all about the celestial textures: silky custard, pillowy poached meringue, and a crunch of caramelized sugar, which in my version comes in the form of sugared almonds. The flavors are so gentle that they allow the vanilla to shine. It is worth using a real pod here rather than extract.

Serves 4

250ml (1 cup) whole milk
150ml (generous ½ cup) light cream
1 vanilla pod, split
4 eggs, at room temperature, separated

140g (5oz) castor sugar
¼ teaspoon cream of tartar
Pinch of fine sea salt
Pink sugared almonds, to serve

SPICE SWITCH

Flavor the custard with pandan extract to lend a sweet, aromatic grassiness, or with green cardamom to make it sing.

To make the crème anglaise, put the milk and cream in a small pan. Scrape in the vanilla seeds and add the pod. Bring to a simmer, remove from the heat to infuse for 10 minutes, then bring back to a simmer. Remove the vanilla pod (rinse and save for another use).

Meanwhile, use a hand whisk to beat the 4 egg yolks with 50g (1¾oz) of the sugar until pale. Slowly pour in half the hot milk, whisking continuously to combine—no need to froth. Pour back into the milk pan. Cook over a low heat, stirring constantly. It is ready when it coats the back of the spoon well and you can draw a clear path through with your finger. Cool, closely cover with plastic wrap, and chill until needed.

Use an electric whisk to make the snow eggs. Whip the egg whites with the cream of tartar and a pinch of salt until foamy, then add the remaining sugar, a spoonful at a time. Whisk at high speed until the mixture is very stiff and glossy, and a pinch between the fingers feels smooth.

Bring a shallow pan of water to a boil and lay out a wad of paper towels. Use two tablespoons dipped in water to shape the meringue into quenelles, aiming for either two or three per person. Drop into the simmering water in batches, poaching for 2 minutes on each side. Remove with a slotted spoon and drain on the paper towels. Repeat to cook them all. Stack and chill until needed.

Serve in shallow bowls with a cool pool of crème anglaise and the snow eggs floating on top. Crush the sugared almonds to a pretty pink rubble and scatter over at the last moment.

Tonka honey mousse

The closest spice to vanilla, not by botany but by flavor, is tonka bean. These wrinkled dark seeds of South America's cumaru trees hold a host of heady fragrances, making them a favorite of French pâtissiers—you might pick up notes of cherry, clove, cinnamon, tobacco, vanilla, and marzipan. With such complexity, other flavors are best left simple, as in this light-as-a-whisper honey mousse.

Tonka beans have been illegal in the US since the 1950s as they can be toxic when eaten in (vast) quantity. Governments have a habit of getting scared by the potency of spice—nutmeg is similarly banned in Saudi Arabia. Undaunted, America is apparently the world's biggest importer of tonka, so it seems prohibition has only heightened the allure.

Serves 6

2 sheets platinum-grade gelatin (optional)
3 tablespoons good floral honey
¼ teaspoon fine sea salt

1 tonka bean, finely grated
3 large egg whites (120g/4¼oz), at room temperature
300ml (1¼ cups) heavy cream

SPICE SWITCH

Use the scraped seeds from a vanilla pod.

Soak the gelatin leaves in cold water for 5 minutes to soften. (You can omit the gelatin if you like, but it makes for a more stable mousse.)

Put the honey in a small pan with the salt and grate in the tonka with a fine grater, as you would a nutmeg. Heat gently to melt and warm the honey, then remove from the heat. Squeeze the gelatin dry and stir to melt into the warm honey. Set aside.

In a large bowl, whisk the egg whites to form stiff peaks.

In a second bowl, whisk the cream to soft peaks. Fold the spiced honey through the cream (if it has started to set, rewarm briefly to melt), then fold in the egg whites. Transfer to a serving bowl or individual glasses and chill for at least an hour to set.

The mousse is good with raspberries.

FLIRTING WITH

FLORALS

Saffron macaroons

One biting November weekend I visited a Stockholm Christmas market, which was impossibly quaint and cloaked in snow. Amid the marzipan pigs balancing red apples on their snouts and gingerbread hearts strung from the beams was a wealth of alluring saffron bakes. Wreaths of glazed golden bread nestled between scrolled saffron buns hailstoned with rock sugar. Saffron also found its way into white chocolate truffles, bottles of schnapps stained the yellow of Chinese silk and wedges of sticky cake. For me it had to be the macaroons, one quickly eaten in gloved fingers, another taken away to savor. Their crackled meringue-like surface hid a squidgy, fragrant, marzipanny center. Here is my recreation of that moment, snow of powdered sugar included.

Makes about 20 macaroons

Large pinch of saffron threads
2 large egg whites (80g/2¾oz), at room temperature
240g (2 cups) confectioners' sugar, sifted

240g (8½oz) ground almonds
2 teaspoons almond extract
¼ teaspoon baking powder
Pinch of fine sea salt

SPICE SWITCH

The pairing of bittersweet almond and saffron is hard to compete with, but you could also try them with ground fennel seeds, rose water, or orange blossom water.

Crumble or grind the saffron and add 1 tablespoon hot water. Set aside to infuse to a deep yellow.

Whisk the egg whites to form stiff peaks.

Sift the confectioners' sugar and set aside 30g (¼ cup) in a shallow bowl. In a large bowl, mix together the ground almonds, saffron liquid, and almond extract. Add the remaining confectioners' sugar, baking powder, and salt. Stir through the egg whites. Don't worry about knocking out the air—the end dough should be dense and sticky.

Line a baking sheet with parchment paper. Use two spoons to help you shape walnut-sized pieces of dough into balls, then roll in the reserved

confectioners' sugar, coating them generously like snowballs. Space out well on the baking sheet and flatten the balls slightly. Leave at room temperature for an hour or so to dry and form a slight shell.

When ready to cook, heat the oven to 325°F.

Gently squeeze the macaroons at the sides to crack the surfaces. Bake for 20 minutes then leave to cool completely on the tray. They will keep in an airtight tin for around a week, their squidgy centers perhaps even better the day after making.

Lavender & raspberry crème brûlée

Lavender in crème brûlée is a classic addition, conjuring summer in Provence. A light hand is best, as you want a waft of evocative herby-floral scent, not soapy intensity. Raspberries shelter beneath the blanket of custard and the crackling sugar shell, offering bursts of sharpness and contrast.

Serves 4

500ml (2 cups) heavy cream
2–3 teaspoons fresh lavender flowers (or 1 teaspoon dried)
20 raspberries
5 egg yolks
50g (1¾oz) castor sugar

SPICE SWITCH

Floral flavors are lovely here. Infuse the cream with ground saffron or rose geranium leaves. Or skip the infusion and flavor with flower waters or classic vanilla extract to taste.

Put the cream and lavender flowers in a small pan and heat slowly up to a simmer then set aside to infuse for half an hour. Strain and return to the pan.

Sit four small heatproof ramekins in a baking tin and put five raspberries in each. Heat the oven to 315°F.

In a bowl, stir together the egg yolks and 25g (1oz) of the sugar. Heat the cream again until a ring of tiny bubbles forms around the edge. Slowly trickle the hot cream into the yolks, stirring constantly.

Divide the mixture into the ramekins then poke down the raspberries to drown them. Fill the baking tin with tap-hot water, to about two-thirds of the way up the ramekins. Bake for 25 minutes, or until the custard is set with a delicate quiver. Cool then chill in the fridge.

Just before serving, sprinkle the remaining sugar over the tops of the four creams and use a blowtorch or hot broiler to melt and caramelize the tops.

SAFFRON

Let me take you to a field, which for 1 or 2 weeks a year is carpeted lilac in the soft light of dawn. We could be in Kashmir, Iran, Morocco or Spain, somewhere with a temperate climate. Underfoot are rows of leafless purple crocuses, their stigmas a fiery blaze of red. When dried these become saffron, the most expensive spice of all. There isn't much time for the harvest, as the heat of the rising sun will soon wilt the flowers, so farmers must work quickly, plucking each fragile strand by hand.

This labor-intensive process accounts for saffron's startling price, at times higher than its weight in gold. It takes 160,000 crocuses and a whole week's work to yield just 1kg (2lb 4oz). Yet the haunting, enigmatic flavor holds such allure we are still willing to pay it, a reminder of the time when all spices were so rare and valued.

Saffron was first cultivated in Asia Minor and it colors 50,000-year-old cave paintings in what is now Iraq. The spice became widely grown across Europe and into China. Can it really be that monkeys were trained to gather the stigmas as suggested in a Cretan wall painting?

All ancient civilizations in the Eastern Mediterranean used saffron: as a dye, a food, a drug, and a perfume, burned in sacrifice and prized as an aphrodisiac.

It stands as a symbol of the sublime in the writings of Ovid, Homer, Virgil and the Bible. Zeus slept on a bed of saffron and Eos, "the saffron mother," linked the spice with desire, love and female empowerment. Away from the realm of the gods, Cleopatra was another strong woman who bathed in saffron-stained milk before taking her lovers.

Romans were particularly enraptured by the golden threads, using them widely for their aroma. They would mix saffron with sweet wine and spritz it into theaters to fill the air with heady fragrance. When the empire fell, so did the European taste for spice. The Moors, who left a great culinary legacy in their wake, reintroduced saffron in the eighth century.

Medieval wedding dresses were stained yellow and the bride would wear a locket of saffron around her neck as a talisman for a blissful marriage. The link to happiness meant that when someone was in a sunny mood, it was said they must have slept in a saffron bag. Saffron bouquets on Renaissance wedding tables harked back to those at Roman banquets, and today it is streaked on the groom's forehead at Indian weddings.

Let's turn to the kitchen where

saffron adds a taste quite unlike anything else. It is honeyed and strongly aromatic with earthy, floral notes, rather like sun-warmed hay.

As a rule of thumb, look for dense threads with a deep reddish color and flaring ends. Inferior crops can look frayed and anything too yellow is likely to be fake—be guided by the smell.

One of the few water-soluble spices, the best way to spread saffron's precious flavor through a dish is by soaking the strands in a little warm water or milk for 15 minutes or more. Make sure they are dry, then crumble to a powder or crush with a little sugar before adding the liquid. The flavor is surprisingly penetrating—use too much and bitterness takes over—rather lucky given the cost. Two strands per person is a good guide.

Saffron features often in South Asian desserts, tinting the milk for ras malai; flavoring laddus (fried balls oozing sweet nectar); and paired with

nutmeg and cardamom in shrikhand. It also is a star of Iranian sweets, such as the rice pudding sholeh zard and the addictive brittle sohan. For Ramadan in Morocco, try fragrant flower-shaped fritters called chebbakia. Move to Western Europe and enjoy saffron-poached pears, Cornish saffron bread, French baba (now more often soaked in rum, but once made with saffron), and a wealth of golden-hued bakes from Sweden.

Drinks too are a wonderful showcase. Make Arabic-style coffee by infusing coffee with cardamom and saffron, or Kashmiri chai by steeping green tea with cardamom, cinnamon, saffron, honey, and blanched almonds. Or simply take a bottle of vodka, add a few red strands, forget about it for a week, then remember with joy.

Saffron & orange blossom ice cream

Spice ice creams are wonderful accompaniments to fruity desserts, bringing a cool-warm paradox and a note of complexity sometimes hard to put your finger on. This saffron ice cream is utterly mesmerizing in both color and flavor.

For something different, see the spice switches below. Coriander seeds were common in ice creams before vanilla became "the thing" and the two together work well. The combination of bay and peppercorn is exceptionally fragrant—try it with poached plums.

Makes 8 scoops

Scant ¼ teaspoon saffron threads
240ml (1 cup) heavy cream
120ml (½ cup) whole milk
70g (2½oz) castor sugar
Pinch of fine sea salt
3 egg yolks
½–1½ teaspoons orange blossom water

SPICE SWITCH

Coriander seed and vanilla ice cream: infuse with 1 tablespoon toasted and coarsely cracked coriander seeds and ½ scraped vanilla pod (save the seeds). Strain as it goes back into the pan and stir in the vanilla seeds at this point.

Bay and peppercorn: infuse with 5 scrunched bay leaves and 1 tablespoon coarsely ground black peppercorns. Strain as it goes back into the pan.

Crush the saffron to a powder and add to a pan with the cream, milk, sugar, and salt. Gently heat to simmering, taking care not to scorch, then leave to infuse at room temperature for about an hour.

Whisk the egg yolks in a medium bowl. Reheat the yellow cream then slowly pour into the egg yolks, whisking as you go.

Return to the pan and set over a low–medium heat. Stir with a silicone spatula, scraping well until the mixture thickens to a thin, smooth custard—if you run a clean finger along the spatula, it should leave a distinct line.

Leave to cool then stir in the orange blossom water (add to taste as they vary in strength; but remember that freezing will mute its taste). Cover with plastic wrap pressed down to the surface to prevent a skin forming then chill in the fridge until really cold. Churn in an ice cream machine following its instructions. Eat straight away or freeze until needed for up to 3 months.

Violet cream chocolate pots

A fragrant, intoxicating obsession with violets overcame Victorian Britain, mirroring the tulip mania of the Dutch Golden Age. Prices soared and the delicate flowers with their ephemeral, powdery scent were used in hatbands, buttonholes, sweets, and perfumes. Widely read floriographies assigned flowers with secret meanings: white violets for innocence, purple for all-consuming love.

Everyone who knows me knows the way to my heart is with a box of rose and violet creams. Unfathomably, many claim to dislike these classic English confections—floral almost to the point of soapiness—but for us lovers, the Victorian fascination holds. My first job was working at the chocolate counter at London's Fortnum & Mason department store. Here one day, a visibly flustered customer presented me with a diamond ring and asked me to bury it in the depths of our largest box of flower creams for a later proposal. Ah, the romance!

I've taken inspiration from these floral confections for dark chocolate pots with an amaretti biscuit hidden within for a hint of sweetness.

Serves 4

150g (5½oz) best dark
 chocolate, 70%
4 eggs, at room
 temperature,
 separated
10–20 drops of violet
 essence
¼ teaspoon fine sea salt
4 crunchy amaretti
 biscuits
Crystallized violets,
 to decorate

SPICE SWITCH

For a touch of the Turkish delight, use rose essence. Or I've also made delightful chocolate pots using geranium or lavender extracts. If floral isn't your thing, omit the amaretti biscuit and go dark and spicy instead: cardamom and orange zest, chili powder and lime zest, or nutmeg and cinnamon.

Melt the chocolate in a medium heatproof bowl set over a pan of just simmering water. Leave to cool.

When the chocolate is not much warmer than body temperature (100°F or you can comfortably dip a finger in), stir in the egg yolks one at a time (if it seizes, rescue by adding 1 teaspoon of boiling water at a time until the smooth consistency returns). Stir in the violet essence and salt. Taste to make sure the intensity of both is right, remembering they will be muted by the egg white.

With an electric whisk and clean bowl, whip the egg whites to soft peaks. With a spatula, stir about a third of the egg white into the chocolate to lighten the mixture then fold through the rest.

Fill four coffee cups or little ramekins with the mixture and push an amaretti into each until it slips beneath the surface. Put in the fridge for a few hours to set. Top with the crystallized violets before serving.

Santiago almond torte

From the Spanish city of Santiago in Galicia, this delicate almond cake was first documented in the sixteenth century and a Moorish influence on the flavors is clear. It is superbly quick and easy to make, and for years has been my fallback for last-minute dinner parties. Spicing is just to enhance the almonds, not to lend a strong character of its own. It is good served with fresh fruit and clotted cream, or cream whipped with a little orange blossom and cinnamon to echo the flavors.

Serves 6

Oil, for greasing
4 eggs
200g (7oz) castor sugar
1–2 teaspoons orange blossom water
½ teaspoon ground cinnamon
¼ teaspoon almond extract
¼ teaspoon fine sea salt
200g (2 cups) ground almonds
Confectioners' sugar, for dusting

SPICE SWITCH

Omit the cinnamon and flavor with finely grated lemon and orange zest.

Heat the oven to 350°F. Brush a 7½–8 inch loose-bottomed tart tin with a little oil.

Beat together the eggs and sugar until the sugar has dissolved and the mixture is gently foamy. Add the orange blossom water, cinnamon, almond extract, and salt. Finally, mix through the ground almonds.

Scrape into the tart tin. Bake for 25 minutes, or until the torte is golden and springy to the touch. Leave to sit for 10 minutes before easing it out of the tin. Serve dusted with confectioners' sugar.

Palm sugar & coconut pandan pancakes

Indonesian sweets often come in a pretty palette of jade, white, and shocking pinks. There are whisper-light steamed sponges, sugared doughnuts, and chewy, gooey sweetmeats made from glutinous rice or tapioca. My enduring favorite are these treacly coconut-stuffed pancakes.

Two delightfully delicate yet complex flavors are at play. The first is pandan leaf, which has a distinctive bosky-floral aroma and stains the crepes green. (If you can't get the fresh leaves, pandan paste or extract can be used.) Dark palm sugar lends the second, bringing much more than just sweetness with its smoky, almost savory notes that offset the fresh coconut beautifully.

Makes 12 pancakes

10 pandan leaves
150g (1 cup) plain flour
2 eggs
2 tablespoons neutral oil

For the coconut filling
150g (5½oz) dark palm sugar, shaved
150g (5½oz) fresh grated coconut or 120g (1⅓ cups) desiccated coconut
2 pandan leaves, bruised and tied in a knot
Pinch of salt

SPICE SWITCH

Add 1 teaspoon ground cinnamon to the filling along with the coconut. This can be instead of or in addition to the pandan.

First make the filling by heating the sugar in 200ml (generous ¾ cup) water. Bring to a boil, then reduce the heat and simmer, uncovered, for about 10 minutes until syrupy. Add the coconut (if using desiccated, add a good splash of water with it), pandan leaves, and a pinch of salt. Cook, stirring, until the mixture is dry and sticky. Leave to cool.

For the pancakes, whiz the pandan leaves and 500ml (2 cups) water in a blender to a vibrant green. Strain the liquid through a fine sieve.

Put the flour in a mixing bowl, break in the eggs, and slowly whisk in the green water to make a thin, smooth batter. Leave to rest for 15 minutes.

Lightly grease a 6-inch frying pan and heat over a medium heat. Ladle in some batter, swirl around the pan, and cook until it sets and curls at the edges. Flip and cook for about 20 seconds on the other side. Slide onto a plate and repeat with the remaining batter.

Fill the pancakes, turn over the edges, then roll them up like spring rolls.

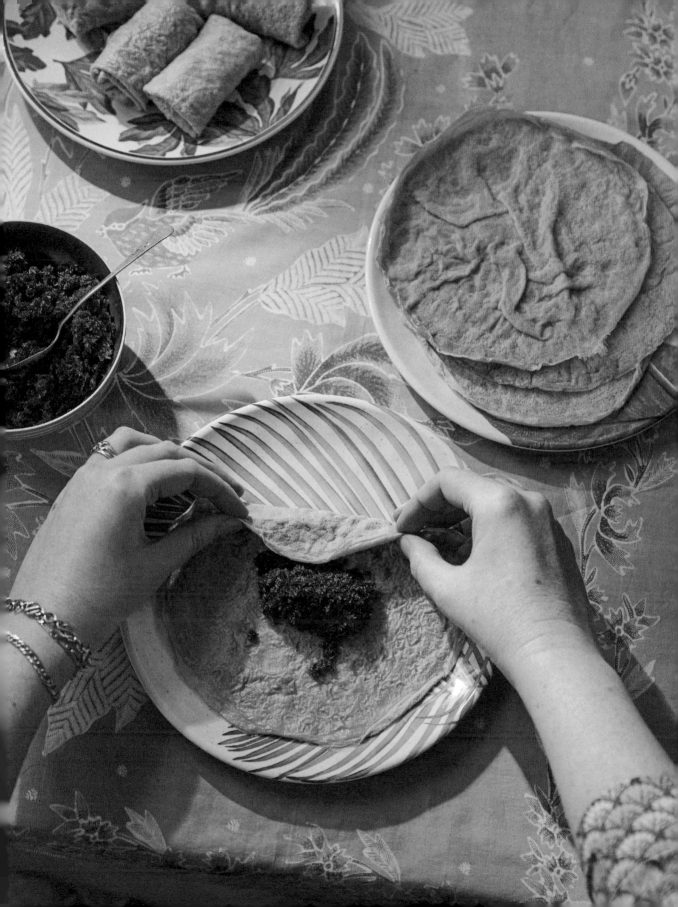

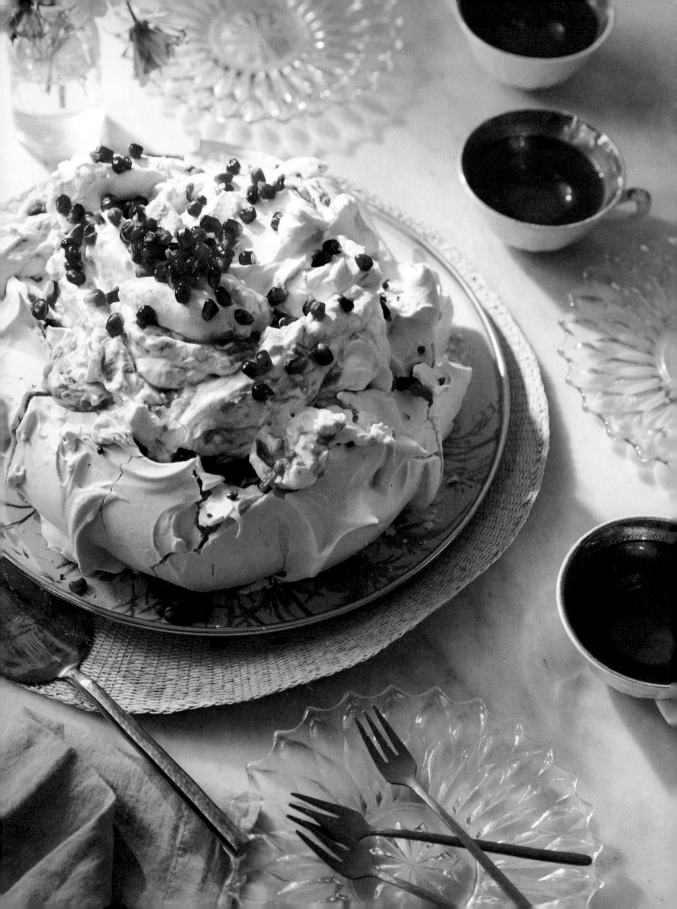

Rose & rhubarb fool pavlova

My love for pavlova knows no bounds. It's the sweet treat my mind wanders to every time I plan dinner for friends. It must be something about the playfulness, the way you can be endlessly creative, and, of course, the marshmallowy soft center under its thin, brittle walls of meringue.

Here I have brought together a bevvy of pinks: puckery rhubarb, musky rose, piney pink peppercorns, and glassy beads of pomegranate. The result is kaleidoscopic layers of sweet, tart, and fragrant.

Serves 8

For the meringue
6 large egg whites (240g/8½oz), at room temperature
375g (13oz) castor sugar
2½ teaspoons corn starch
2 teaspoons white wine vinegar
½ teaspoon rose water
¾ teaspoon pink peppercorns, ground

For the rhubarb fool
350g (12oz) rhubarb, roughly chopped
3 tablespoons castor sugar
½–1 teaspoon rose water
225ml (scant 1 cup) heavy cream

75ml (⅓ cup) Greek-style yogurt
Pomegranate seeds, to serve

SPICE SWITCH

Add 1 heaping teaspoon ground cinnamon to the meringue and top with whipped cream and dark autumn berries.

Draw a roughly 9-inch circle on a piece of parchment paper (I draw around a cake tin) and put it pencil-side down on a baking sheet. Heat the oven to 350°F.

In a stand mixer or with an electric whisk on medium speed, beat the egg whites until they become white and foamy. Add the sugar patiently, a spoonful at a time, whisking all the while. Turn up the speed and whisk for 5–10 minutes until the mass is glossy and thick. If you rub a little between your fingertips, it should feel smooth. At low speed, briefly whisk in the corn starch, vinegar, rose water, and pink peppercorns.

Tip the meringue onto the baking sheet, mounding it high and swirling it into the shape of a cake using the circle as a guide. Smooth the edges using a small offset spatula then drag the sides from bottom to top to create deep grooves all around the edge.

Put into the oven and immediately lower the temperature to 300°F. Bake for 1 hour 15 minutes. Leaving the meringue in the oven, turn off the heat and let it cool slowly without opening the door. The longer you leave it, even overnight if you have time and patience, the less it will crack—though a few cracks are normal and will soon be buried in cream anyway.

For the rhubarb fool, shake together the rhubarb, sugar, and rose water in a pan. Set over a medium heat and cook, uncovered, for 15 minutes or so—the juice will seep out then start to reduce as the stems tenderize and collapse into a compote. Leave to cool.

Whip the cream to soft peaks then gently fold through the yogurt. Ripple in the stewed rhubarb and chill in the fridge until ready to serve.

At the last moment, spoon the rhubarb fool into the center of the meringue and top with a hot-pink scattering of pomegranate seeds.

Sri Lankan love cake

Cashew nuts, semolina, rose water, and spices combine to make a cake that is sweet, fragrant, and fudgy like no other. This recipe is inspired by, but is not quite, a traditional Sri Lankan love cake. I have omitted the preserved pumpkin and simplified the method so it isn't a labor of love, but still utterly lovely to eat.

Serves 8 or more

75g (2½oz) cashew nuts
115g (4oz) fine semolina
10 green cardamom
 pods, seeds ground
1 teaspoon ground
 cinnamon
¼ teaspoon ground
 clove
¼ teaspoon grated
 nutmeg
¼ teaspoon fine sea salt

4 eggs, at room
 temperature
Finely grated zest
 of a lime
90g (⅓ cup) unsalted
 butter, at room
 temperature
225g (8oz) castor sugar
2½ tablespoons honey
½–1 tablespoon rose
 water

SPICE SWITCH

Speed up the spicing by using 1 tablespoon mixed spice. This will lend a different character to the cake but offer a similar sweet warmth.

Use a food processor to grind the cashew nuts to a gritty sand. Toast the semolina in a dry frying pan over a medium heat, stirring occasionally, until it takes on a slight tinge of nutty brown. Meanwhile, measure the spices and salt into a bowl with the ground nuts. Mix in the toasted semolina.

Line the base and sides of an 8-inch square tin with parchment paper. Heat the oven to 325°F.

With an electric whisk at high speed, beat the eggs with the lime zest for a few minutes until pale and moussy. In a second large bowl, cream together the butter and sugar. Beat in the honey and rose water, then the whipped eggs. Finally, fold through the spiced nutty mixture.

Pour the thin and fragrant batter into the cake tin. Bake for 35–45 minutes, until the top is browned and springy to the touch.

Leave to cool in the tin before cutting into small pieces. Serve with a pot of Ceylon tea to people you love.

CREAM ♡ SPICE

Most sweets can be enhanced by the voluptuous richness of dairy, and what quicker way to add a little magic than flavoring the cream?

Cold cream whips the lightest, so either chill the bowl or hold a bag of frozen peas around the edge as you beat. Combine with sugar and spices first, adjusting the sweetener to taste and thinking about what you will be serving it with. Start whisking at a low speed, increase to higher, and stop as soft peaks form. You can do this at the last minute, or up to 24 hours in advance and chill in the fridge. To serve up to 8 people as an accompaniment, 250ml (1 cup) of cream should suffice.

Rose & cardamom cream

Whisk 200ml (generous ¾ cup) **heavy cream** with 50ml (scant ¼ cup) **crème fraîche,** 1 tablespoon **granulated sugar**, 1 teaspoon **rose water** (or to taste), and the ground seeds of 4 **green cardamom pods.**

Match with: roasted rhubarb or stone fruits

Vanilla Chantilly

Scrape the seeds of ½ a **vanilla pod** into 250ml (1 cup) **heavy cream**. Add 1–2 tablespoons **sugar** and ½ teaspoon **vanilla extract** then whip.

Match with: sponge cakes or chocolate ice cream

Cassis & cinnamon cream

Whisk 250ml (1 cup) **heavy cream** with 3 tablespoons **crème de cassis**, ½ teaspoon **ground cinnamon,** and 1 heaping tablespoon **brown sugar.**

Match with: red or purple fruits

Saffron shrikhand

Soak a pinch of **saffron** in 1 tablespoon warm **milk**. Stir into 250g (1 cup) thick **Greek-style yogurt** with 2½ tablespoons confectioners' **sugar,** and the ground seeds of 2 **green cardamom pods.**

Match with: spiced cakes or fresh mango

Sweet ricotta

In a food processor, combine 250g (9oz) **ricotta,** ¼ teaspoon **ground fennel seed**, finely grated zest of ½ **lemon,** and 1 tablespoon **honey** until smooth and creamy.

Match with: pancakes and strawberries

Ginger & lime soured cream

Mix 250ml (1 cup) **sour cream** with the zest and juice of a **lime**, 2 teaspoons **ginger juice** (see page 110), and 1 heaping tablespoon **confectioners' sugar**. For a thicker cream, make the cream in advance and chill.

Match with: tropical fruits or melon

Orange blossom & Cointreau mascarpone

Whip 150g (5½oz) **mascarpone** and 100ml (scant ½ cup) **heavy cream** with 2 tablespoons **honey**, 1 tablespoon **Cointreau**, 1 teaspoon **orange blossom water,** and a flourish of finely grated **orange** zest.

Match with: almondy cakes or tarts

Tonka & white chocolate ganache

Gently melt 50g (1¾oz) **white chocolate** into 250ml (1 cup) **heavy cream**. Grate in ½ **tonka bean**, leave to cool then chill. Whisk the ganache until light and fluffy.

Match with: sponge cakes

Maple & nutmeg cream

Whisk together 250ml (1 cup) **heavy cream**, 3 tablespoons **maple syrup**, ½ teaspoon grated **nutmeg**, and a pinch of fine **salt**.

Match with: fruit pies or crumble

Wattleseed whip

Soak 1 teaspoon **ground wattleseed** in 1 tablespoon hot water. Whip into 250ml (1 cup) **heavy cream** with 1 teaspoon **confectioners' sugar**.

Match with: coffee or hazelnut desserts

Elderflower yogurt

Sweeten 250g (1 cup) thick **Greek-style yogurt** with 2 tablespoons **confectioners' sugar** and 3 tablespoons concentrated **elderflower cordial**. Add a brightening squeeze of **lemon juice**.

Match with: summer berries or rhubarb sweets

Vanilla honey butter

Whisk 50g (1¾oz) **salted butter** until light and fluffy. Add 50g (1¾oz) **honey** and 1 teaspoon **vanilla extract** and keep whisking until really airy.

Match with: fluffy pancakes

Cardamom coffee cream

Whip 250ml (1 cup) **heavy cream** with 2 teaspoons **espresso powder**, the ground seeds of 4 **green cardamom pods,** and 1 heaping tablespoon **sugar**.

Match with: chocolate desserts

Muscovado & long pepper cream

Whip 250ml (1 cup) **whipping cream** with 3 tablespoons **light muscovado sugar**, 3 **ground long peppers,** and the seeds scraped from a **vanilla pod**.

Match with: cherries or nectarines

Brown sugar & allspice crème fraîche

Stir together 250ml (1 cup) **crème fraîche**, 1½ tablespoons **light muscovado sugar**, 1½ tablespoons **brandy**, ½ teaspoon **vanilla extract**, and ¼ teaspoon **ground allspice**. Sprinkle with extra **muscovado** before serving.

Match with: Christmas dessert or big meringues

Cocoa amaretti cream

Mix 1 tablespoon **unsweetened cocoa powder**, 1 tablespoon **granulated sugar,** and 1 tablespoon **amaretto liqueur** to make a paste. Whisk with 250ml (1 cup) **heavy cream** to soft peaks then fold through a crumbled handful of **amaretti biscuits**. Save a few crumbs to dust over the top.

Match with: dark chocolate tarts or mousses

Brown butter & cherry oat squares

Two flavor boosters are at work in these crumbly based, gooey-topped bars. Firstly mahleb, the kernel found inside the pit of the mahaleb cherry. It is a spice much used in enriched Greek breads and Middle-Eastern bakes for its bewitching, fruity-floral, slightly almondy aroma. Rather inevitably, it is wonderful with cherries.

Butter is the second. Taking it beyond melting point until its milk solids gently toast gives a caramel nuttiness that is transformative. A tip if, like me, browned butter is your baking vice: up the ante by adding a little dried milk powder to scale up those precious brown flecks.

Makes 9 squares

For the cookie base
½ teaspoon mahleb kernels, finely ground
115g (4oz) plain flour
30g (1oz) granulated sugar
¼ teaspoon fine sea salt
100g (3½oz) cold unsalted butter, diced

For the oaty top
60g (¼ cup) unsalted butter
½ teaspoon dried milk powder (optional)
70g (⅓ cup) dark muscovado or soft dark brown sugar
50g (1¾oz) granulated sugar

Pinch of fine sea salt
1 teaspoon vanilla extract
100g (3½oz) rolled oats
80g (2¾oz) dried sour cherries, whole
2 eggs

SPICE SWITCH

Spice the base with 1 teaspoon vanilla extract or a grated tonka bean.

Line an 8-inch square tin with an overhanging layer of parchment paper. Heat the oven to 350°F.

Finely grind the mahleb and set aside for a couple of minutes to help the bitter flavors dissipate. (If you are using ready-ground mahleb, increase the quantity by about half, as the flavor will be muted.) Put the mahleb, flour, sugar, and salt in a food processor. Add the cold butter cubes and blend until the mixture comes together into clumps of dough. Press these into the baking tin to form an even base. Bake for 15–20 minutes to a pale golden biscuit.

Meanwhile, make the oat top. Put the butter and milk powder (if using) in a medium pan over a medium heat. Cook, stirring often, as first the butter melts then fizzles until the milk solids turn a delicious golden brown under the foamy top. Remove from the heat and stir in the sugars and salt. Leave to cool for 5 minutes or so before mixing in the remaining ingredients.

Spread the oaty mixture over the cooked base and return to the oven for 15–20 minutes. The top should be firmly set and golden.

Leave to cool completely in the pan for a few hours before cutting into squares.

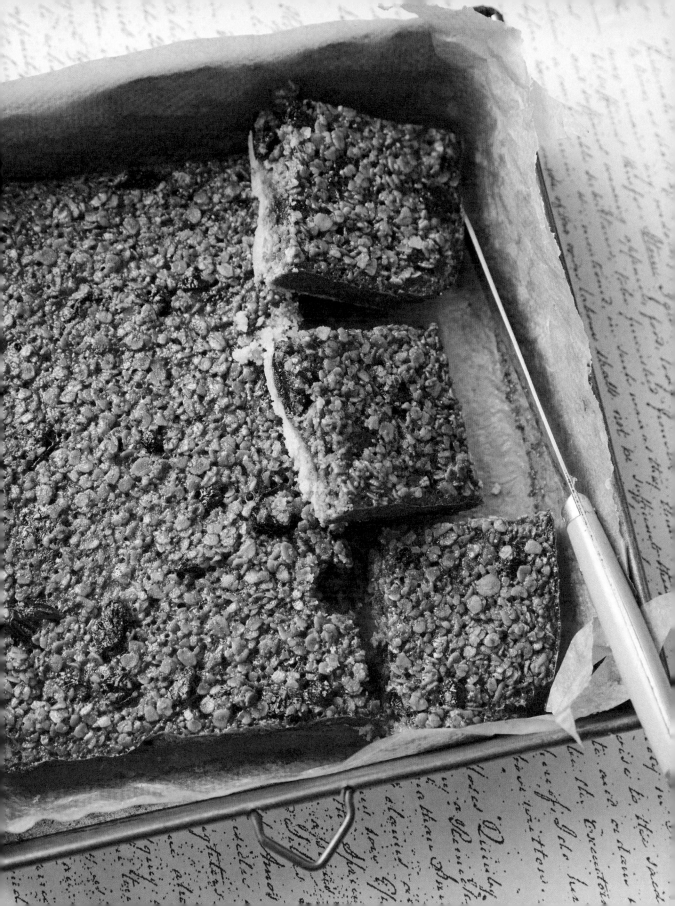

Roast strawberry soufflés

These are the easiest, most forgiving soufflés as you can make them in advance and keep in the fridge for a few hours before baking. Cook last minute and they will whoosh up pleasingly to airy lightness. A hint of Turkish delight floridness along with a quick oven-roasting brings out the flavor of even underwhelming, early-season strawberries.

Eat with a cool drizzle of cream or make a hole in the top of each soufflé at the table and slip in a spoonful of berry sorbet.

Serves 4

500g (1lb 2oz)
 strawberries, hulled
1 lemon
80g (⅔ cup)
 confectioners' sugar
½–1 teaspoon rose
 water
½–1 teaspoon orange
 blossom water
5 egg whites (175g/6oz),
 at room temperature
Butter, for greasing

SPICE SWITCH

Roast the strawberries with a teaspoon of sumac and a good grinding of black pepper. Omit the flower waters.

Heat the oven to 400°F.

Line a baking tray with parchment paper and lay out the strawberries, cutting any big ones in half. Using a peeler, pare off strips of lemon zest and lay on top. Roast for 15 minutes so the strawberries intensify in color and start oozing lipstick-red juices.

Press them through a sieve to make a juicy purée, discarding the pulp and lemon zest. Stir in 2 tablespoons lemon juice along with the confectioners' sugar, rose, and orange blossom waters. Taste—flower waters vary hugely in strength, so adjust accordingly. We are after ethereal, not incense. Leave to cool.

Whisk the egg whites until stiff. Use a spatula to gently fold through the strawberry mixture.

Butter four large heatproof ramekins and spoon in the mixture, piling them high with bulky pinkness. Chill in the fridge until needed, but not more than a few hours.

Heat the oven to 350°F.

Cook the soufflés for 12–14 minutes—don't open the oven door early—until crowned pale brown. Serve at once with cream.

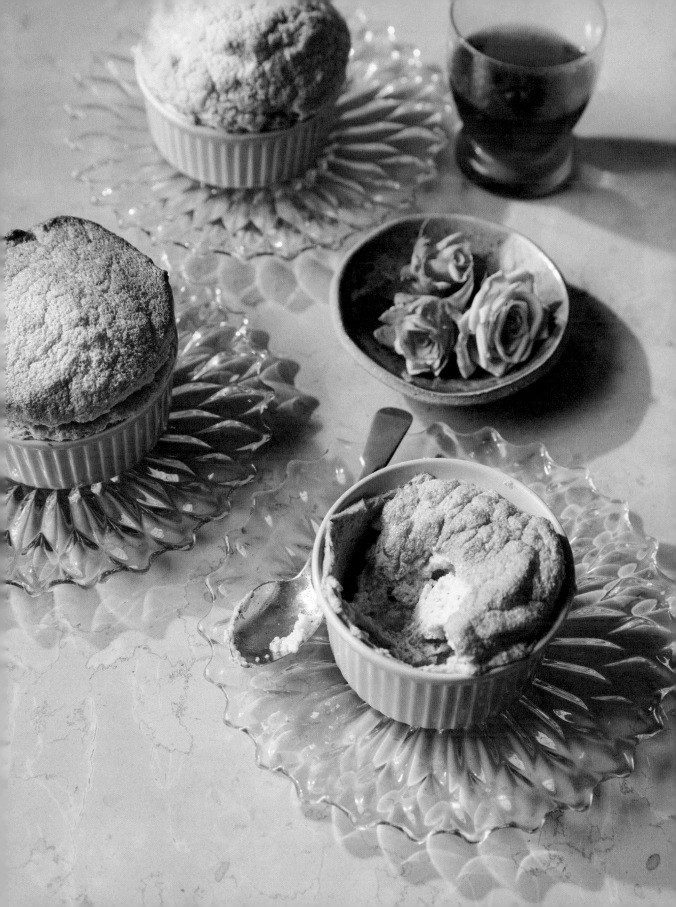

NUTTY, EARTHY, SMOKY

Turmeric & tahini diamonds

Even before you bake the cake, the batter has a bittersweet fragrance redolent of the Middle East as well as a glorious gamboge yellow color. Both are intensified in the oven heat.

An interesting quirk of this Lebanese home kitchen favorite is that the tahini is used to grease the tin rather than combined into the sponge. Beyond that, it is the easiest one-bowl recipe imaginable. Its name, "sfouf," means "lines" signaling the cuts made to form it into diamonds or squares.

To turn the cake into a dessert, serve with poached fruit and a spoonful of thick Greek-style yogurt topped with honey and sesame seeds.

Serves 10–12

2 tablespoons tahini
170g (6oz) fine semolina
125g (4½oz) plain flour
225g (8oz) castor sugar
1 tablespoon ground
turmeric
1½ teaspoons baking
powder
¼ teaspoon fine sea salt

240ml (1 cup) whole
milk
120ml (½ cup) mild
olive oil or other
neutral oil
1 teaspoon orange
blossom water
2 tablespoons pine nuts
and/or sesame seeds

SPICE SWITCH

Keep the turmeric, which is essential to the character of the cake, but you can alter the sweetly scented accent by switching the orange blossom for rose water or ground aniseed.

Heat the oven to 375°F. Brush the tahini thickly over the base, sides, and corners of an 8-inch square cake tin.

In a large mixing bowl, combine the semolina, flour, sugar, turmeric, baking powder, and salt. Stir in the milk, olive oil, and orange blossom water to make a loose, yellow batter. Pour into the tin and scatter the top with pine nuts and/or sesame seeds.

Bake for 25 minutes, or until the top is firm and bouncy to the touch and the pine nuts/sesame are pale golden.

Cool in the tin for 10 minutes before removing to a rack to cool completely. Use a serrated knife to cut into strips lengthwise and then lines at a diagonal to form diamonds. Store in an airtight tin for up to 3 days.

Flavor options

		NUT/SEED		SWEETENER
Smooth ↓	NUT MILK	Almond Coconut Cashew Walnut	Pecan Peanut Hazelnut	Sugar Maple syrup Date syrup
	NUT BUTTER	Peanut Almond Cashew Hazelnut Pecan	Walnut Sesame Sunflower seed Pumpkin seed	Honey Agave syrup Maple syrup Dates Brown sugar
	PRALINE	Hazelnut Almond	Walnut Pistachio	Caramel
	GROUND NUTS	Pistachio Chestnut Almond Walnut	Hazelnut Cashew Pecan Coconut	Sugar Dates Honey
	CARAMELIZED NUTS	Walnut Hazelnut Pine nut Peanut	Pecan Pistachio Almond Cashew	Sugar Brown sugar Maple syrup Honey
Crunchy	BRITTLE	Almond Peanut Coconut Pistachio	Pine nut Sesame Pumpkin seed Walnut	Caramel

FRAGRANCE	WARMTH	DEPTH	INSPIRATION
Fennel seed Rose water Kewra Cardamom Cinnamon Vanilla Saffron	Black pepper Ginger	Turmeric Toasted coconut Chocolate Poppy seed	***THANDAL*** Almond + sugar + fennel seed + rose water + black pepper
Cinnamon Cardamom Clove Vanilla	Ginger Aleppo Urfa biber Chipotle Cayenne Ancho	Salt Seaweed Soy sauce Marmite Coriander seed Za'atar	***FIRE BUTTER*** Roasted peanut + honey + ginger + cayenne + salt
Vanilla Allspice Quatre épices Cardamom	Black pepper Ginger Chili	Salt Cocoa Coffee Wattleseed	***CHOCOLATE PRALINE*** Hazelnut + caramel + cocoa powder + salt
Cardamom Nutmeg Citrus zest Flower waters Vanilla Cinnamon Star anise	Ginger	Salt Coffee Chocolate Cumin Coriander seed	***PISTACHIO AMARETTI*** Pistachio flour + sugar + cardamom + rose water
Cinnamon Clove Nutmeg Garam masala Mixed spice	Paprika Black pepper Cayenne Chipotle Ginger	Salt Cumin Soy sauce Sesame	***CHRISTMAS MARKET NUTS*** Almond + sugar + cinnamon + clove + salt
Fennel seed Lavender Citrus zest Cinnamon Cardamom Rose petals Five spice	Cayenne Urfa biber Chili flakes Black pepper Ginger	Cacao nibs Coffee Cumin seed Coriander seed Caraway Salt	***SPICED COCONUT PRALINE*** Coconut + caramel + five spice + chili flakes

Coriander, cumin, & brown sugar fudge

Coriander and cumin seeds are more often found together than apart, the lemony tones of coriander singing prettily above the earthy base notes of its partner. However, the combination is almost invariably savory, thrumming through a curry perhaps, or a tagine. Here I've nudged it not just to sweet but to the sweetest end of the confection spectrum. Can I tempt you?

I like my fudge melt-in-the-mouth crumbly, veering toward Scottish tablet—it is the final whisking that gives a glorious granular texture. I've also taken inspiration from penuche fudge by using half brown sugar. The walnuts are optional but go well with the nutty combination.

Makes 36 pieces

1 teaspoon cumin seeds
1 teaspoon coriander
 seeds
400g (2 cups) light soft
 brown sugar
350g (12oz) granulated
 sugar
¼ teaspoon fine sea salt
110g (3¾oz) unsalted
 butter, diced

150ml (generous ½ cup)
 whole milk
395g (14oz) tin of
 condensed milk
85g (3oz) toasted
 walnuts, roughly
 chopped

SPICE SWITCH

Double ginger fudge: add 2 teaspoons ground ginger to the mixture when it comes off the heat, then mix through a handful of chopped crystallized ginger at the end in place of the walnuts.

Line an 8-inch square tin with parchment paper.

Toast the cumin and coriander seeds in a dry frying pan over a medium heat, stirring until they smell nutty and fragrant. Tip them into a bowl and set aside.

Put the sugars, salt, butter, milk, and condensed milk in a large heavy-based pan and heat gently, stirring with a wooden spoon, to melt the butter. Turn up the heat to medium–high and boil the mixture fiercely, stirring and scraping almost constantly, for 15–20 minutes. It is ready when a sugar thermometer reads 244°F or a small spoonful of the mixture dropped into iced water forms a soft, pliable ball.

Turn off the heat and add the whole spices. Use an electric whisk on high to beat the caramel-colored mixture for about 5 minutes—it will lose its shine and become thick and creamy. Mix in the walnuts and spread into the lined tin, smoothing the top. Leave to set for a few hours before cutting the fudge into chunks.

CUMIN & CORIANDER

I have a pot of sweets on my desk, uneven sugared balls in shades of chartreuse, amber, chalk, orchil, and Indian yellow. Just as their pretty, dirty colors are quirky next to the usual jewel tones of boiled sweets, so their taste is unexpected. Jeera goli are a South Asian digestive made from sweetened rose paste rolled around a toasted cumin seed and spiked with black pepper, each color signaling a different flavor, including tamarind, sour mango, ginger, and black grape.

Musky, pungent cumin is usually at home with resoundingly savory flavors, lending a sunbaked earthiness to cooking from Mexico to Sri Lanka. Likely to have originated in the Nile Valley, where the cumin harvest is described in the Bible, it is now widely cultivated across Asia, North Africa, and the Americas.

Despite this broad reach, finding cumin paired with sweet preparations remains a rarity. In India, shortbread cookies studded with the boat-shaped seeds make a lovely match for spiced chai. A pinch can also be added to sweet-tart drinks made with tamarind or lime, adding intrigue to a very refreshing preparation. Use cumin judiciously though—too much and the bitterness overtakes.

I may be taking things too literally, but in moderation I think cumin's earthy flavors ground a dish.

Try a modicum when baking enriched breads or fruitcakes. Nigella Lawson plays with the classic English seed cake by adding toasted cumin seeds in place of the usual caraway, then flattering their bittersweet growl with a pretty splash of orange blossom water. And what would you say to cumin with chocolate or caramel? French pâtissiers have experimented, as it seems better suited to French palates than a whack of chili.

Coriander seed is another spice bound largely to savory, but its march into the dessert realm has been more successful. With a very different flavor profile to its leaf, the seeds (actually two seeds held together in a papery husk) have a woody, floral warmth. They form the core of Central American Christmas candies called colaciones, season Catalan doughnuts, and were a common flavor in early Italian gelato before vanilla took over. If toasted to bring out the nutty notes, the seeds work well when root vegetables nudge into baking: in carrot cakes and pumpkin pies. But there is also a citrus delicacy to raw coriander seeds that makes them a natural pairing for lemon and orange.

Cumin and coriander are often married in cooking because they bring out the best in each other: the earth, the bright warmth, those background herbal notes that lift baking just as much as they do savory food.

Together their powers stretch beyond the kitchen.

If you want to stop lovers or chickens running away, turn to cumin.

At least this held true in the Middle Ages, when the plant was also carried at weddings to ensure a happy union. Coriander seeds were the secret to sexual rejuvenation for the ancient Chinese. Tutankhamun was buried with coriander alongside jewels, and a hoard of seeds was found by archaeologists in a cave near the Dead Sea where they lay undisturbed for 8000 years, meaning they join ginger and sugarcane as some of the earliest seasonings still used today.

Finally, a tip if you ever grow your own cumin: writing in the fourth century BC, Theophrastus recommended when sowing the seeds, one should "curse and slander" to ensure a healthy crop.

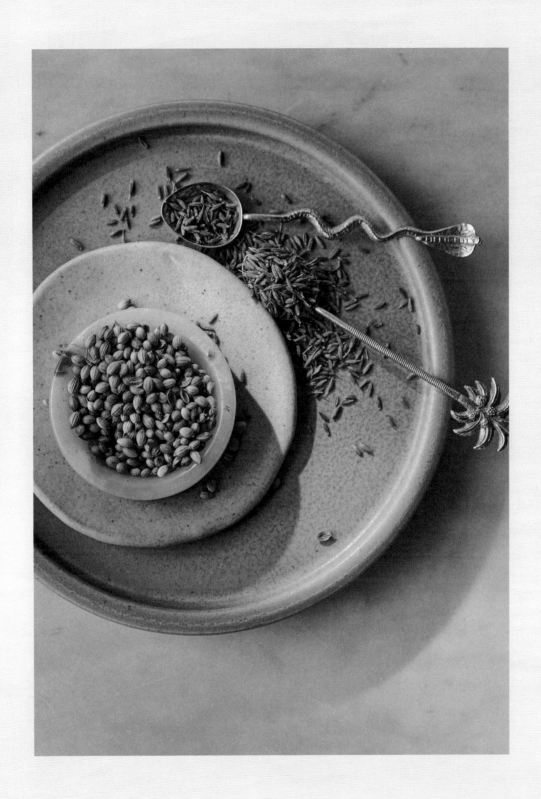

Garam masala & chocolate chunk cookies

When musing on spices and flavor I had an idea for a garam masala cookie, then pushed it away as madness. After all, the spice blend is designed for finishing curries, lending bittersweet complexity from the nutmeg, cinnamon, pepper, cumin, cloves, and coriander. Yet my mind was caught and, happily, I'm here to tell you it works. The blend offsets the dark chocolate while the nuggets of fiery crystallized ginger play off the warming heat that gives garam masala its name.

The best, squidgiest cookies enforce patience, as you need to rest the dough overnight to allow the flour to fully hydrate and the flavors develop. I then suggest cooking in batches as needed, as they are arguably at their finest warm from the oven while the kitchen still smells of baking butter and spices and the chocolate chunks sit in molten puddles.

Makes 18–20 cookies

250g (1⅔ cup) plain flour
1 teaspoon garam masala
1 teaspoon ground ginger
1 teaspoon baking powder
1 teaspoon baking soda
½ teaspoon fine sea salt
150g (5½oz) dark chocolate, cut into chunks
100g (3½oz) crystallized ginger, cut into chunks
140g (5oz) unsalted butter, at room temperature
140g (5oz) dark muscovado or soft dark brown sugar
100g (3½oz) castor sugar
1 egg
Sea salt flakes, for sprinkling

SPICE SWITCH

Trade in the garam masala for other sweet and complex spice mixes such as hawaij, baharat, ras el hanout, or advieh.

Line two baking sheets with parchment paper.

Whisk together the plain flour, garam masala, ground ginger, baking powder, baking soda, and fine salt in a bowl. Stir through the chocolate and ginger chunks.

In a stand mixer with a paddle or bowl with a wooden spoon, cream together the butter and both sugars until well mixed but not aerated and fluffy. Beat in the egg well, then add the dry ingredients and mix through.

Using an ice cream scoop (I use one 1¾ inches in diameter), scoop out balls of the dough and space well apart on the baking sheets to allow room for spreading. Chill in the fridge overnight or for up to 2 days.

The next day, heat the oven to 350°F.

Sprinkle a little flaky salt over the top of each cookie ball. Still cold from the fridge, bake for 12 minutes. Cool on the sheets then store in an airtight tin.

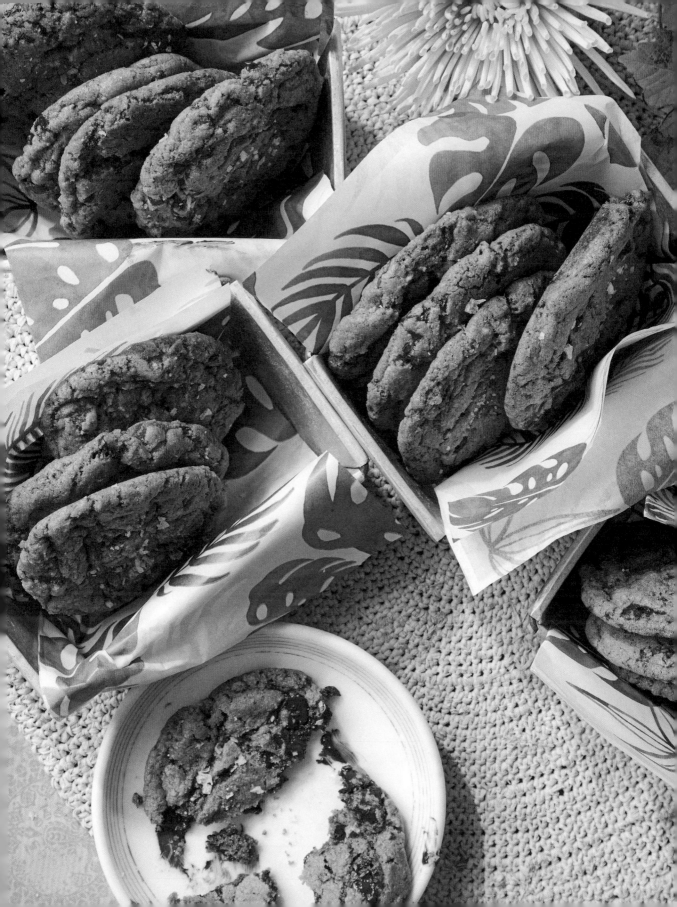

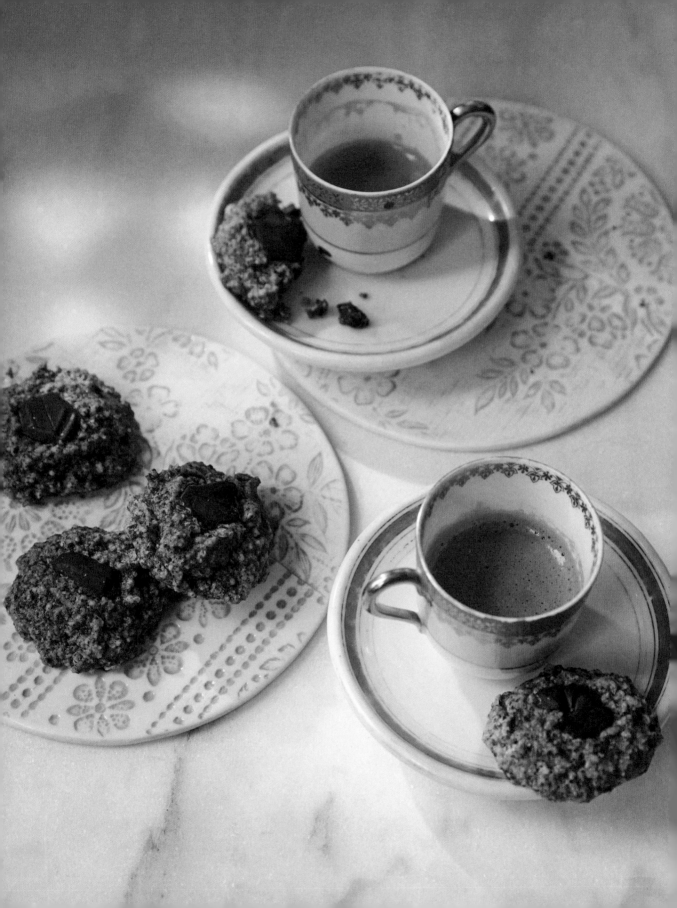

Hazelnut, cardamom, & chocolate amaretti

One of my favorite recipes is by my friend Joe Trivelli for chocolate amaretti. They are incredibly quick to make, cook, and eat (and I love that he wrote it as a small batch, the sort of thing to throw together when you have a left over egg white).

I was musing with Joe whether I could make a spiced hazelnut version. Being Italian, he was quick to disapprove of using hazelnuts here, but soon warmed up to the idea and started riffing on spices. We settled on cardamom and here is the result. Though maybe not a true amaretti, it is every bit as nutty and delightful as I hoped.

Makes 10 amaretti

50g (1¾oz) hazelnuts
50g (1¾oz) blanched
 almonds
5 green cardamom
 pods, seeds ground
Small pinch of fine sea
 salt

50g (1¾oz) golden
 castor sugar
50g (1¾oz) best dark
 chocolate, 70%,
 broken into pieces,
 plus more to decorate
1 large egg white

SPICE SWITCH

Use 1 tablespoon instant espresso coffee powder in place of the cardamom.

Line a baking sheet with parchment paper. Heat the oven to 375°F.

Put the nuts, cardamom, salt, and about half the sugar in a food processor. Blitz to a fine grind. Add the chocolate and whiz again to fine sand.

Whisk the egg white to soft peaks, add the remaining sugar and continue whisking until thick and glossy. Fold into the nutty mixture.

Use a spoon to shape ten rough balls on the baking sheet. Stick a shard of chocolate in the center of each.

Bake for 10 minutes—they will look too soft but aren't. Cool on the sheet for 10 minutes or more before digging in.

Red wine & wattleseed chocolate torte

Intense and complex ingredients can rule a dish, or they can be matched like for like and take each other on. Here are three combined in a rich cake. Cocoa brings dark chocolaty thrum; red wine gives fruity tannic depth; and the wattleseed is woody, roasted, and nutty. These native Australian seeds (known as ariepe by the Arrernte First Nations language group) are almost coffee-like and have a similar ability to bring out the best in chocolate.

This torte stands up well to being made a day in advance, and maybe even improves as the texture gets fudgier.

Serves 8

For the chocolate torte
150g (1 cup) plain flour
40g (⅓ cup) unsweetened cocoa powder, plus more for dusting
1 tablespoon ground wattleseed
½ teaspoon baking soda
¼ teaspoon fine sea salt
90g (⅓ cup) unsalted butter, at room temperature
175g (6oz) castor sugar
2 eggs, at room temperature, beaten
90ml (generous ⅓ cup) dry red wine
150ml (generous ½ cup) sour cream

For the wattleseed sour cream
2 teaspoons ground wattleseed
250ml (1 cup) sour cream

SPICE SWITCH

Mulled wine chocolate torte: to give a sweet, spicy note use 1 teaspoon ground allspice, ½ teaspoon ground cinnamon, ¼ teaspoon ground clove, and a good grating of orange zest. Dust with cocoa and cinnamon and serve with plain sour cream or crème fraîche.

Line the base and grease the edges of an 8-inch cake tin. Heat the oven to 375°F.

Sift together the flour, cocoa, wattleseed, baking soda, and salt. Set aside.

In a stand mixer, cream the butter and sugar for about 3 minutes, until very light and fluffy. Add the beaten egg, a bit at a time, followed by about a third of the dry ingredients. Mix in the red wine, then another third of the dry. Mix in the sour cream and finish off with the dry.

Scrape into the cake tin and rap on the work surface to level. Bake for 20–25 minutes, until the top is set but with a slight wobble beneath. Cool in the tin.

For the wattleseed sour cream, put the wattleseed into a cup and moisten with a splash of boiling water. Leave to soak, swell, soften, and cool. Drain any excess liquid from the sour cream, then stir in the wattleseed slurry.

Dust the torte liberally with cocoa before serving with the wattleseed sour cream.

Baked apricots with maple & fenugreek

The angular, toffee-colored seeds of fenugreek are usually employed in savory cooking, adding an earthiness to Indian and Ethiopian foods in particular, yet they also have a brown sugar quality, which leads them to play a key role in mock maple syrups. The secret is to toast the seeds, which pares back the bitterness and brings the nutty sweetness to the fore.

In the Arab world, fenugreek seeds stud a syrupy, yeasted cake called helbeh, and in India sweet balls of laddu can be made with fenugreek and jaggery. I've used them here to lend a touch of intrigue to simple baked apricots, adding real maple syrup to double down on that flavor. It is a combination either loved or hated by my testers; turn to the spice switches for something more universal.

Serves 4

⅓ teaspoon fenugreek
 seeds
3 tablespoons maple
 syrup
½–1 teaspoon rose
 water
Small pinch of fine
 sea salt
8 ripe apricots
25g (2 tablespoons)
 unsalted butter

For the whipped yogurt
175g (6oz) Greek-style
 yogurt
125ml (½ cup) heavy
 cream
Gingersnap or amaretti
 biscuits, to serve

SPICE
SWITCH

Vanilla lemon apricots: mix the seeds of a vanilla pod with 3 tablespoons sugar, then lay the scraped pod, some strips of lemon zest, and 20g butter over the apricots as they bake.

Honey aniseed apricots: use 3 tablespoons honey, 20g butter, and 1 teaspoon aniseed.

Heat the oven to 375°F.

In a dry frying pan, toast the fenugreek seeds over a medium heat until they smell nutty. Tip into a small bowl and mix in the maple syrup, rose water, and salt.

Halve the apricots by cutting along the natural indentation of the fruit. Remove the stones and lay the fruit cut-side up in an oven dish. Cut the butter into small nubs and divide among the apricots. Drizzle over the spiced syrup.

Bake for 20–35 minutes, depending on the ripeness of the fruit. They should be soft and syrupy—a skewer will go in with no resistance—but not entirely collapsed.

Meanwhile, whip together the yogurt and cream for a couple of minutes. Spread the mixture over a serving plate and top with warm baked apricots. Crumble over some gingersnap or amaretti biscuits or serve alongside.

Black rice, black cardamom

Black cardamom utterly captivated me when I first came across it, its large, dark pods holding a deep, resinous smokiness. It is more often employed in savory cooking, but I wanted to find a way to use it in a dessert, so turned to a dish popular in Indonesia, Malaysia, and Thailand—black rice pudding. Not just color coordination led me to the pairing; the rice is nutty and interesting (and also highly nutritious) and holds up against the bold cardamom. With so few ingredients—rice, spice, sugar—it is surprising how complexly flavored and delicious this is.

Finish with salted coconut cream, either store-bought with a pinch of salt (my usual choice) or make your own toasted coconut cream for another layer of complexity: caramel brown drizzled over inky black at the table. How chic.

If you want a bite of freshness, some cubes of pineapple brightened with a squeeze of lime juice and pinch of chili powder make a good accompaniment.

Serves 4

For the black rice pudding
200g (7oz) black glutinous rice
4 black cardamom pods, lightly bashed
40g (1½oz) palm sugar, shaved (or more to taste)

For the toasted coconut cream
150g (1⅔ cups) desiccated coconut
Pinch of fine sea salt

SPICE SWITCH

For a more classic spicing, infuse the rice with 2 pandan leaves, bruised and knotted, or a stick of cassia.

A day in advance, wash the rice well in several changes of water, picking out any grit or husks. Leave to soak in cold water overnight. It needs long soaking to soften the fiber-packed hulls before cooking to soft submission.

Also the day before, prepare the coconut cream if you are making your own. Heat a frying pan and toast the coconut, stirring, until a deep toasty brown. Tip into a heatproof blender with 1.25 liters (5 cups) recently boiled water. Soak for 20 minutes, then blitz well. Strain and squeeze through a nut bag, muslin, or fine strainer to extract all the liquid, then put in the fridge overnight. (Discard the solids or refrigerate for up to 5 days to use in smoothies.)

The next day, the liquid will have separated. Scoop the thick coconut cream from the top and stir in a little of the watery coconut milk below to get a smooth cream with a thick, pouring consistency. Add a good pinch of salt. (Use the left-over watery coconut milk to make up some of the cooking liquid for the rice or save to use in soup.)

To cook the black rice pudding, drain the rice and wash again. Put in a pan with 800ml (3¼ cups) water and the black cardamom. Bubble uncovered over a medium heat for about 40 minutes, stirring occasionally, until you have a soft, porridge-like rice pudding. Depending on your rice, it may need more water and longer cooking for the grains to yield.

Discard the cardamom and stir in the palm sugar. Reduce the heat and simmer, stirring, for a final 5 minutes. Taste for sweetness—you may want more palm sugar. Leave to cool.

Serve the rice pudding at room temperature with the toasted coconut cream alongside for drizzling.

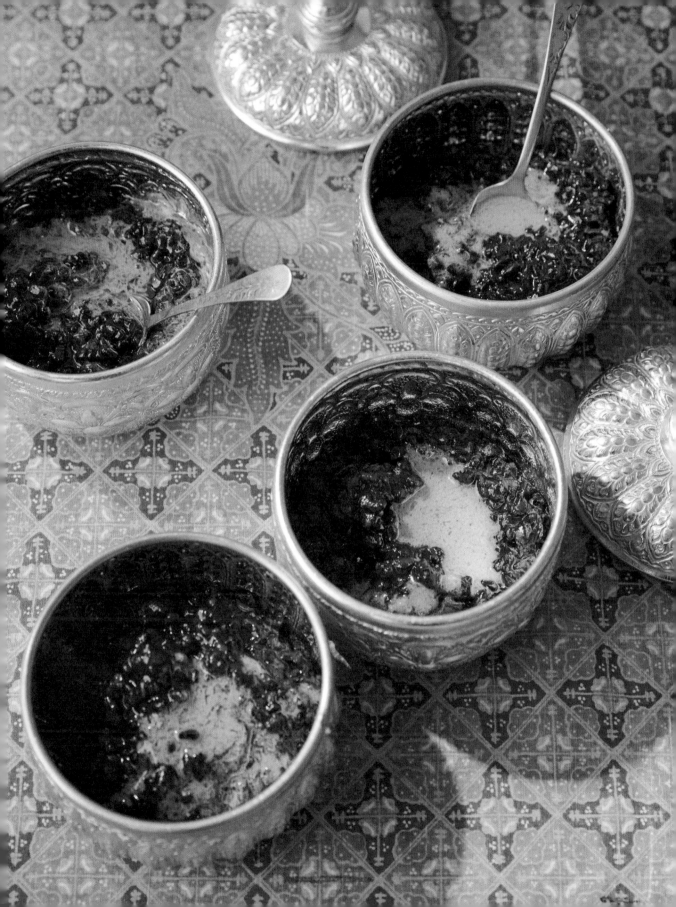

SOUR &

CITRUSY

Lime leaf possets

In the seventeenth century, a posset was a custardy wine and spice-spiked drink taken at bedtime by newlyweds. Today, it has evolved into a softly set cream to be enjoyed by everyone.

Whereas panna cotta uses gelatin to set the cream, possets use the thickening powers of citrus alone to do the job, so are a cinch to make. These ones have a heady fragrance of lime leaves to match the tang of lime juice. From the Asian makrut (also known as kaffir) lime tree, these leaves are citrusy, floral, and intensely perfumed. Choose fresh or frozen leaves over dried and scrunch to release the flavors.

Serve with sweet tropical fruit or almond biscuits.

Serves 4–6

400ml (generous 1½ cups) heavy cream
100g (3½oz) castor sugar
8 fresh lime leaves, scrunched
Zest of a lime, pared off in strips
150ml (generous ½ cup) lime juice (4–6 limes)

SPICE SWITCH

Lemongrass posset: infuse the cream with 3 bruised lemongrass stems.

Heat the cream, sugar, lime leaves, and lime zest in a small pan until just bubbling. Boil hard for a couple of minutes, stirring constantly, until the cream rises toward the rim of the pan. Remove from the heat and leave to infuse for half an hour.

Stir in the lime juice and pass the mixture through a fine sieve into a jug.

Divide into four to six small pots or glasses and chill for at least 3 hours to set.

Chocolate ganache with black lime

Dried limes are an Omani way of preserving the fruit, leaving them as hard balls supercharged with flavor. Black ones are the most intense. They are citrusy, yes, but also have musky, funky fermented notes that make this Daliesque combination of chocolate, olive oil, salt, and toast even more special and unexpected. It is rich and bittersweet, but each serving holds just a few tantalizing mouthfuls.

Serves 4–6

250g (9oz) best dark
 chocolate, 70%
5 dried limes
1–2 dried small red
 chilis (optional)
250ml (1 cup) heavy
 cream
Sourdough loaf
Best extra virgin
 olive oil
Sea salt flakes

SPICE SWITCH

Infuse the cream with 3 bruised stems of lemongrass for an unpredictable yet magical combination. Or instead, bring smoky complexity by using 5 lightly cracked black cardamom pods.

Finely chop the dark chocolate and put it into a heatproof bowl.

Crack the dried limes and put the crumbly shards in a small pan with the dried chilies and cream. Warm gently for 10 minutes, stirring often, then turn up the heat to bring to a simmer. As soon as it bubbles, pour the infused cream through a sieve into the bowl of chocolate. Beat with a spoon until smooth. (If the chocolate doesn't fully melt, sit the bowl over a pan of simmering water and stir until glossy.)

Leave to cool and set for a couple of hours. Store in the fridge if making in advance but serve at room temperature.

To make crisp toasts, chill the bread, which will make it easier to cut. Cut into slices as thin as possible and lay out on a baking sheet. Put in an oven, turn the temperature to 275°F and cook until crisp and light golden, maybe about 15 minutes.

Scoop the ganache into small glasses, douse with a little olive oil, and finish with a flourish of flaky salt. Serve with the crisp toasts.

Rujak fruit salad

A bright and refreshing way with tropical fruits popular on the island of Java, Indonesia. The dressing is wonderfully tangy and sweet with a good thwack of chili heat. This comes from sambal oelek, a hot and sharp seasoning paste made with red chilies and salt.

Vary the fruit as you like but try to choose ones that have a crispness, so firm mangoes are preferable to juicy, sweet ones in this instance. You can also add vegetables such as cucumber or daikon into the mix if the mood takes you.

Serves 4–6

Fruits
½ pineapple
1 papaya
1 firm mango
2 star fruit

For the dressing
50g (1¾oz) palm sugar
1–2 teaspoons sambal
 oelek
½–2 tablespoons
 tamarind paste

SPICE SWITCH

Taking inspiration from Mexico, dress a salad of sweet, ripe fruits with the finely grated zest and juice of a lime, ½ teaspoon ground chili, and a pinch of salt.

Or inspired by Indian fruit chaat, toast then crack ½ teaspoon each of fennel seeds and black peppercorns and add to ripe fruits along with black salt, the juice of a lemon, and shredded mint leaves.

Prepare the fruit, peeling and dicing as needed. Tumble together in a serving bowl.

Make the dressing by shaving the palm sugar with a knife then mixing in a small saucepan with 75ml (⅓ cup) water. Heat gently to melt then turn the heat to medium and bubble for 3–5 minutes to make a syrup. Leave to cool.

Stir in the sambal oelek and tamarind. (Tamarind pastes vary hugely in strength—if yours is an inky concentrate, dial back the quantity. I favor a lighter, less concentrated one.) Taste with a piece of fruit—you want to find a balance of sweet, sour, hot, and salty. Adjust each element until you find perfect harmony.

Spoon the dressing through the fruit and serve.

Pistachio, lemon, & coriander seed cake

I hesitated even to write coriander seed in the recipe title, as I don't want you to dismiss this heavenly cake as self-consciously quirky or bizarre. But then again, perhaps it drew you here?

Either way, I implore you to smell a pot of coriander seed. Notice how bright, almost citrusy the aroma is. That is why it works so well to make this oh-so-easy, lemony pistachio cake sing. It gets even better the day after you make it, the subtle flavors becoming a little more pronounced and the texture squidgier.

Serves 8–10

For the pistachio cake
200g (7oz) shelled pistachios
100g (⅔ cup) plain flour
175g (6oz) unsalted butter, at room temperature
175g (6oz) castor sugar
3 eggs, at room temperature

150g (5½oz) natural yogurt
1 teaspoon baking powder
¾ teaspoon fine sea salt
Finely grated zest of 2 lemons
2 tablespoons coriander seeds, ground

For the lemon icing
150g (1¼ cups) confectioners' sugar
25ml (2 tablespoons) lemon juice

SPICE SWITCH

Use the ground seeds of 8 green cardamom pods instead of the coriander seeds and add a splash of rose water to the icing.

Grease and line an 8-inch cake tin. Heat the oven to 315°F.

In a food processor, grind the pistachios with the flour to a slightly sandy powder. Tip out and set to one side.

Put the butter and sugar in the food processor and whiz to a paste. Add all the remaining ingredients, including the pistachio flour, and whiz again. Scrape the batter into the tin and rap on the work surface a few times to level.

Bake for up to an hour, until the top is golden and springy and a skewer in the middle comes out clean. Leave in the tin for 10 minutes before turning out onto a rack to cool completely before icing.

For the icing, mix the confectioners' sugar and lemon juice to make a slick of glossy white. Pile into the middle of the cake and encourage it to ooze languidly toward the edges. This cake keeps well in a tin for a few days and the flavor only gets better, but the icing looks at its sleekest when fresh.

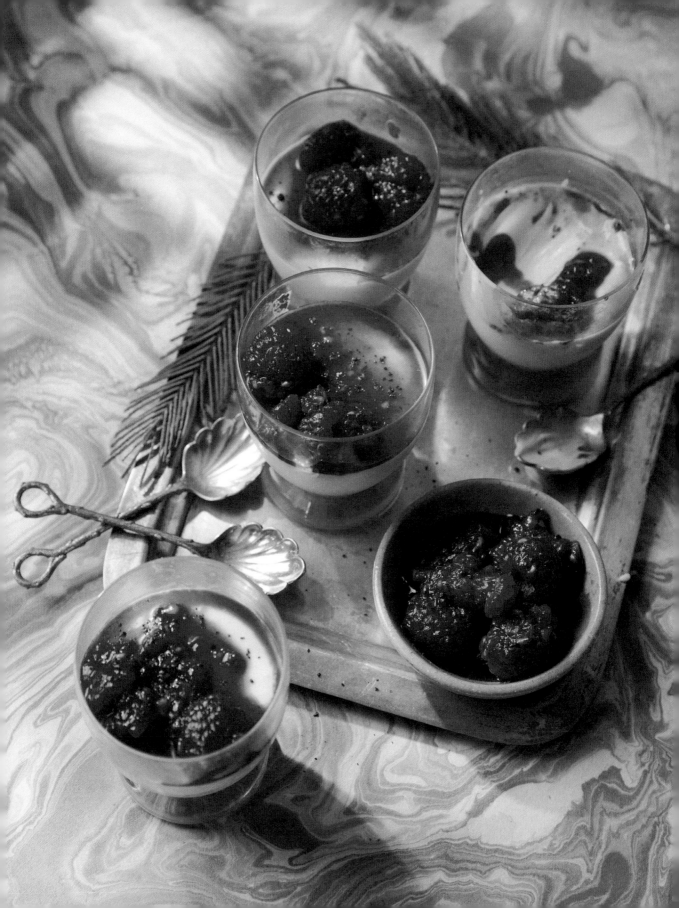

White chocolate pots with sumac–soured berries

This is an outrageously easy dessert—not that your guests will ever know it. They'll be too busy being enraptured by the combination of silky sweet cream and mouth-puckeringly sour raspberries.

You could use other berries here too—blackberries, strawberries, blueberries, cranberries, pomegranates. Sumac and pomegranate molasses both bring tartness to contrast with the white chocolate and enhance the flavor of the fruit. Just taste for sweet-sour balance and adjust accordingly.

Serves 4

For the white chocolate pots
150g (5½oz) best white chocolate
150ml (generous ½ cup) crème fraîche
150g (5½oz) Greek-style yogurt

For the sumac-soured berries
200g (7oz) raspberries or other berries
2 teaspoons pomegranate molasses
1 teaspoon ground sumac, plus more for sprinkling
1 scant tablespoon demerara sugar

SPICE SWITCH

For a spicy kick, trade the sumac for a pinch of ground cayenne.

Break the chocolate into squares and melt gently in a bowl set over simmering water. Remove from the heat and stir through the crème fraîche then the yogurt. Divide into four small pots or glasses and chill in the fridge for a few hours.

Just before serving, use a fork to half crush the raspberries with the pomegranate molasses and sumac. Taste, adding a crunch of demerara sugar if needed.

Spoon the raspberries onto the chocolate pots and sprinkle over a final pinch of sumac.

1730 prune & tamarind tart

Heavy spice use entered English cookery in medieval times with cinnamon, ginger, cloves, and saffron often bound with honey in dishes. By the 1700s, sugar was in vogue, expanding cooks' repertoires into splendid sweets. This recipe is based on one in Charles Carter's *The Complete Practical Cook* of 1730 and shows off imports of the day: prunes from Spain, Caribbean sugar, mace from Indonesia, cinnamon from Sri Lanka, and tamarind shipped in via the East India Company.

 Food historian Ivan Day rendered the original recipe and mine is adapted from his. I attended a talk he gave where Hattie Ellis had made glorious, sunshine-yellow tarts for us to taste the history. So good were they, I begged for the recipe.

Serves 8

For the prunes
150g (5½oz) soft, stoned prunes
2 teaspoons Marsala or Madeira fortified wine
85g (3oz) dark muscovado or dark soft brown sugar
2–3 teaspoons tamarind paste

For the pastry
170g (6oz) plain flour
45g (1½oz) confectioners' sugar
85g (3oz) cold unsalted butter, diced
Pinch of fine sea salt
1 tablespoon ice-cold water
1 egg, beaten

For the custard
3 egg yolks
50g (1¾oz) castor sugar
240ml (1 cup) whipping cream
1 teaspoon ground cinnamon
⅓ teaspoon ground mace

SPICE SWITCH

In place of the warming spices added to the custard, warm the cream with a pinch of crumbled saffron, infuse for 15 minutes then mix it into the egg yolks and sugar.

Cut the prunes into quarters and mix with the Marsala, brown sugar, and tamarind paste (adjusting the amount according to how concentrated yours is). Marinate at room temperature while you prepare the pastry (or overnight).

To make the pastry, combine the flour, confectioners' sugar, butter, and salt in a food processor. Pulse to crumbs. Add the water and half the egg (saving the rest) and pulse again just until the pastry starts to clump together. Turn out and form into a flat disk, working it as little as possible. Wrap in plastic wrap and refrigerate for at least an hour (or overnight).

On a lightly floured surface, roll out the pastry to a circle about 1/16-inch thick. Use it to line a 9-inch loose-bottomed tart tin. Tuck it into the edges and leave an overhang of pastry. Put in the freezer to chill briefly.

Heat the oven to 350°F. Put a baking sheet in the oven.

Line the tart case with foil, shiny side up, and weigh down with baking beans (or in the absence of these, use a generous mound of sugar; when you are finished parcel it in the foil and save for future tarts). Sit the tin on the baking sheet and blind-bake for 25 minutes. Remove the foil and trim the overhang. Brush the remaining egg over the pastry and return to the oven for 10 minutes.

Meanwhile, make the custard. Mix together the egg yolks, sugar, cream, and spices.

Reduce the oven to 300°F.

Dot the prune mixture over the base of the tart and pour over the custard. Bake for 45–50 minutes, until set with a faint wobble. Cool completely.

Lemon meringue roulade with ginger & passion berries

Inevitably it was the name that drew me to the Ethiopian pepper known as passion berry. Writing a book about love and spices, how could I resist? Then I was caught by its flavor. Peppery yes (a gentle "cool" heat similar to Sichuan peppercorns), but combined with an intense and unmistakable passion fruit aroma. It makes a wonderful partner for fruits—think strawberries, mango, pineapple, or peach—or here sparkles with ginger, cream, and lemon curd in marshmallowy meringue.

Serves 8

For the lemon passion curd
3 egg yolks
115g (4oz) castor sugar
Finely grated zest of 3 lemons
80ml (⅓ cup) lemon juice
55g (4 tablespoons) unsalted butter, cubed
1½ teaspoons passion berries (optional)

For the meringue
4 large egg whites (160g/5½oz), at room temperature
Pinch of fine salt
200g (7oz) castor sugar
1 teaspoon corn starch
1 teaspoon lemon juice

For the filling
250ml (1 cup) whipping cream
2–3 balls of stem ginger in syrup, chopped

SPICE SWITCH

Make a lemongrass curd by adding 3 chopped lemongrass stems to the lemony mixture as you cook, then passing through a sieve at the end.

Or take the roulade in a different direction by scenting whipped cream with lemon zest and 2 teaspoons aniseed, then tumbling over chopped strawberries before rolling. (Omit both the curd and the ginger.)

To make the curd, put the egg yolks and sugar in a small heavy-based pan and beat with a silicone spoon. Add the lemon zest, juice, and butter and set over a medium–low heat. Stir constantly for 8–10 minutes, until it thickens to a pudding-like consistency.

Toast the passion berries in a dry frying pan until fragrant, then crush with a pestle and mortar. Stir into the curd. Leave to cool and chill until needed.

For the meringue, line a 9 inch x 13 inch baking tray with parchment paper. Heat the oven to 350°F. In a stand mixer or with an electric whisk, beat the egg whites and salt at medium speed until foamy. Add the sugar slowly, a spoonful at a time. Turn the speed to high and keep whisking for 5 minutes, until the mixture is very stiff and glossy. Finally,

turn the speed to low and briefly mix in the corn starch and lemon juice. Spread into the tin. Bake for 15 minutes, or until crisp to the touch and lightly golden. Turn upside down onto another sheet of parchment paper and peel the paper from the base. Leave to cool while you make the filling by whipping the cream to soft, billowy peaks.

Scatter the stem ginger over the meringue. Swirl the lemon passion curd and whipped cream together then spread evenly over the top. Use a knife to score down the long side, slightly in from the edge. Start here to fold then roll the meringue, using the paper to help you. Sit the roll on a plate with the join at the base. Cut into swirled slices to serve.

DRINKS ♡ SPICE

Cold drinks
For alcoholic drinks, see Alcohol ♡ spice (page 122).

Strawberry & rose lassi

To cool and delight two hot people on a summer day, blend 5 hulled **strawberries** with 250g (1 cup) **natural yogurt**, ¼ teaspoon ground **cardamom,** and 2 tablespoons **rose syrup** until smooth and frothy. Taste for sweetness. Serve over **ice.**

Sweet tamarind jamu

Jamu are Javanese tonics ascribed with many health-bringing qualities and this one has a lovely, cola-like taste. In a pan, combine 2 tablespoons **tamarind paste** (I use a lighter, less concentrated one), a thumb of **fresh turmeric**, chopped, 3 scrunched **lime leaves**, 1 knotted **pandan leaf**, 50g (1¾oz) **dark palm sugar,** and a pinch of **salt.** Add 750ml (3 cups) **water**, cover, and bring to a boil slowly, then simmer for 10 minutes. Strain, cool, and serve over **ice.**

Green cardamom sharbat

A perfumed drink to evoke *One Thousand and One Nights*. Smash and bash 20 **green cardamom,** pods and all, and put in a small pan with 100g (3½oz) **sugar** and 75ml (⅓ cup) **lemon juice**. Warm slowly to melt the sugar, then simmer for 7 minutes. Strain, squeezing the cardamom to extract all the precious syrup. Use as a cordial, stirring in **iced water** to taste.

Hibiscus pepper lime

Brilliant red, the tartness of hibiscus flowers is balanced with sugar and just a prick of pepper. Combine 10g (¼oz) **dried hibiscus**, ½ teaspoon **black peppercorns**, and 100g (3½oz) **sugar** in a pan with 500ml (2 cups) **water**. Cover, heat slowly to melt the sugar, then simmer for 10 minutes. Leave to cool, add the juice of a **lime**, then strain. Serve chilled.

Turmeric switchel

Sweet, sour, spicy. In a 500ml (17fl oz) sterilized jar, combine 10g (¼oz) finely chopped **ginger**, ½ teaspoon finely chopped **fresh turmeric**, 2 tablespoons **apple cider vinegar**, 1 teaspoon **lemon juice,** and 1½ tablespoons **honey**. Muddle well then top up with **water**, leaving about a 1¼-inch space at the top of the jar. Seal, infuse overnight, then refrigerate. Strain before drinking.

Black lime iced tea

A fragrant refresher for those who like funky, bittersweet flavors. Bash a **black lime** to shrapnel with a pestle and mortar. Combine with 1½ tablespoons **sugar** and 500ml (2 cups) **water** in a small pan, cover, and simmer for 5 minutes. Strain through a coffee filter. Cool, taste for sweetness, then chill before serving.

Lemon myrtle shrub

Capture the citrusy notes of Australian lemon myrtle. Dissolve 200g (7oz) **sugar** in 240ml (1 cup) **rice vinegar** over a medium heat. Add 1 tablespoon **dried lemon myrtle leaves** then leave to cool and infuse for 30 minutes. Strain. Serve over **ice** as a nip, or with **cucumber** and **mint** topped up with **sparkling water.**

Juniper refresher

A suggestion of gin & tonic but in lemony, soft drink form. Combine 1 teaspoon cracked **juniper berries**, ½ teaspoon **fennel seeds,** and ½ teaspoon **coriander seeds** in a pan with 100g (3½oz) **sugar** and 75ml (⅓ cup) water. Heat slowly to dissolve the sugar, then simmer for 7 minutes. Cool and squeeze in 100ml (scant ½ cup) **lemon juice.** Strain into a jug and top with 500ml (2 cups) chilled **sparkling water.**

Hot drinks

Vietnamese ginger coffee

Ginger gives coffee a warm complexity. Brew strong coffee with a bruised slice of **ginger** per person. Puddle a tablespoon of **sweetened condensed milk** in the base of a glass and top with the gingered coffee. Serve hot or with **ice**.

Cardamom coffee

Gahwa is the ultimate display of Arabic hospitality. In a pan, add 1 heaping tablespoon finely ground **coffee** for each cup of **water**. Simmer for 5 minutes then stir in ¼ teaspoon **ground cardamom** and 1 teaspoon **sugar** per cup. A strand or two of **saffron** is optional. Pour, then leave the grounds to settle for 5 minutes before drinking, perhaps alongside some dates.

Spilsbury tea

My aunt, Tania Compton, makes a herbal tea blend by mixing **sage leaves**, dried from her garden, with shards of **licorice root**. Brew a spoonful in hot water for a naturally sweet infusion.

Verbena berry lemon tea

Into a teapot: 2 **white tea bags**, 3 slices of **fresh lemon**, 1 teaspoon cracked **verbena berries**. Top up with 2 cups of boiling **water** and steep for 5 minutes. The result is delicately bewitching.

Extra spicy chai

Subtlety is lost on me—here is Indian chai masala for six at full throttle. Put 1 tablespoon minced **ginger**, 6 bruised **green cardamom pods**, 1 bruised **black cardamom pod**, 2 **cloves**, 1 **long pepper**, and ½ **cinnamon stick** in a pan with 500ml (2 cups) **water**. Bring to a boil and simmer for 5 minutes. Add 1 tablespoon **Assam tea** and 2 tablespoons **sugar** and heat for a further 2 minutes. Add 250ml (1 cup) **milk**, simmer for 10 minutes, then strain and serve.

Star anise milk

The anise both sweetens and flavors the warm milk—make this for children as they do in The Netherlands. For two small mugs, put 250ml (1 cup) **milk** in a pan with 2 **star anise** and 1 scant teaspoon **vanilla sugar**. Heat gently for 5–10 minutes. Serve with the stars bobbing in the milk.

STMJ

A warming Indonesian drink to soothe colds. Bring 250ml (1 cup) **milk** slowly to boil with 2 bruised **ginger** slices. In a bowl, whisk an **egg yolk** with 1 tablespoon **honey**, then beat in the hot milk. Decant into a mug and serve to the invalid at once.

Aztec-inspired hot chocolate

Dark, rich, and sultry. Heat 400ml (generous 1½ cups) **water** in a saucepan with 2 tablespoons **light muscovado sugar**, 4 teaspoons **unsweetened cocoa powder**, ¼ teaspoon each of **ground cinnamon** and **allspice**, and a pinch of **ground chili**. Remove from the heat, add 80g (2¾oz) chopped **dark chocolate** and beat with an electric whisk for 2 minutes. Warm through. Serves 2.

Sbiten

If you were facing the icy onslaught of a twelfth-century Russian winter, this is the mulled honey drink you would need. Heat 500ml (2 cups) **water** with 4 tablespoons **blackberry jam**, 1 tablespoon **honey**, 1 **cinnamon stick**, 2 **cloves,** and a lantern of **mace**. Simmer with the lid on for 10 minutes, then turn off the heat and leave to infuse for 2 minutes longer. Strain into mugs.

Mulled apple juice

Heat 1 liter (4 cups) **cloudy apple juice** with a host of sweetly warming spices, simmering with the lid on for 10 minutes. Adjust according to your spice collection: perhaps try 6 **cassia buds**, 4 **allspice berries**, 4 **passion berries**, 2 **cloves**, and 2 **star anise**. Serve hot, leaving the spices in.

Tangy lemon & juniper bars

Lemon bars are a US classic, so I turned to one of the grand dames of American baking, Alice Medrich, for inspiration in this recipe. It was her saying that some deemed her bars too lip-puckeringly sour that made me know I would love them.

I have taken a liberty with Anglo-American relations, adding a British twist with the flavors of gin. Everyone knows gin and lemon are the perfect match, so it follows that the spirit's key botanicals—juniper and coriander seed—fit beautifully in the buttery biscuit base of a lemon bar.

Makes 16 bars

For the cookie base
1 teaspoon juniper
 berries
½ teaspoon coriander
 seeds
¼ teaspoon fine sea salt
110g (3¾oz) unsalted
 butter, melted
30g (1oz) castor sugar
125g (4½oz) plain flour

For the tangy topping
225g (8oz) castor sugar
45g (1½oz) plain flour
3 eggs, lightly beaten
1½ teaspoons finely
 grated lemon zest
120ml (½ cup) fresh
 lemon juice

SPICE SWITCH

Lavender in the cookie base is rather lovely. Add 2 teaspoons finely chopped fresh lavender flowers in place of the spices.

Line an 8-inch square baking tin with parchment paper. Heat the oven to 350°F.

For the cookie base, grind together the juniper and coriander using the salt as an abrasive. Breathe in the gin-like scent. Mix the spices into the melted butter with the sugar. Stir through the flour, just until combined. Press the dough evenly over the bottom of the baking tin.

Bake for 25–30 minutes, until the base is golden in the center and well browned at the edges.

While the base is baking, make the topping. In a large bowl, mix the sugar and flour. Stir in the eggs followed by the lemon zest and juice.

When the base is ready, turn down the oven to 300°F. Slide out the oven rack, pour the topping straight onto the hot base, and gingerly slide back into the oven. Bake for 20 minutes longer, or until there is only the faintest jiggle in the center if you tap the side of the tin.

Cool completely in the tin, then lift out onto a chopping board. The foamy tops don't concern me but if they do you, blot with a paper towel to let the sunny yellow shine, or dust with confectioners' sugar. Slice into 16 squares. They will keep in the fridge for 3 days.

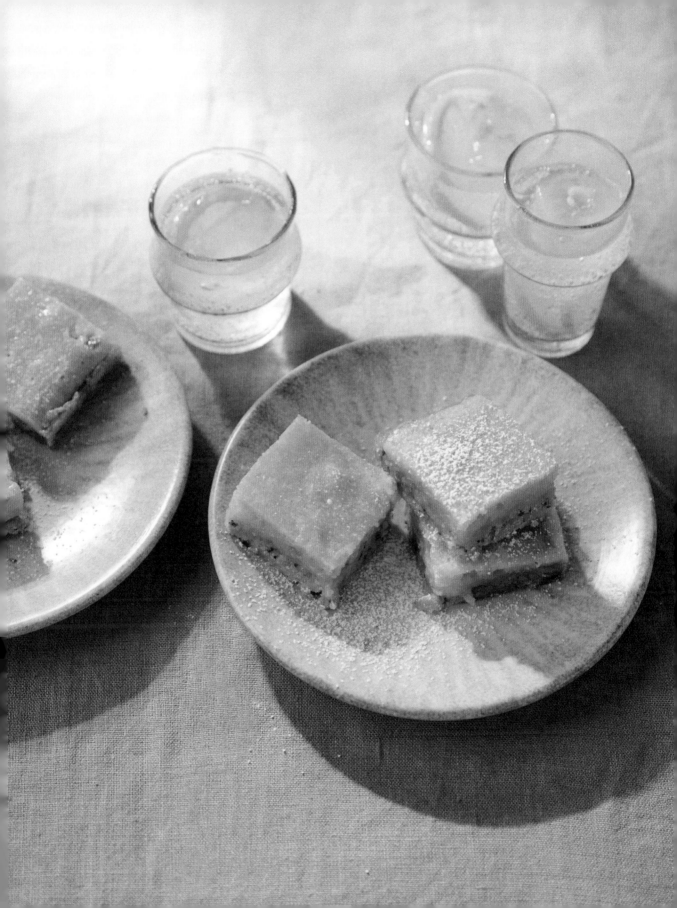

Golden lemon drizzle cake with poppy seeds

A cake that has it all: sweet, sour, fluffy, sugar-crusted crunch, and luxurious filling. And then the sponge! Sunshine gold to lift any mood.

My secret is ground turmeric in the batter, which also serves to echo the slight bitterness of lemon, offsetting the sweetness, while a generously juicy drizzle brings intense tang. The idea for the lemon mascarpone center came from Tonia George in a magazine cutting I have held onto for 15 years. I will be forever grateful to her, as this might just be my favorite cake.

Serves 8

For the cake
200g (7oz) unsalted butter, at room temperature, plus more for greasing
Finely grated zest of 2 lemons
200g (7oz) castor sugar
4 eggs, at room temperature

2 teaspoons baking powder
¾ teaspoon ground turmeric
¼ teaspoon fine sea salt
2 tablespoons poppy seeds (optional)
200g (1⅓ cups) plain flour

For the drizzle
100ml (scant ½ cup) lemon juice (from about 4 lemons)
75g (⅓ cup) granulated sugar

For the filling
125g (4½oz) mascarpone
125g (4½oz) tangy lemon curd

SPICE SWITCH

Cardamom, lemon, and ginger drizzle: substitute the turmeric and poppy seeds in the sponge with the ground seeds of 5 green cardamom pods. Sandwich the cakes with a slick of ginger marmalade and a larger quantity of lightly sweetened whipped cream.

Grease and line two 8-inch sandwich tins. Heat the oven to 375°F.

In a large bowl or stand mixer, beat the butter with the lemon zest and sugar until softened. Beat in all the remaining cake ingredients except the flour. Once smooth, gently fold in the flour.

Divide between the two tins and level the surfaces. Bake for 20 minutes, or until the tops are browned and springy.

Leaving the cakes in their tins, prick the surfaces all over with a cocktail stick. Mix the lemon juice and sugar together briefly then drizzle the liquid slowly over the two cakes, saving all the undissolved sugar to spoon over the top cake. Once the liquid has sunk in, remove the cakes from their tins and cool on a rack.

For the filling, swirl the mascarpone and lemon curd together. When the cakes are completely cool, sandwich them together with the lemony mixture, using the sugar-crusted cake on the top.

Best on the day it is made, but if keeping longer then store in the fridge.

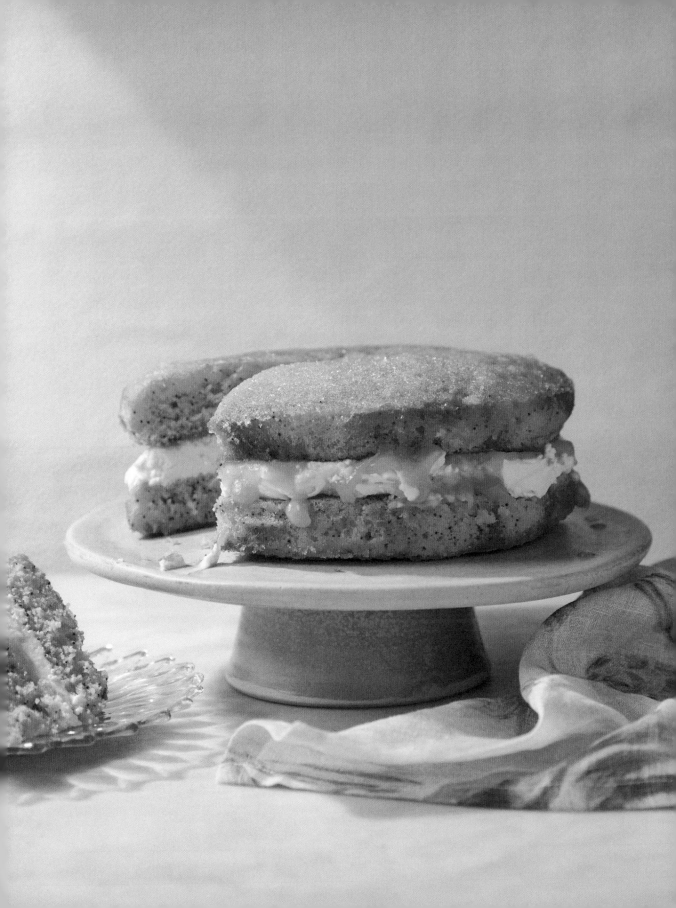

SOME LIKE IT HOT

Smoky chili brownies

Brownies and sponge cakes are opposites. For a sponge you are doing everything for ethereal lightness: whipping in air, keeping it through careful folding, then using leavening agents to expand those air bubbles in the oven. In a brownie you want squidgy, fudgy richness, so the reverse is called for: damp sugars, a molten batter, teetering toward the edge of undercooking.

These brownies are particularly good because they are intensely chocolaty without veering into truffle territory. There are a few tricks for this: first, a high ratio of dark chocolate along with an additional kick of cocoa powder. Second, whole wheat flour to give a slight nubbly heft, just enough to add interest. Finally, a couple of flavor enhancers—chili and smoked salt both serve to lift and intensify the chocolate flavor without taking over. Choose a Mexican ground chili such as pasilla or ancho, which bring a mild, complex warmth that matches the chocolate wonderfully. If using a chili like cayenne, which is more about heat than flavor, scale back to a couple of pinches.

Makes 12 brownies

200g (7oz) best dark chocolate, 70%
100g (3½oz) unsalted butter
135g (4¾oz) whole wheat spelt flour
30g (¼ cup) unsweetened cocoa powder
⅓ teaspoon baking powder
½ teaspoon fine sea salt

2 teaspoons pasilla or ancho chili powder or 2 pinches of cayenne
2 large eggs
135g (⅔ cup) light muscovado or light soft brown sugar
135g (4¾oz) castor sugar
Smoked sea salt flakes, for sprinkling

SPICE SWITCH

Take the chili-spiked brownies in the direction of Mexican hot chocolate by dusting the tops with cinnamon after cooking.

Line an 8-inch square tin with parchment paper. Heat the oven to 350°F.

Break the chocolate into squares and melt with the butter in a bowl set above just-simmering water. Leave to cool slightly.

Whisk together all the dry ingredients to break down any lumps—the flour, cocoa powder, baking powder, salt, and chili.

In a large bowl or stand mixer, whisk the eggs and two sugars together to a light, fluffy mass. Slowly mix in the melted chocolate followed by the dry ingredients, just to combine.

Spread out the mixture in the tin and scatter the top lightly with the flaky sea salt. Bake for 20 minutes, or until the brownies are set with a faint wobble. Leave to cool and firm in the tin before cutting into squares.

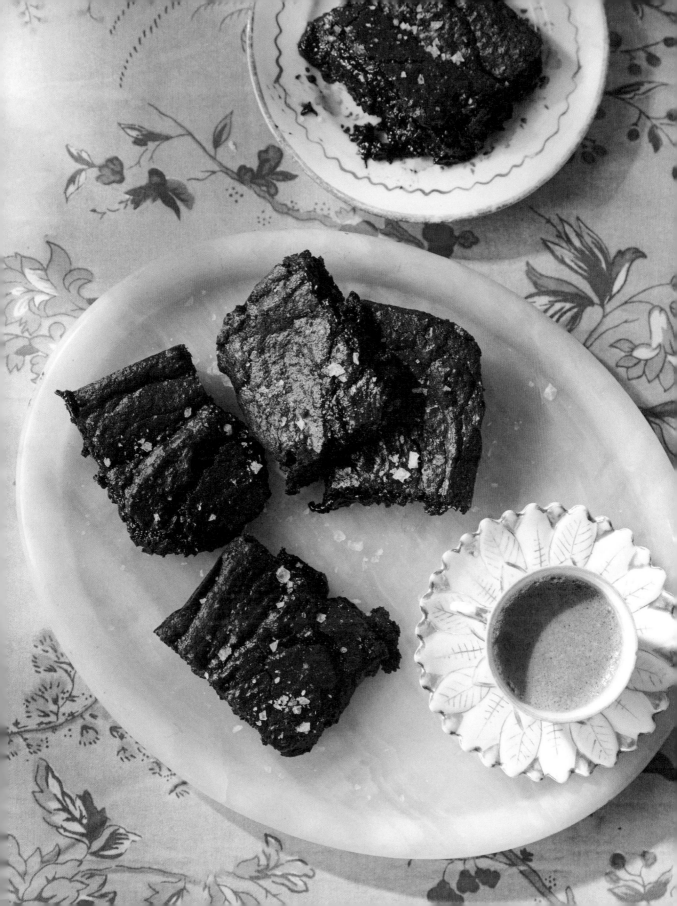

Chocolate mousse for lovers

A bounty of reputed aphrodisiacs—chocolate, cinnamon, cardamom, chili, and black pepper—all come together to bring a sultry warmth. Chocolate has a curious affinity with spice, allowing it to take more heat than you'd think.

I like my choc mousse pure and dark without cream and sugar. But then again, I use both as accompaniments in the form of softly whipped folds and crunchy pepper praline to balance the intensity. This way they offer contrast as well as harmony; after all isn't that what we want from any union?

Serves 2

For the chocolate mousse
100g (3½oz) best dark chocolate, 60–70%
2 green cardamom pods, seeds ground
¼ teaspoon ground cinnamon
Small pinch of ground chili
Small pinch of fine sea salt

10g (½ tablespoon) unsalted butter
3 eggs, at room temperature

For the black pepper praline (makes extra)
75g (⅓ cup) castor sugar
30g (1oz) toasted hazelnuts, roughly chopped

1 tablespoon cacao nibs
½ teaspoon black peppercorns, cracked

For the Chantilly cream
100ml (scant ½ cup) whipping cream
1½ tablespoons castor sugar

SPICE SWITCH

For a gentler romance, swap the spices in the mousse for a few drops of jasmine extract.

Crack the chocolate into squares and put in a large heatproof bowl with the spices. Set above, not in, a pan of simmering water. Once largely melted, remove from the heat and stir regularly to melt fully. Melt in the salt and butter. Remove the bowl from the pan and leave to cool for a few minutes.

Separate the eggs, putting the whites in a large bowl and the yolks in a smaller one. Whisk the whites to stiff peaks.

Stir the egg yolks one at a time into the lukewarm chocolate until smooth. Mix in a third of the whisked egg whites to lighten the mixture, then very gently fold in the rest, keeping in all the precious air bubbles. Divide between two dishes, or one sharing bowl, and chill for at least 4 hours.

For the praline, line a baking sheet with baking parchment. Heat the sugar without stirring in a heavy-based pan over a medium heat. It will melt to form a deep amber caramel—if it starts browning before fully melting, lower the heat and swirl a little until it all catches up. Stir in the hazelnuts, nibs, and pepper and pour onto the parchment, spreading it out slightly. Once set, chop into a mixture of chunks and smaller crumbs.

For the Chantilly cream, whisk the cream and sugar together to form soft peaks. Chill until serving.

Serve the praline and cream in separate bowls alongside the mousse so you can delve into each as you eat. There is probably more praline and cream than you'll need here, but now is not the time to be restrained.

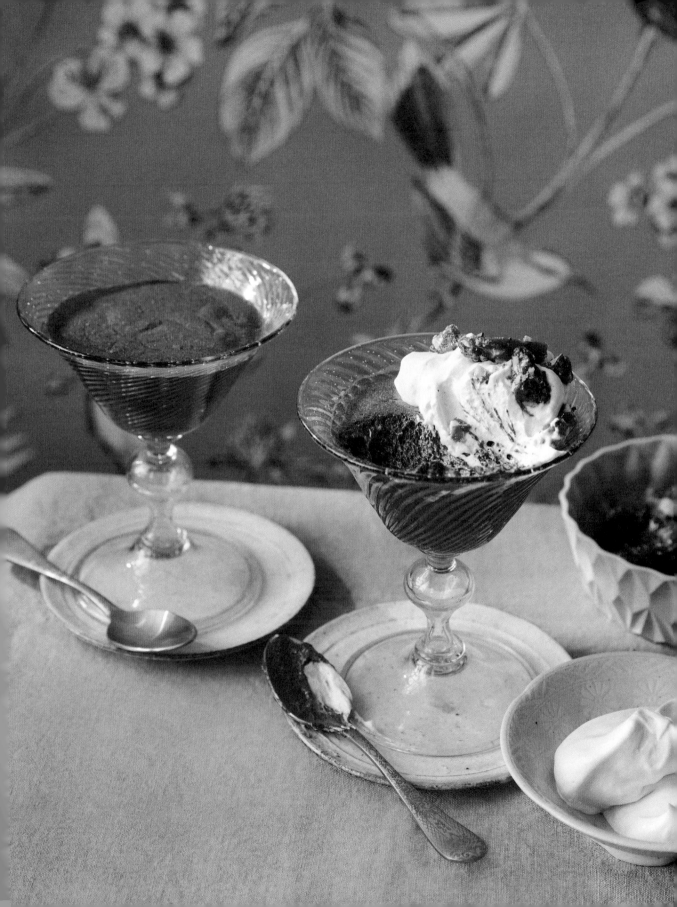

Spicy butter caramel popcorn

Get ready for the most addictive snack with a cloak of butter caramel and intense cacophony of warming spices. I particularly like the mustard seeds here; they are rarely used in sweet preparations, but they have a nutty aroma that works well with popcorn and release a snap of sharp heat if you happen to bite one.

Serves 4–8

1 tablespoon sunflower oil

110g (3¾oz) popping corn

200g (7oz) unsalted butter, diced

200g (1 cup) soft light brown sugar

1 tablespoon clear honey or golden syrup

½ teaspoon baking soda

For the spices

1 scant teaspoon fine sea salt

1 teaspoon black mustard seeds

1 teaspoon cumin seeds

½ teaspoon coarsely ground black pepper

½ teaspoon ground cinnamon

¼ teaspoon ground mace

¼ teaspoon ground chili

SPICE SWITCH

Use 2 teaspoons garam masala or a mixture of 1½ teaspoons ground cinnamon and ½ teaspoon ground allspice. I like to add salt to any combination for that salty-sweet vibe.

Mix all the spices together in a small bowl. Line a baking sheet with parchment paper or a silicone liner.

Heat the oil in a large pan over a medium–high heat, add the popping corn and cover. Cook, shaking the pan occasionally for about 4 minutes, until the popping stops. Tumble into a large bowl, picking out and discarding any unpopped kernels.

Wipe out the pan with a paper towel then add the butter, sugar, and honey. Cook gently, stirring until the sugar dissolves. Turn the heat to medium and bring to a boil without stirring. Leave to bubble for 4–5 minutes—if you have a sugar thermometer, it should read 253°F, or the bubbles will get slower and larger when it is ready. Remove from the heat and quickly stir in the spices followed by the baking soda, which will cause the mixture to bubble to a hot foam.

Immediately pour over the popcorn and stir to coat. Spread out onto the baking sheet to cool. It should set hard. Don't worry if humidity, temperature, or kitchen jinni conspire against you, leaving the caramel sticky, or you simply want more crunch: put the tray of popcorn in the oven at 325°F for 10 minutes or so, break up any large clumps then cool again. Once dried, it will keep in a tin for a few days.

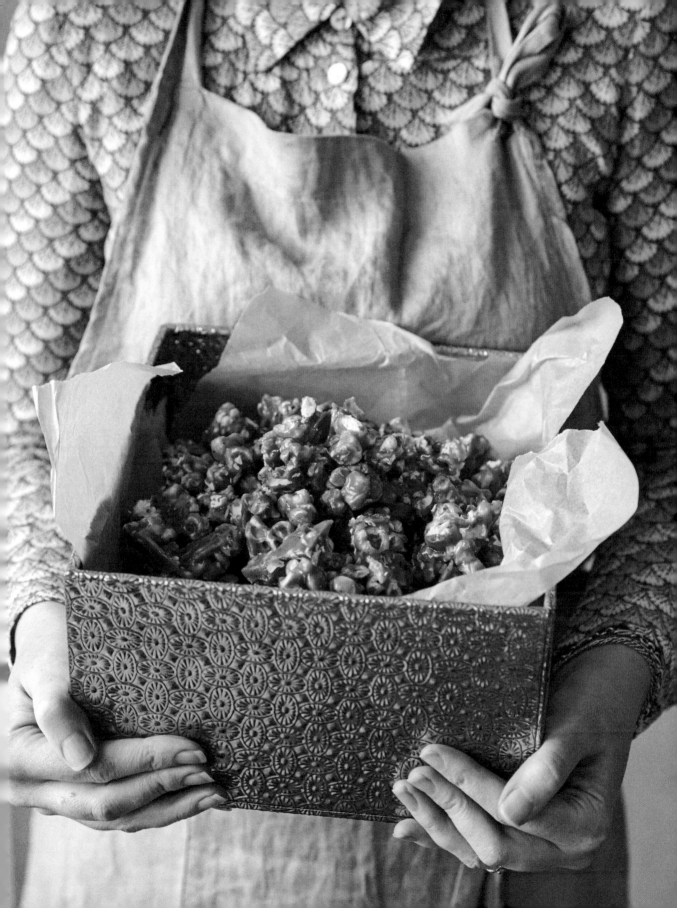

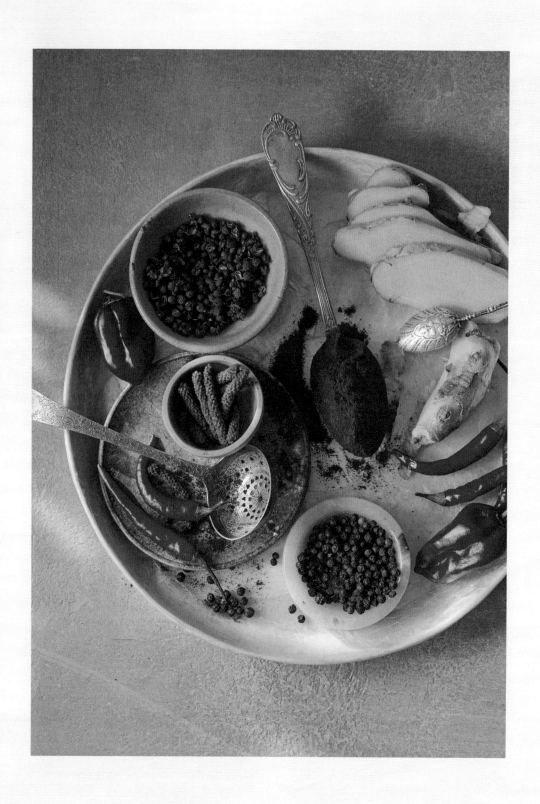

HOT SPICES

We can trace three distinct eras of human history by following our taste for spicy heat. Even though piquancy is designed to be aversive—it is plants' defensive chemicals to repel pests—people have always been drawn to the thrill of the disquieting. Ginger was one of the first foods on the move, its thunderous warmth making it popular cargo for Austronesian sailors 6000 years ago. This marks the start of early intermingling, when commodities and ideas began to spread overseas.

Pepper defines another era. A reliable and versatile whack of heat that traveled well, it was greeted hungrily—in the Middle Ages, 90 percent of spice imports to Europe were Indian peppercorns, and the Chinese were reportedly taking ten times the quantity. Explorers set out in search of new routes to satiate the hot desire for pepper, so redrawing world maps and fueling the European Age of Discovery.

One such explorer was Christopher Columbus, who sailed west in his hunt and so happened upon chili (and America). This third spice era saw the Old and New Worlds collide and new foodstuffs crossing in each direction. Chili, the hottest spice of them all, became the fastest spreading and most used on Earth.

We don't just love spicy heat for the tingle on our palates and the race of our pulses. "Spicy" has come to mean erotic and heat is synonymous with passion. This has fired these ingredients' reputations as aphrodisiacs and stimulants.

They are our spices for vices.

It is curious then that "gingerly" means cautious, but actually the root words are different. Ginger itself is anything but—it is bold and strident, and in Hawaii, a symbol of royalty. The zing of the fresh rhizome comes from three stimulating compounds: gingerol, shogaol, and zingerone. Use it when you want a herbal, citrusy heat in baking. A clever Cantonese treat employs the enzymes in ginger juice to both flavor and coagulate sweetened milk, setting it in minutes to a soft cream that occupies some notional ground between liquid and solid. When dried to a powder, ginger's lemony freshness morphs to a more peppery heat, perfect for spiced cookies. In the eighteenth century, English taverns had shakers of dried ginger on the bar for drinkers to spark up their warm ale.

To excite a lady, the fabled Kama Sutra advised its readers to douse their nether regions with peppered honey. While pepper is more usually channeled to savory cooking, it does indeed combine rather wonderfully with honey and other sweets. Sugar tames the lingering heat and lifts the floral, woody notes held in the creped black skin of peppercorns. Both Roman and medieval cooks knew this well and often peppered sweet dishes, a trend happily reemerging. The wine-like complexity of dark chocolate combines particularly well, as does sweet fruit, both tropical and berries. Choose a fine-quality peppercorn like Tellicherry to make all the difference. You can also try other varieties, such as cubeb or long peppers, or those not botanically related, including pink peppercorns, Sichuan pepper, and sansho pepper.

Finally, chili, the most powerful punch of all. The fierce heat of fresh chilies is wonderful with fruit, especially when you find that mouthwatering balance of hot, sweet, and sour. In baking, it is the concentrated, fruity flavors of dried chilies that make a better match.

Explore the many varieties, from chipotle to pasilla, to pull out notes of raisin, tobacco, and smoke,

and pair with nutty grains, dark chocolate, or bittersweet caramels for a sultry combination.

Brown sugar meringues with chili & tamarind

Resolutely brown food, but with big, bold flavors. The meringues are a showcase for the sugar, so I would choose a good light muscovado that has a deep toffee intensity. The sauce is then thrillingly chili-hot and mouth-twistingly sour from the tamarind. If that kind of thing is your jam, you must try this recipe.

Serves 4

For the brown sugar meringues
2 egg whites (70g/2½oz), at room temperature
55g (¼ cup) castor sugar
55g (¼ cup) light muscovado or light soft brown sugar

For the tamarind chili sauce
3 tablespoons tamarind paste (I favor a lighter, less concentrated one)
1 tablespoon castor sugar
1–2 bird's eye chilies, finely chopped

For the whipped cream
150ml (generous ½ cup) heavy cream
1 teaspoon castor sugar
Ground chili, to dust (optional)

SPICE SWITCH

Whisk ½ teaspoon ground cinnamon into the meringue, then serve with softly whipped cream, nibbed pistachios, and sliced figs.

Line a baking sheet with parchment paper. Heat the oven to 300°F.

In a stand mixer or with an electric whisk at medium speed, beat the egg whites to soft peaks. Whisk in the white sugar then brown sugar, adding a spoonful at a time. Increase the speed and continue beating for 5–10 minutes, until the manilla-colored mixture is stiff and shiny and you can't feel any sugar crystals if you pinch a little between your fingers.

Dollop the meringue into four hillocks and use the back of the spoon to press and lift on the surface to tease out beautiful spikes. Bake for 1½ hours, or until the meringues are firm enough to lift away from the paper easily. Leave to cool in the oven with the door ajar.

To make the tamarind chili sauce, combine the tamarind paste and sugar in a small pan with 3 tablespoons water. Add chili to taste—I like it hot so I keep the seeds in, but you can scale it back. Cook over a medium heat for a couple of minutes to make a dark and fiery sauce.

Whip the cream and sugar together to soft folds.

Serve the meringues with a dollop of whipped cream, a dusting of ground chili, if desired, and a pool of tamarind chili sauce.

Spicy pickled cherries

Pickling fruit intensifies it, making it sweeter, sharper, juicier. These cherries are spicy to boot. It is also the quickest dessert imaginable to prepare (though you need to do so a day or two in advance). They are especially good with vanilla ice cream and also work alongside soft cheeses.

Serves 4

500g (1lb 2oz) ripe cherries

120ml (½ cup) rice vinegar

85g (3oz) honey

50g (1¾oz) granulated sugar

¼ teaspoon fine sea salt

5cm (2 inches) fresh ginger, thinly sliced

10 black peppercorns

5 cloves

1 dried Thai chili or 2 pinches of chili flakes

SPICE SWITCH

A split vanilla pod (save the seeds for another use) and 2 star anise.

You can remove the cherry stones if you wish, but they look rather pretty whole with the stems on. In this case, prick each with a skewer first. Pack into a bowl or jar.

In a small pan, combine the vinegar, honey, sugar, salt, ginger, peppercorns, cloves, and chili. Simmer until the sugar has dissolved.

Pour the hot brine along with the spices over the cherries, cool to room temperature then cover. Chill in the fridge for 1–3 days, giving the jar an occasional shake to douse all the cherries in the liquid. They will keep for a week or more.

Eat the cherries without their pickling liquor, or with a drizzle if you can't resist the hot tang.

Strawberry sansho sorbet

This is a cheat's strawberry sorbet. Only 5 minutes more preparation than store-bought and it tastes so fresh and fruity it is worth every one of them. It is then lifted by an unexpected prickle of pepper.

Sansho pepper is an undoubtedly exciting ingredient, offering a tangy, lemony lick and an almost electric tingle on the tongue. This dried Japanese berry is normally channeled toward savory uses and is a key player in the spice mix shichimi. Buy a little pot—it keeps well—and you can also put it to more eccentric uses, such as sprinkling over milk ice cream as they do in some pepper shops in Japan. Alternatively, choose Sichuan peppercorns, which have a similar "cooling" heat and mouth-numbing buzz.

Serves 4

400g (14oz) frozen
 strawberries
75g (2½oz) golden
 syrup
1 tablespoon
 pomegranate
 molasses
Small pinch of fine
 sea salt
Ground sansho pepper
 or Sichuan pepper,
 to serve

SPICE SWITCH

Use 1 teaspoon ground sumac instead of the pomegranate molasses. Alternatively, exchange the pomegranate molasses for good balsamic vinegar and serve with a twist of black pepper.

Blitz the frozen strawberries, golden syrup, pomegranate molasses, and salt in a food processor or high-speed blender to a smooth slush. (If your food processor has a low motor and is struggling, let the strawberries semi-defrost first.)

Scrape into a freezer box and freeze for 1–2 hours.

Scoop into tumblers or small bowls and serve with a sharp dusting of sansho or Sichuan pepper.

Raspberry, balsamic, & peppercorn parfait

Black pepper has a deeply aromatic warmth—woody, floral, sometimes even with a suggestion of citrus. These qualities work very well with berries, bringing out their sharpness and fragrance. Balsamic vinegar plays a similar role; both are there as support acts for the raspberries to make them taste more, well, raspberryish.

Serves 8

350g (12oz) raspberries, plus more to serve
1 tablespoon runny honey
1 tablespoon balsamic vinegar
1 teaspoon black peppercorns, ground

150g (⅔ cup) castor sugar
4 egg yolks
200ml (generous ¾ cup) heavy cream

SPICE SWITCH

Add a teaspoon of rose water in place of, or in supplement to, the pepper.

Loosely line a narrow loaf tin or 1 liter (35 fl oz) freezer box with plastic wrap.

Quarter 50g (1¾oz) of the raspberries and set aside. Press the rest through a sieve to make a scarlet purée (blend first if you want to—easier but more washing up). Mix in the honey, balsamic, and black pepper, then set this aside too.

Make a syrup with the sugar and 100ml (scant ½ cup) water. Bring slowly to a boil to melt the sugar, then raise the heat and cook until it reaches 248°F—firm ball stage.

Meanwhile, whisk the egg yolks until they lighten, ideally in a stand mixer. As soon as the syrup reaches the right temperature, start trickling it very slowly into the yolks as you whisk. Keep whisking at high speed for 5 minutes or more, until the mixture is cool and has expanded in volume to a billowy mass. Fold in the raspberry purée. Chill in the fridge.

Whisk the cream until soft and thick—stop before the peaks stiffen. Fold in the raspberry mixture to create a uniformly pink cream. Add the quartered berries and very gently fold together—just a few deep folds with a large spoon.

Scrape into the lined tin, cover with plastic wrap, and freeze for at least 6 hours or overnight. Turn out onto a plate to serve, remove the plastic wrap, and cut into thick slices. Serve with more fresh raspberries.

Stone fruit galette with marzipan & long pepper

A rustic tart with buttery-crisp pastry and just-sweet-enough fruit, well suited to harvest feasting. I love the creativity this freeform way of baking allows you, and I find myself switching things up and trying different flavor combinations every time I make it. Here is a failproof template to riff on.

I have chosen my favorite fruits—plums and cherries—but you can use any combination of peaches, nectarines, plums, blackberries, blueberries, cherries, or apricots. Just make up to around 450g (1lb) in weight. Then choose a citrus zest and spices. Here I have gone for long pepper, a granite-gray catkin grown in India and Indonesia, which has the hot bite of black pepper but with more of a violet-scented pungency.

Serves 6

For the pastry
120g (4¼oz) unsalted butter, frozen
180g (6½oz) plain flour, plus more for dusting
¼ teaspoon fine sea salt
2 teaspoons granulated sugar
100ml (scant ½ cup) iced water

For the filling
300g (10½oz) plums, stoned and sliced
150g (5½oz) cherries, stoned
3 tablespoons granulated sugar
2 tablespoons corn starch
Finely grated zest of a lemon

SPICE SWITCH

Keep it hot with a good pinch of black pepper, Aleppo pepper, or chili flakes. Or take it more floral with lavender blossoms, cracked coriander seeds, ground cardamom, or toasted and ground fennel seeds.

Freeze the butter in advance, wrapped in foil. The aim is to keep everything cold for light, flaky pastry.

Combine the flour, salt, and sugar in a large bowl. Coarsely grate in the frozen butter, holding it in the foil as you grate. Stir in with a table knife as you go to coat the wisps of butter in flour. Stir in two-thirds of the iced water, adding more only as needed to form a shaggy (not sticky) dough. Use your hands to lightly bring it together and wrap in plastic wrap. Chill in the fridge for half an hour (or up to 3 days).

When you are ready to cook the galette, heat the oven to 400°F.

Tumble the fruit with 2 tablespoons of the sugar, the corn starch, lemon zest, and spice.

Lightly dust a baking sheet with flour and roll out the pastry on it to a circle about ¼-inch thick. Roll out the marzipan to a very thin circle, smaller than the pastry, and lay it on top. Pile on the fruit, leaving a 2¾ inch border. Fold the edges up and over the fruit, pleating and pinching as needed to keep it in place.

Beat the egg white until pale and very foamy. Brush the foam onto the pastry and sprinkle it with the remaining tablespoon of sugar.

Bake for 35 minutes. The pastry should be crisp and golden and the fruit juicy and bubbling. I think it is best warm, about an hour out of the oven.

FRUIT ♡ SPICE

Speedy, spicy ways to end a meal elegantly

Peaches & cream

Lay slices of peeled **peach** in a heatproof dish. Slightly sweeten a bowlful of **heavy cream**, add a glug of **amaretto,** and whip to billowing peaks. Drape over the fruit like a duvet then top generously with a mixture of one part **ground cinnamon** to six parts **castor sugar**. Broil for just long enough to caramelize the top like crème brûlée.

Ice cream with blackberry chili syrup

Combine in a pan 150g (5½oz) **blackberries**, 100ml (scant ½ cup) **maple syrup**, ½ teaspoon **chili flakes,** and the juice of ½ **lemon**. Bring to a boil over a medium heat and bubble gently for 5 minutes, stirring and squashing the berries occasionally. Leave to cool (and pass through a sieve if you'd like a smooth syrup). Serve over **vanilla ice cream**.

Sambuca watermelon

Dice **watermelon** and splash with **sambuca** and fresh **lemon juice**. Toss with a sprinkling of **sugar**, a good scrunch of **salt,** and an optional sliced **chili**. Chill in the fridge for about an hour to let fruit soak up the anise-scented liquor. Serve cold, strewn with freshly chopped **mint**.

Poached fruit

The perfect way to put unusual spices to use. Add a scattering to the poaching liquid but don't be aggressive here—you want to enhance not overwhelm the delicacy of the fruit. Try **verbena berries** with **rhubarb**, **passion berries** with **apples**, **long pepper** with **plums**, or **cassia buds** with **pears**.

Salty sumac pears

Give each guest a **pear**, a knife, a small dish of **ground sumac** seasoned with a pinch of **sugar** and another of fine **salt**. Slice, dip, repeat.

Italicus sorbet

Italicus is a liqueur with floral spice. Add a shot to a champagne flute, top up halfway with **prosecco** then slip in a scoop of **berry sorbet** and a few fresh **berries** on top.

Nutmeg date shake

For a Californian road trip in a glass, freeze 200ml (generous ¾ cup) **milk** in ice cube trays. In a high-speed blender, whiz the milk ice with 2 pitted **medjool dates**, a grating of **nutmeg,** and a suspicion of **salt**. Add a good glug more **milk** to help the blades turn and make a thick, toffeed milkshake. Drink at once and dream of sunshine.

Black pepper strawberries

Set out a dish of high-season **berries** and three small bowls: one with **white sugar**, one with coarsely ground **black pepper,** and the final one with a puddle of **balsamic vinegar**. Dip the strawberries into the bowls as you eat, enjoying the contrast of sweet, sour, and rounding pepper heat.

Chaat masala fruits

Tumble a mixture of tropical fruits like **mango** and **papaya** with a squeeze of **lime juice**, a pinch of **sugar,** and the Indian spice mix **chaat masala**. The blend combines salty, hot, sour, and funky to turbocharge all the flavors.

Spicy pineapple

Arrange slices of **pineapple** on a plate and add the grated zest and juice of a **lime**. Sprinkle with a mixture of equal parts **sugar**, **salt**, and **chili powder**, or use the same as a dip.

Grilled Sichuan pepper pineapple

To finish a barbecue, cut a **pineapple** into spears. Make a glaze from equal parts **brown sugar** and melted **butter**, then season with **salt** and ground **Sichuan pepper**. Paint onto the pineapple as you grill it for 5–10 minutes.

Prunes in Armagnac

Make at least a week in advance and they'll keep indefinitely, so you'll always have an instant, boozy treat on hand. Briefly boil together 350ml (scant 1½ cups) **water**, 2 tablespoons **brown sugar**, 6 **cloves**, 6 **allspice berries**, 2 **star anise,** and a **cinnamon stick** to make a syrup. Pack 350g (12oz) **Agen prunes** into a jar, pour over the syrup and spices, and top up with 120ml (½ cup) **Armagnac**. Store in the fridge; eat with **chocolate ice cream**.

A platter of ripe figs

Serve with **Rose & cardamom cream** (page 170), crisp **almond biscuits,** and good conversation.

Gingerbread love tokens

Gingerbread is a broad term, warmly embracing everything from crisp snaps to darkly sticky cakes. Across centuries and across Europe it has taken many delicious guises, the only prerequisites being sweetness and spice—and the spice doesn't even have to include ginger.

British gingerbreads, with all their many regional variations, tend to lead with it; in Dutch speculaas it falls into second place to other sweet spices; while French pain d'épices omits it entirely in favor of aniseed, clove, nutmeg, and cinnamon. Scandinavian renditions usually have a pepper or cardamom edge, giving them names like pepparkakor.

For these spicy little numbers (pictured on page 236), I have taken inspiration, for the shape at least, from the gingerbread hearts given as favors at Germany's Oktoberfest. They are slightly soft, very spicy, and exceptionally good.

Makes around 40 hearts, depending on size

1 tablespoon ground ginger
2 teaspoons ground cinnamon
1½ teaspoons ground clove
1 teaspoon ground mace or grated nutmeg
A few twists of ground black pepper
½ teaspoon fine sea salt
340g (12oz) plain flour
1 teaspoon baking powder
225g (8oz) unsalted butter
170g (6oz) golden castor sugar
170g (6oz) dark muscovado or soft dark brown sugar
1 egg
80g (2¾oz) crystallized ginger, finely chopped

SPICE SWITCH

Borrowing spicing from an eighteenth-century Swedish recipe, use: 1 teaspoon ground cardamom, 1 teaspoon ground cinnamon, ½ teaspoon ground clove, ½ teaspoon ground grains of paradise (or black pepper), the finely grated zest of a ½ lemon and ½ orange, and 1–3 teaspoons rose water.

Whisk together the dry ingredients in a large bowl —the spices, salt, flour, and baking powder.

Melt the butter in a pan, stir in both sugars, and leave to cool. Mix in the egg. Make a well in the dry ingredients and add the butter mixture slowly to make a stiff, tawny dough. Mix through the crystallized ginger without overworking the dough.

Between sheets of parchment paper, roll out to about ⅛-inch thick. Chill in the fridge until completely cold.

Heat the oven to 375°F. Line two or three large baking sheets with parchment paper.

Cut out the cookies with heart-shaped cutters and lay on the baking sheets (they won't spread much). Cook for 10–12 minutes, or until rich brown at the edges and slightly paler inside. Leave to firm a little on the trays before moving to a rack to cool.

By all means get creative and decorate the hearts with lacy swirls of icing, but they are also very good just as they are. Store in a tin for up to a week.

Jamaican ginger cakes with buttered rum

A quadruple hit of ginger is in these treacly little cakes (pictured on page 237): fresh, ground, stem, and ginger beer. Ginger laid on ginger accented with nutmeg and allspice makes for a festival of husky heat. The cakes are darkly sticky yet light, not heavy as you may expect, topped off with a sparkling glaze of buttered rum.

Makes up to 24 cakes, depending on size

For the cakes
2 tablespoons grated fresh ginger
2 tablespoons chopped stem ginger in syrup
2 tablespoons dark rum
120ml (½ cup) ginger beer
250g (9oz) black treacle
100g (3½oz) dark muscovado or soft dark brown sugar
100g (3½oz) unsalted butter

260g (1¾ cups) plain flour
1 teaspoon baking powder
¼ teaspoon baking soda
1 teaspoon ground ginger
¼ teaspoon grated nutmeg
¼ teaspoon ground allspice
¼ teaspoon fine sea salt
2 eggs, beaten

For the buttered rum glaze
40g (3 tablespoons) unsalted butter
2 tablespoons dark rum
¼ teaspoon grated nutmeg
100g (3½oz) confectioners' sugar, sifted

SPICE SWITCH

The ginger elements are intrinsic, but you could use any combination of sweet and warming spices as accents in the cakes and glaze: allspice, clove, nutmeg, mace, cinnamon, cardamom, or black pepper.

Heat the oven to 350°F. Use a silicone mold pan in shapes such as mini Bundt cakes, loaves, or muffins. Alternatively, use paper cases in muffin trays.

Put the fresh and stem ginger in a pan with the rum, ginger beer, treacle, sugar, and butter. Heat to melt into a dark pool then set aside to cool.

In a large bowl combine the flour, baking powder, baking soda, spices, and salt, using a whisk to get rid of any lumps. Add the eggs to the treacly mixture then mix into the flour.

Divide the thin batter equally in the molds—they should be about three-quarters full. Bake for 15–20 minutes (depending on the size of the cakes), until they are springy to the touch and

a skewer in the middle comes out clean. Cool in the pan for 5 minutes then turn out onto a rack to cool completely.

Eat the cakes as they are or, to make the glaze, melt the butter with the rum and nutmeg over a low heat. Remove from the heat and stir in the confectioners' sugar. Dip in the tops of the cakes to coat then leave to harden—it is a dipping glaze rather than an icing, so you won't use it all, but spoon any extra over the tops if you insist. They will keep in a tin for 5 days.

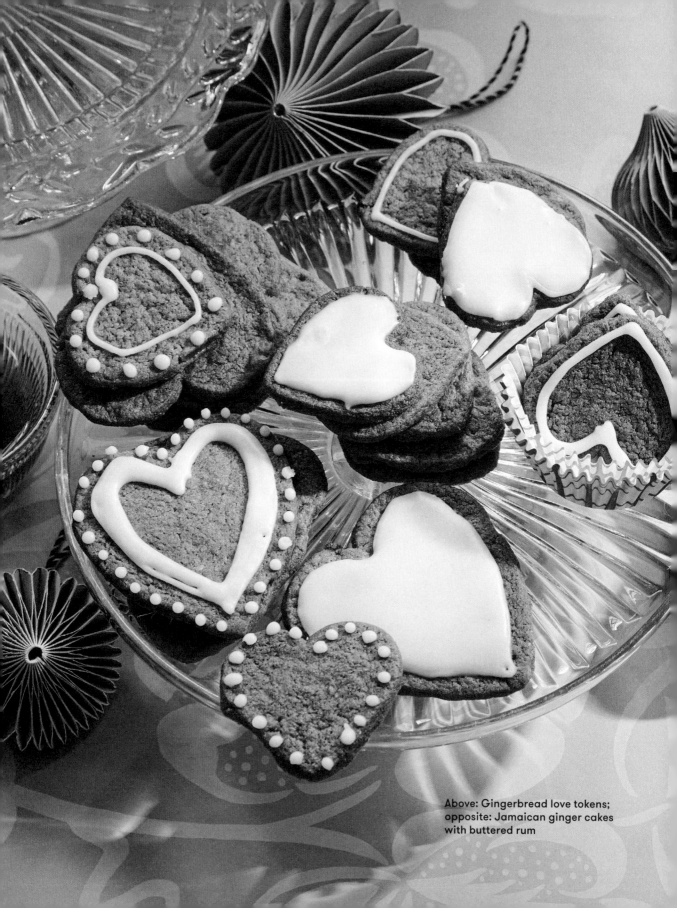

Above: Gingerbread love tokens; opposite: Jamaican ginger cakes with buttered rum

Carrot, spice, & candied ginger cake

Carrot cake can sometimes be a saccharine affair, but this gingery version is pared back in its sweetness to let the nutty, autumnal flavors shine. I think this is the best carrot cake in the world—I'd love you to try it and let me know if you agree.

Stem ginger, the sort stored like orbs of amber in syrup, is two ingredients in one. The rhizome itself is tender and juicy with its kick of heat untamed, while the syrup is suffused with a gentler warmth and used here in a silky mascarpone frosting.

Serves 8–10

150g (1 cup) plain flour
150g (⅔ cup) castor sugar
1 teaspoon ground ginger
1 teaspoon ground cinnamon
1 teaspoon fine sea salt
1 teaspoon baking powder
1 teaspoon baking soda
100g (3½oz) walnuts, coarsely chopped
100g (3½oz) stem ginger in syrup, roughly chopped

250g (9oz) carrots, grated
150ml (generous ½ cup) light olive oil or sunflower oil
3 eggs, beaten

For the frosting
250g (9oz) mascarpone
3 tablespoons confectioners' sugar, sifted
2–3 tablespoons stem ginger syrup
Walnuts, to decorate

SPICE SWITCH

Russian cookery author Alissa Timoshkina makes an unusual carrot cake spiked with caraway. To take my cake toward her flavor direction, leave out the stem ginger, add finely grated orange zest, and switch the spices with 2 teaspoons toasted caraway seeds and ½ teaspoon ground allspice. Serve without frosting, but with spoonfuls of sour cream alongside.

Grease an 8½-inch deep, loose-bottomed cake tin and line the base with parchment paper. Heat the oven to 350°F.

In a large mixing bowl, whisk together the flour, sugar, spices, salt, baking powder, and baking soda. Mix through the walnuts and stem ginger, then the carrot.

Make a well in the middle and add the olive oil and eggs. Mix together to make an even batter. Turn into the cake tin and level the surface.

Bake for 30 minutes, or until the cake is golden and firm to the touch, its sides beginning to shrink away from the tin. Allow to cool for 10 minutes in the tin, then loosen with a blunt knife and turn onto a rack to cool completely.

To make the frosting, drain off any liquid from the mascarpone. Stir in the confectioners' sugar and ginger syrup. Spread on the cake and decorate with walnuts. Once iced, store in the fridge.

Salt & pepper shortbread

Don't keep pepper only for savory cooking—its fragrant heat is lovely in these wedges of shortbread. I have used grains of paradise too, which have a similar flavor profile with added gingery-citrusy notes, akin to cardamom or coriander seed. These West African seeds, named with a stroke of medieval marketing genius, used to be widely popular but fell out of favor in Renaissance Europe when the price of black pepper fell, allowing it to become the spice of every table. They can now be hard to find, so by all means double the black pepper quantity in their stead.

Makes an 8-inch round, 8 wedges

50g (1¾oz) castor sugar, plus more for sprinkling
100g (3½oz) unsalted butter, at cool room temperature
150g (1 cup) plain flour
¼ teaspoon fine sea salt

½ teaspoon black peppercorns, coarsely ground
½ teaspoon grains of paradise, ground (or more black pepper)
Sea salt flakes, for sprinkling (optional)

SPICE SWITCH

For Mary Queen of Scots' favorite, swap the pepper and grains of paradise for 2 teaspoons caraway seeds. Or for something decidedly un-Scottish, use 1 teaspoon ground ginger and a good pinch of ground Sichuan pepper, or add 1½ teaspoons ground wattleseed.

Cream the sugar and butter until well combined but not airy. Add the flour, salt, and spices, mixing just until it starts to clump together.

Grease an 8-inch cake tin, then press in the dough using the back of a spoon. Prick the top prettily and score with spokes like a bicycle wheel. Chill in the fridge for 30 minutes.

Heat the oven to 350°F.

Bake the shortbread for 20–25 minutes until pale golden, firm, and a little sandy to the touch. Re-score while warm then cool in the tin. If you like, sprinkle the top with a little sugar and some flaky salt.

AN A–Z OF APHRODISIACS

Wherever there is heat, scent, or exoticism, aphrodisiac qualities have been optimistically ascribed. Is it any wonder that spices have long been the spiciest ingredients of them all?

ALLSPICE
Warming poultices of allspice, pepper, mallow, and rice were daubed onto men in China to cure impotence.

ANISEED
Aniseed gave a breath of licorice to rich, spicy cakes served at ancient Roman weddings.

ANNATTO
Leaves of the achiote tree were brewed into love teas in early Mexico.

ASAFETIDA
The pungent resin is used in Ayurveda and Tibetan medicine for its aphrodisiac qualities.

CACAO
Mesoamericans drank chocolate as an energy booster, libido enhancer, and medicinal tonic with mystical qualities.

CARAWAY
Medieval Europeans held that caraway would prevent the theft of any item that contained it and so the seeds found their way into love potions: feed caraway to your lover and they cannot be stolen from you.

CARDAMOM
In Arabic countries, the seeds of green cardamom have long been considered to enhance sexual vitality.

CHILI
Hot spice encourages hot love. A little is said to awaken a hesitant lover; too much will have the opposite effect.

CINNAMON
In the courts of Maharajas, cinnamon syrup was drunk to arouse carnal desire.

CLOVES
Thought to encourage yearning, cloves were a popular ingredient in philters (sixteenth-century love potions).

CORIANDER
Scheherazade, the mythical Arabian princess of *The Thousand and One Nights*, named coriander seeds as an aphrodisiac.

CUBEB
Early Arabic manuals recommended cubeb peppers mixed with honey or wine as a powerful stimulant.

DILL
Ascribed magical properties, dill seeds were a key ingredient in love potions from Roman times onward.

FEVER TREE
The South American cinchona tree has been used as a tonic for many ailments, and for its firing-the-furnace power.

GINGER
The medieval medicinal school of Salerno advised: "Eat ginger, and you will love and be loved as in your youth."

GINSENG
Prized in China and North Korea as a fertility aid, ginseng rhizomes shaped like a human body are thought to be the most potent.

HEMP
A psychoactive aphrodisiac was made in ancient India by mixing bhang leaves and seeds with sugar, musk, and ambergris.

JUNIPER
Native Americans drank a juniper infusion as contraception.

LAVENDER
Lustful Josephine served a bedtime drink to her lover, Napoleon: coffee steeped with lavender blooms and dark chocolate.

LICORICE
Long a medicine before it was a sweet, licorice was prescribed as a stimulant and aphrodisiac in early China, India, and Egypt.

MUSTARD
Monks in Medieval Europe were forbidden from eating mustard lest its heat be too stimulating.

NUTMEG
Nutmeg fires the male libido in Arabic and Indian tradition, but in China and Zanzibar, it is women who cannot resist its potency.

ORANGE BLOSSOM
"Angel water" was used to bathe genitals in eighteenth-century Portugal. The scented mixture contained distilled waters of orange blossom, rose, and myrtle mixed with ambergris and musk.

ORCHIDS
Roots of *Orchis morio* grown in the Turkish mountains are viewed as a wondrous love agent. In ancient times, satyrion was so popular it went temporality extinct; today it is churned into ice creams and made into the custard-like hot drink salep.

PEPPER
In Han Dynasty China, "pepper houses" were built for the emperors' concubines, the pepper ground into the plaster to scent the chambers with warm, sultry spice.

ROSE
The rose has been a symbol of love since antiquity. When Cleopatra seduced Marc Antony, she carpeted her bedchamber with a layer of the perfumed petals an inch thick.

SAFFRON
Phoenicians would eat saffron-stained moon cakes to honor Ashtoreth, the goddess of fertility.

SILPHIUM
A spice so loved that Romans ate it to extinction in the first century, silphium's heart-shaped seeds were imprinted on money and may even have inspired the enduring association of the symbol with romance.

SWEET FLAG
The Crees of North America would chew on the gingery rhizome (today used in colas) to induce hallucinations and enhance sexual stamina.

TONKA
In the magical world, tonka has been dubbed the "love-wishing bean."

TURMERIC
Many Indian cultures paint the bride and groom with turmeric before their wedding as a blessing.

VANILLA
According to Totonac legend, Xanat, daughter of the fertility goddess, was unable to marry her mortal beau, so instead transformed herself into the vanilla orchid to provide him endless sensual pleasures.

ZALLOUH
The roots of this mountainous Middle-Eastern shrub have been used by lovers for thousands of years. As with many spices, scientific discovery is now proving some of the spicy effects long supposed by our ancestors.

Sources & further reading

Abbott, Elizabeth. *Sugar: A Bittersweet History* (Penguin Canada, 2008)

Bilton, Sam. *First Catch Your Gingerbread* (Prospect Books, 2021)

Coopey, Erin. *Infusing Flavours: Intense Infusions for Food and Drink: Recipes for Oils, Vinegars, Sauces, Bitters, Waters & More* (Cool Springs Press, 2016)

Dalby, Andrew. *Dangerous Tastes: The Story of Spices* (The British Museum Press, 2000)

Dell, Linda Louisa. *Aphrodisiacs: An A–Z* (Skyhorse Publishing, 2015)

Dunn, Richard S. *Sugar and Slaves: The Rise of the Planter Class in the English West Indies, 1624–1713* (University of North Carolina Press, 1972)

Eltis, David et al. *The Trans-Atlantic Slave Trade Database: A Database on CD-ROM.* (Cambridge University Press, 1999)

Etter, Roberta B. *Tokens of Love* (Abbeville Press, 1990)

Farrimond, Dr Stuart. *The Science of Spice: Understand Flavour Connections and Revolutionise Your Cooking* (Dorling Kindersley, 2018)

Ford, Eleanor. *The Nutmeg Trail: A Recipes and Stories Along the Ancient Spice Routes* (Apollo Publishers, 2022)

Hendrickson, Robert. *Lewd Food: The Complete Guide to Aphrodisiac Edibles* (Chilton Book Company, 1974)

Hildebrand, Caz. *The Grammar of Spice* (Thames & Hudson, 2017)

Hill, Mark Douglas. *The Aphrodisiac Encyclopaedia: A Gourmet Guide of Culinary Come-ons* (Square Peg, 2011)

Isin, Mary. *Sherbet and Spice: The Complete Story of Turkish Sweets and Desserts* (I.B. Tauris, 2012)

Kay, Emma. *A Dark History of Chocolate* (Pen and Sword Books, 2021)

Keay, John. *The Spice Route: A History* (John Murray, 2005)

Krondl, Michael. *Sweet Invention: A History of Dessert* (Chicago Review Press, 2011)

Langley, Andrew. *The Little Book of Spice Tips* (Bloomsbury USA, 2006)

McFadden, Christine. *Pepper: The Spice that Changed the World* (Absolute Press, 2008)

McGee, Harold. *McGee on Food and Cooking: An Encyclopedia of Kitchen Science, History and Culture* (Hodder & Stoughton, 2004)

Mintz, Sidney W. *Sweetness and Power: The Place of Sugar in Modern History* (Viking, 1985)

Monger, George P. *Marriage Customs of the World: An Encyclopaedia of Dating Customs and Wedding Traditions,* 2nd edition, volumes 1 & 2 (ABC-Clio, 2013)

Morton, Timothy. *The Poetics of Spice: Romantic Consumerism of the Exotic* (Cambridge University Press, 2000)

Norman, Jill. *The Complete Book of Spices: A Practical Guide to Spices and Aromatic Seeds* (Dorling Kindersley, 1990)

Page, Karen & Dornenburg, Andrew. *The Flavor Bible: The Essential Guide to Culinary Creativity, Based on the Wisdom of America's Most Imaginative Chefs* (Little, Brown and Company, 2008)

Roith, Cynthia. *Bygones: Love and Marriage Tokens* (Corgi, 1972)

Roux, Jessica. *Floriography: An Illustrated Guide to the Victorian Language of Flowers* (Andrews McMeel Publishing, 2020)

Segnit, Niki. *The Flavour Thesaurus: A Compendium of Pairings, Recipes and Ideas for the Creative Cook* (Bloomsbury, 2010)

Turner, Jack. *Spice: The History of a Temptation* (Harper Perennial, 2004)

Usmani, Sumayya. *Mountain Berries and Desert Spice: Sweet Inspiration from the Hunza Valley to the Arabian Sea* (Frances Lincoln, 2017)

Vâtsyâyana. *A Lover's Alphabet: A Collection of Aphrodisiac Recipes, Magic Formulae, Lovemaking Secrets and Erotic Miscellany from East and West* (Hamlyn, 1991)

Acknowledgments

Creating this book has been a true joy—our house filled with sweet treats, ensuring endless opportunities to scoff and to share, and to press them upon loved ones.

Thank you to everyone who has joined me on the journey.

The project was in part inspired by an ode to cardamom I wrote in 2007 (find it on page 63). It was a spice that hadn't featured much in my life and I was captivated by its utterly transformative, irresistible effect. At the time, being an author was a distant but consuming dream. Reflecting on the path from then to now, I know that many more people than I can mention on this page have inspired and supported me in my writing, dispensing wisdom and insight. I hope you know who you are and I thank you sincerely.

I am enormously grateful to Murdoch Books for their enthusiasm for me, the idea, and overseeing the creation of such a beautiful book. Justin Wolfers, self-described enthusiast, combines buoying support with acutely intelligent insight. To Corinne Roberts, thank you for your belief, and Céline Hughes and Jemma Crocker-Wilson for embracing this book so generously. To Kay Halsey, thank you for your considerate editing. To Helena Holmgren, you turn index-writing into an art form. And Heather Holden-Brown, ever the most kind and encouraging agent, thank you.

Kristy Allen and Madeleine Kane came together in the design to realize my dream of botanicals, birds and spices in fantastical prints. The result is mesmerizing. Skye McKenzie's illustrated maps and endpapers complete the Arcadia.

Working with the same photography team as for *The Nutmeg Trail*, we harnessed the artistry and love they put into every shot. Ola O. Smit, Kitty Coles, Wei Tang, Florence Blair and Matthew Hague—you are the best.

To ensure these recipes work in your kitchen as well as mine, I have relied upon a team of testers who have gone to great lengths, including importing wattleseeds and making pastries in hot caravan kitchens. Thank you for sharing your time and expertise: Robin Currie, Tracy Carey, Trudy Born, Fiona Rough, Lyn Waldron, Paula Godden, Mark and Tanya Howroyd, Jane Pilling, Thuy Hoang, Loraine Mosley, Chris Kemp, Tony Watson, Jang Kwon, Joanna Stoneham, Kelly Hooper, Manfred Tures, Kirsten Thomas, Jayanthi Vinayagamoorthy, Susannah Day, Lindsay Roberts, Rachel Bates, Anne Marchini, Philippa Coe, Liz Rennie, Georgie Lyon, Frances Wilson, Clare Dempsey, Nadine Corscadden, Stella-Maria Thomas, Krati Agarwal, Alessandra Maggiora, Fatemah Rajah, Nicola Wood, Anne Wander, Anne Marchini, Gill Hogg, Louise Dilworth, Debbie Stephenson, Marta Biriş, Kathy George, Elizabeth Long, Kathryn Meacher, Tanya Cordrey, Geva Blackett, Hayley Evans, Viki Paterson, Debbie Quinn.

Sebastian nobly tasted every recipe in this book while Otto and Sylvia diligently ensured no empty mixing bowl went unlicked. What a team!

My sweet Sylvia, this book is for you.

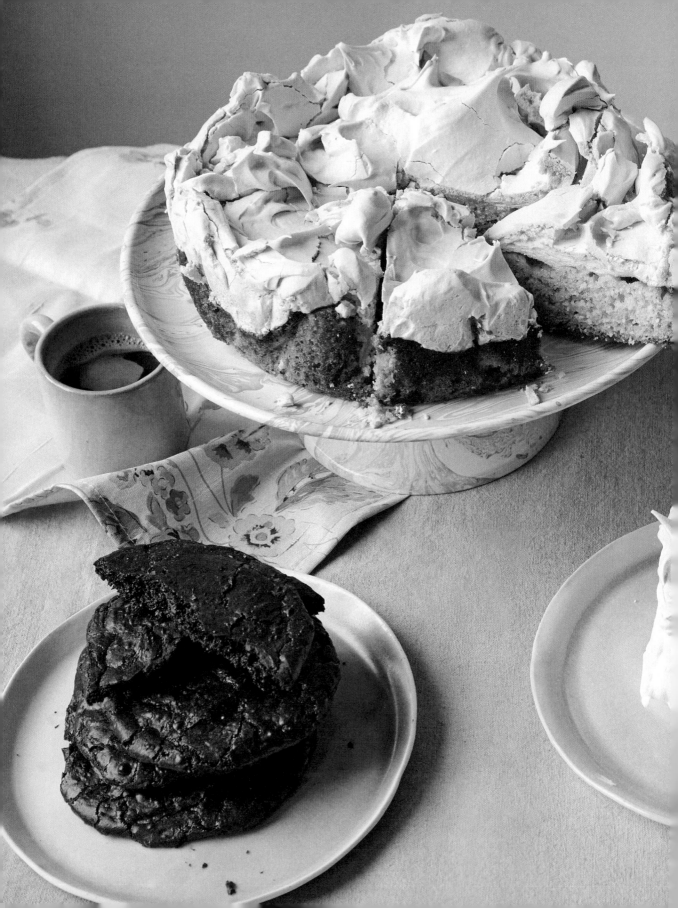

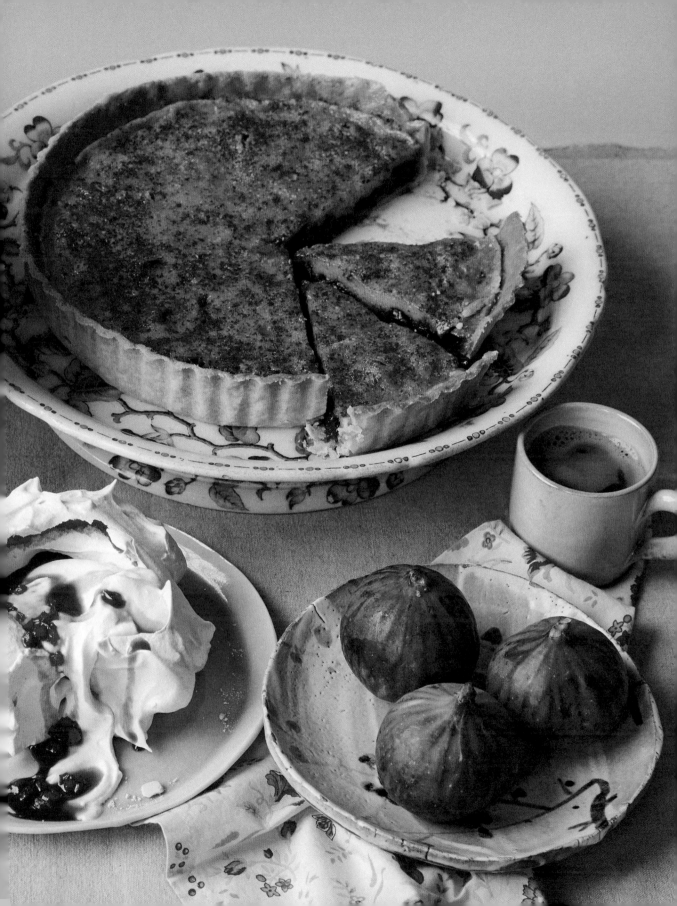

Index

Oven Guide: You may find cooking times vary depending
on the oven you are using. The recipes in this book were
tested using a fan-forced (convection) oven.

Tablespoon Measures: We have used 15 ml (3 teaspoon)
tablespoon measures.

FSC
www.fsc.org
MIX
Paper | Supporting
responsible forestry
FSC® C008047

Eleanor Ford is an award-winning food writer
and the author of *Samarkand* (with Caroline Eden),
Fire Islands, and *The Nutmeg Trail*. Her books have
been named books of the year in multiple publications,
won an Edward Stanford Travel Award 2020, and
Guild of Food Writers Awards in 2017 and 2020.
She lives in London. @eleanorfordfood